LEARNING BY DI

Pacific Northwest Coast Native Indian Art

Volume 1

This publication follows the beginner's book, "Learning by Doing Northwest Coast Native Indian Art," by Karin Clark and Jim Gilbert, first published in 1987, reprinted in 1990, 1993, and 1999.

Raven Publishing
P.O. Box 325
5581 Horne Street
Union Bay, B.C. V0R 3B0
Canada

Phone: 250-335-1708 or 250-478-3222
Fax: 250-335-1710 or 250-478-3222
Email: artandculture@ravenpublishing.com
Website: http://www.ravenpublishing.com

© COPYRIGHT 1999 by Jim Gilbert and Karin Clark
ISBN 0-9692979-3-9

No part of this publication or its contents, written or graphic, may be reproduced in any manner whatsoever without the written consent of the publishers. This includes transfer, copy, reproduction or transmission by mechanical, photographic, electronic or any other means, with the intent to sell, resell, or barter to garner profit. Please contact the copyright holders, Raven Publishing, for permission before using or reproducing any material.

First Edition - 11/99

ILLUSTRATIONS
Unless otherwise noted, all illustrations in *Learning by Designing, Volumes 1 and 2*, are the original artworks of Jim Gilbert.

Printed and bound in Canada by Hemlock Printers Ltd, Vancouver, B.C.

Thank you to: Acknowledgments

We, the authors, wish to acknowledge and give thanks to the many First Nations people, in particular the elders, who have, over the years, shared their wisdom, knowledge, skills, stories, humour and unselfishly extended their hospitality and kindness. We owe these people an enormous debt. It is from this group of people that we have also learned to respect the artform and the culture from whence it originated and is inseparable.

Special thanks is extended to the Hunt family of Victoria B.C. for the opportunity afforded Jim Gilbert in the early 1970's, to experience a traditional apprenticeship with master artists, at the Arts of the Raven workshop and the Thunderbird Park art training program.

Since the revival of traditional Northwest Coast First Nations art, in the 1960's, recognition must be given to those master artists who extended the opportunity for the training of others, which has ultimately led to the advancement and revitalization of the art.

The following is a list of some of the First Nations master artists, teachers and artists, who helped initiate, have sustained and contributed in the renaissance:

Mungo Martin, the Hunt family - Henry, Tony, Richard, Eugene, Stanley, Shirley, Calvin, Ross, George Jr., Tom, Tony Jr., Stephen, Jason; Mervyn Child; Bill Reid; Doug and Kevin Crammer; Sam, Don, Mark and Bill Henderson; Frank Nelson; Fah Ambers; Wayne and Bruce Alfred; Roy Henry Vickers; David Boxely; Chuck Heit; Simon and Beau Dick; Marvin Oliver; Stan Greene; Dwayne Simeon; Geg Colfax; Susan Point; Nancy Dawson; Nathan Jackson; Robert and Reg Davidson; Phil Janze; Ken and Victor Mowatt; Freda Diesing; Walter Harris; Vernon Stephens; Earl Muldoe; Ron Sebastian; Art and Neil Sterritt; Sam Wesley; Don Yeomans; Jerry and Russel Smith; Francis Williams; Clarence Mills; Doug Wilson; Norman Tait; Larry Rosso; Floyd Joseph; David Neel; Roy Hanuse; Stan Bevan; Ken McNeil; Dempsey Bob; Butch Dick; Victor and Carey Newman; Cicero August; Simon Charlie; Doug Lafortune; Francis Horne; Charles Elliot; Joseph Wilson; Terry Starr; Victor Reece; Henry Greene; Glenn Tallio; Jim Hart; Robert Jackson; Alvin Adkins; Glen Wood; Gerry Marks; Dale Campbell; Bradley Hunt; Art Thompson; Ron Hamilton; Joe David; Tim Paul; Patrick Amos; Lyle Wilson; Alfred Collinson; Danny Dennis; and Clarence Wells.

Many non-native master artists, artists and teachers have played a prominent role in the rebirth, understanding and growth of Northwest Coast art.

Non-natives are only now being recognized for their contribution in the renaissance of this great artform, whether it be in the production of original, fine quality native-style art, conducting classes or workshops, giving lectures, or writing articles and books. Artists with various cultural backgrounds who have contributed are in part:

Bill Holm, Duane Pasco, John Livingston, Phil Nuytten, Steve Brown, Ron Burleigh, David Forlines, David Horsley, Jim Bender, Barry Herem, Jay Haavik, Jerry Hill, Don Smith and the Lelooska family, Loren White, Greg Blomberg, Edith Newman, Glen Rabena, Gene Brabant, G. Mintz, Robin Wright, Henri Nolla, E. Arima, Tom Duquette, Tom McFee, Peter Grant, Tom Patterson and Brien Foerester.

An internationally recognized authority in the field of North American First Nations art and culture, is Bill Holm. This Seattle master artist, art historian, scholar, author and teacher, began an academic exercise in the mid-1950's which led to the publication in 1965 of a most influential book. *Northwest Coast Indian Art: An Analysis of Form,* has guided, influenced and educated more artists on the subject of two-dimensional Northwest Coast art than any other publication.

Thank you to:

Acknowledgments

Since its release, Bill Holm has continued to contribute to the development, understanding and recognition of the artform and artists by structuring and teaching classes at the University of Washington in Seattle Washington and writing countless articles and books on the subject. For nearly half a century, Bill has generously supported, directed, encouraged and given guidance to many scholars, and artists.

Another Seattle non-native master artist is Duane Pasco. Essentially a self-taught artist, he is one of the most highly regarded creators of Northwest Coast Native-style art.

"A full-time professional artist and teacher since 1967, he has taught classes at the Kitanmax School of Northwest Coast Native Indian Art at 'Ksan in northern British Columbia, the Sitka Indian Cultural Centre and Ketchikan Heritage Centre, both in Alaska, as well as Universities and Colleges in Washington State."[1]

In the early 1970's, Bill Holm stated, "Duane Pasco was the most important single contributor to the success of the revival of 'Ksan... his instruction and example...set the direction and standard of the work."[2]

[1] Averill, L. and Morris, D. *Northwest Coast Native and Native-style Art. A guidebook for Western Washington.* University of Washington Press 1995, p.165

[2] Bill Holm. *'Ksan Breath of our Grandfathers, - Art of 'Ksan.* National Museum of Man, Ottawa, 1972.

Friends and Family

Jim's parents, Harry and Mary Gilbert
Jim's wife, Joan
Karin's parents, Arnold and Irma Becker
Eric Lange
Lisa Becker
Roland and Aline Lange
Dixon Taylor
Bruce Obee
Ruth Cook
Margaret Klaassen

Editing
Joan Gilbert

Manuscript Review
Chief Tony Hunt
Carey Newman
Steve Brown
Ron Stacy
Reg Ashwell
Nella Nelson
Ron Burleigh
Ed Doerksen
Sue Coleman
Vernon Stephens
Jim Clayton
Edith Newman
Gary Hargreaves

Colleagues
Printing consultants, Art Thompson and Grant Forrest

Mid Coast Art Style Butterfly

Learning by Designing: Pacific Northwest Coast Native Indian Art, Volume 1

About the Authors

Jim Gilbert, B.A.

Born and raised on southern Vancouver Island, author/artist Jim Gilbert has had a lifetime of exposure to, and experience with, Pacific Northwest Coast aboriginal art. For the past thirty years, Jim has been a serious student of the culture, heritage and art of the coastal First Nations people. Jim also learned from his father, Harry Gilbert (1898 - 1967), who painted and carved in the Native style. A versatile and award winning artist, Jim works in all mediums in both traditional and contemporary art styles. All his designs are original, using centuries-old conventional design elements, structure and colour. His artworks can be found in collections worldwide.

In this two-volume publication, *Learning by Designing Pacific Northwest Coast Native Indian Art*, companion for the previously published *Learning by Doing Northwest Coast Native Indian Art*, Jim shares his passion and respect for the art form and passes on his own training, understanding, skill, and experience with traditional art apprenticeship methods. Jim's understanding of effective methods of passing on artistic knowledge and skills is partly the result of experience gained while teaching First Nations art in Victoria public schools and through giving workshops and seminars. Jim also used his artistic skills to create over fifteen hundred original illustrations for the two volumes of *Learning by Designing* as well as illustrating *Learning by Doing*.

Jim's long association with many First Nations artists working in all of the four art styles represented in these books, along with his qualifications as a biologist, teacher, artist and author make him uniquely suited to be involved in the production of this extensive, working guide and reference book on the aboriginal art of the Pacific Northwest Coast.

Exposure to a lifetime of Pacific Northwest Coast First Nations Art

Jim Gilbert and his sister, Marie, receive a lesson on carving a model totem pole from their father, Harry Gilbert, in 1939.

Peter Gilbert and his sister, Victoria, receive a lesson on carving a model totem pole from their grandfather, Jim Gilbert, in 1999.

About the Authors

Karin Clark, M.Ed.

Working with adults at a summer workshop

Writer/teacher/artist Karin Clark has had over 20 years experience working with children and adults. Most of this time has been spent learning and teaching with British Columbia's First Nations in public and private schools, colleges, art classes, aboriginal/social studies courses, and university teacher education programs.

In her first book, *Learning by Doing Northwest Coast Native Indian Art*, co-authored with Jim Gilbert, she used her experiences and training in special and cultural education to produce an easy-to-follow, beginners skill development curriculum designed to foster respect for First Nations culture through art.

Karin spends her work time evaluating teaching/learning strategies and materials; creating curriculum material, writing story books and readers; using frameworks to create First Nations language programs; creating material and workshops to: enhance self-esteem and motivation, create Native Indian art, learn and teach using the Cognitive Education Method (CEM) - 6 keys to success, identify and explore your own personal learning styles and strategies; identify, strengthen, and remediate thinking skills and strategies; train instructors, paraprofessionals and curriculum developers; and designing flyers and brochures.

In writing *Learning by Designing Pacific Northwest Coast Native Indian Art* with Jim, she has been able to use all her skills and experience to create a useful resource for artists, students, teachers, and collectors.

Other Works:
- First Nations Awareness: Putting It All Together
- First Nations in B.C.: Comparing Interior and Coastal Cultures
- Whale's Tales: Positive Stories About Contemporary First Nations Young People
- Potlatch Perspectives
- First Nations Full Day Kindergarten: From Our Treasure Box *(with Sheilia Austin)*
- First Nations Art Projects and Activities *(with Butch Dick)*
- Sk u k altx "To Teach in School" - Salish Language and Art Curriculum *(with Butch Dick)*
- Ucwalmicwts Language Curriculum Framework *(with Veronica Bikadi)*
- Woodworking Curriculum *(with Scott McIver)*
- First Nations Young People: Becoming Healthy Leaders for Today and Tomorrow *(with Paul Stevenson)*
- A reading series of six books with First Nations content for beginning readers: *Raven Visits Victoria, Victoria Long Ago, First Nations Families, Grandma s Special Feeling (First Nations use of plants), First Nations Technology (Past & Present), Wait for Me!,*
- Framework for Developing First Nations Curriculums *(with Nella Nelson)*
- First Nations Art Teachers' Record Keeping Book *(with Victor Newman, Butch Dick, Alex Clark, Brad Dick)*
- The Longhouse Project: Contemporary Stories about First Nations Cultures on Vancouver Island *(with Butch Dick, Shane Pointe, and Nella Nelson)*

Preface

The aim of this book is to give the reader some understanding of the highly developed, sophisticated Pacific Northwest Coast First Nations two-dimensional art styles. These styles have evolved over thousands of years, from crude pictographs on rocks to the highly stylized and abstracted designs we see today. Because of this complexity, we have attempted to keep the text and illustrations simple and clear.

We believe that creative and original artwork is the result of thorough grounding in traditional conventions and principles. We have purposely avoided complex art jargon, terminology, descriptions, and explanations. For additional clarity, we have included a glossary. For further information on a variety of related topics, we suggest you consult the bibliography. However, the primary educational tools in this publication are the many and varied illustrations and examples. *Learning by Designing* is a reference book, rather than a rule book.

As a reference book, *Learning by Designing* is not intended as a substitute for an apprenticeship system of learning traditional two-dimensional art. As in any art training, it is traditional to copy from the masters for the purpose of understanding the process. The illustrations in this book, as faithful to the aboriginal masters' styles as possible, provide students with models from which to create their own works. Therefore, this publication is offered as a supplement to the traditional apprenticeship training process.

We hope that the information contained herein will, first and foremost, help aboriginal art students, as well as artists, teachers and collectors, to expand their understanding and appreciation of two-dimensional Northwest Coast First Nations' art styles and the cultures from which they spring.

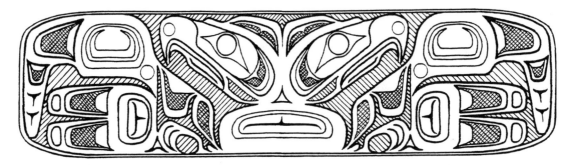

Bracelet Design - Split Eagle

Learning by Designing: Pacific Northwest Coast Native Indian Art, Volume 1

Table of Contents

Introduction .. 1

 Goals ... 7
 Overview of Learning by Designing ... 7
 Aboriginal Art within a Cultural Context ... 8
 Map: Culture & Art Style Regions of the Pacific Northwest Coast 15
 Map: Four Major Art Style Regions of the Pacific Northwest Coast 16
 History and Description of the North Coast Art Style ... 18
 History and Description of the Mid Coast Art Style .. 21
 History and Description of the South Coast Art Style ... 23
 History and Description of the West Coast Art Style .. 25

Basic Design

 Formline: An Introduction .. 27
 Formline .. 28
 Ovoid .. 35
 U shape ... 44
 S shape .. 53
 Joining Design Units ... 58
 Salmon Head Design .. 66
 Heads .. 73
 Examples of Heads in Design Units ... 74
 Examples of Free Form Heads ... 76

Head Components

 Head Components - Beaks and Bills ... 77
 Head Components - Cheeks .. 79
 Head Components - Ears .. 81
 Head Components - Eyebrows ... 88
 Head Components - Eyes ... 90
 Head Components - Foreheads ... 103
 Head Components - Gills ... 105
 Head Components - Hats, Headbands, Hair .. 107
 Head Components - Moustaches, Fur .. 109
 Head Components - Whiskers, Beards .. 110
 Head Components - Mouths ... 111
 Head Components - Noses ... 118

Body Parts and Appendages .. 125

 Body and Appendage Designs ... 126
 Split Body Designs .. 127

Learning by Designing: Pacific Northwest Coast Native Indian Art, Volume 1

Table of Contents continued

Balance, Apparent Symmetry, and X-ray Design ... 130
Comparing Bodies Across Art Styles ... 131
Arms and Hands - Human .. 132
Legs and Feet - Human .. 133
Legs and Feet - Animal .. 134
Flippers - Seal, Whale and Sea Creature ... 134
Legs and Feet - Bird Toes, Claws, Webs ... 136
Fins and Tails - Fish and Sea Creature .. 137
Tails - Whale ... 140
Tails - Otter ... 142
Tails - Animal .. 143
Wings and Tails - Bird .. 145

How to Draw

How to Draw Ovoids ... **148**
 Approaches to Drawing Ovoids .. 149
 Making Ovoid Patterns or Templates ... 150
 Making Ovoid Patterns or Templates ... 151
 How to Draw Ovoids Across Art Styles ... 153
 Ovoids Used in Designs Across Art Styles .. 154
How to Draw a North Coast Art Style Eye and Eyelid **155**
How to Draw U shapes ... **160**
 Approaches to Drawing U shapes ... 161
 Making U shape Patterns or Templates .. 162
 How to Draw U shapes for Design Purposes .. 165
 U shapes Used in Designs Across Art Styles .. 166
How to Draw an Eagle Head .. **167**
How to Draw a Salmon Head ... **171**
How to Draw a Human Head .. **177**
How to Draw a Killer Whale ... **185**
How to Draw a Wolf Head .. **193**

Glossary .. i
Glossary - Art Terms .. v
Bibliography and Resources .. viii
Index .. xi

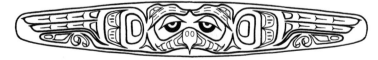

Bracelet Design - Owl

Learning by Designing: Pacific Northwest Coast Native Indian Art, Volume 1

Introduction

What qualifications do we have?

We asked ourselves some searching questions before we started developing this book. The most difficult was: *Why would two non-aboriginal teachers/writers/artists create a book based on a culture that is not our own?*

Looking in from outside the culture, we are able to analyze, categorize and explore the differences between groups. If we were inside the cultures, we could not be as objective. We also looked at our experience: Karin's 20 years and Jim's lifetime (60+ years) of association and working with the First Nations communities around the province of British Columbia. We looked at what has been produced by aboriginal schools of art, school districts, First Nations communities and other non-aboriginal authors and artists. We discovered a need that had not yet been filled and we believed we had the means to fill that need.

Who is this book for?

It came to our attention that an advanced reference book on Pacific Northwest Coast aboriginal design was being sought by young First Nations artists. We were told that the First Nations art community could use a reference book that compared major art styles of the peoples of the Pacific Northwest Coast and gave concrete examples of the similarities and differences in the styles. We believed that the wider art community could use an in-depth reference book that put aboriginal art within a historical time context and within a framework of respect for the accomplishments and beliefs of many aboriginal people.

Why did we write the book?

We believe that the global community has the need to feel the richness, spiritual connection and the will to live that is resurgent in aboriginal communities. Coming to this belief, we have been influenced by the children we have taught within the school system over the years. All cultural groups involved in the aboriginal art programs increased their respect for aboriginal culture and for themselves as they mastered the introduction to an intricate and difficult art form as taught in the first curriculum we wrote: *Learning by Doing Northwest Coast Native Indian Art*. We used a less academic, more accessible approach; we have used this approach again.

We are filled with an immense gratitude for the sharing of skills, knowledge, spirit and emotions we have experienced with our students, our aboriginal colleagues, First Nations artists who struggled to keep the form alive and vibrant, and other aboriginal community members who encouraged us to continue and expand our own experience of First Nations culture. With this book, we are returning, in small measure, the gifts we have been given. We hope that the book enriches you, as well.

Why move away from apprenticeship-style instruction or art within the village or community structure?

The apprenticeship approach is still used to teach aboriginal art, but if larger groups of students are to be taught, an additional approach is needed. Many First Nations communities, public and private schools, colleges and other larger groups have used our first book to bring skills and experience to their students.

This book, with its global approach, respect for aboriginal culture, and many art design examples, is our answer to the requests we received.

Introduction

Introduction continued

How can you use this book?

We sincerely hope that you will be able to learn enough about Pacific Northwest coast Native Indian art to appreciate and understand more about First Nations culture. "First Nations" refers to the aboriginal people of Canada or the *first nations* that were here before the European explorers arrived. We will be using "First Nations," "Aboriginal" and sometimes "Native Indian" throughout the book, referring to the first people in Canada.

About the word, "Indian": an often overlooked possibility for the origin of the word "Indian" is quoted in *Indian Giver* by Warren Lowes:

> "When Columbus first met the inhabitants of the North American shores, he believed these people must have been made in the true image of God, ***du corpus in deo.*** Thus, ***in deo*** became ***Indian***."[1]

We wanted to leave a legacy similar to the one First Nations people, especially the artists, have left to us. We took a thorough look at the aboriginal art of the entire Pacific Northwest Coast, and chose to divide art styles into north coast, mid coast, south coast and west coast of Vancouver Island style areas. Of course, there are no rigid boundaries between the areas. Contact among different aboriginal cultures influenced the art. However, we have given comparative design examples so that it is possible to see the similarities and differences among the art styles of the regions. The designs used are only stylistic representations of the four coastal art groups and are original designs that Jim created specifically for this book.

We invite you to look at the philosophy, history, spirit, and context of Pacific Northwest Coast aboriginal art before you attempt to analyze or create your own work based on the art forms. We remind you that First Nations people have a very proprietal view of their art and traditionally own copyright to it. They are sensitive to others exploiting the art for financial gain or using it in disrespectful commercial ways.

We have also used unusual terms throughout the book. Some terms are exclusive to First Nations art. A typical example would be the line of varying thickness that surrounds most aboriginal designs and gives them a form. This line is commonly termed the "formline."[2] The single pencil-width lines in a design are called *finelines*. We used terms like *trigon*, *quadron* or *quinton* for negative, closed, curved-sided units in the formline design.

Initially, the book is intended to help you look analytically and critically at a design and begin to notice the unique style differences which are the typical signposts that indicate from which area an artwork originates.

After that, the book is intended to help you create some of the art designs yourself to increase your awareness of, and respect for, the aboriginal art forms.

There is a glossary of terms and concepts at the end of the book. There is also an index to help locate designs and theory.

Our book is intended as a reference book for many of your interests and needs and a historical record of traditional Pacific Northwest Coast aboriginal art design theory.

We hope you enjoy using this book.

[1] *Ontario Indian* (Vol.5 No.9) September, 1982. (original *source*)
[2] Bill Holm, *Northwest Coast Indian Art: An Analysis of Form*, Seattle, University of Washington Press, 1965, p 65.

Introduction continued

What is our philosophy?

Philosophy is made up of beliefs, attitudes and values. Following are the beliefs, attitudes and values we hold in relation to this book.

Beliefs *(definition)*: **an acceptance of something as true, trust, confidence, conviction**

We accept the diversity and variety of knowledge, skills and experience First Nations cultures have to offer. We recognize that much of this information was given generously and freely. Early European explorers would have perished without their aboriginal advisors, guides and teachers. Aboriginal art flourished with initial contact and trade, resulting in more advanced tools, new materials and a larger market for aboriginal items. However, historical injustices, like widespread diseases brought from the Old World, laws that actively sought to destroy aboriginal social, financial/business and family systems need to be acknowledged. Present-day racism is still alive and well. Our culture is still struggling to achieve acceptance of differences, harmony and peace.

Through this book, we believe we can influence others to reflect on their beliefs. In this, we have been influenced by aboriginal artists, friends, colleagues and community members.

Attitudes *(definition)*: **the manner of acting, feeling, or thinking that shows one's disposition, opinion, situation, standing, etc.**

We have a very high opinion of both aboriginal art forms and aboriginal artists and share the information in this book with an attitude of respect, caring, and gratitude. These artists often teach as well as create, spreading their knowledge, skills and energies outward to the wider community and inward toward their own aboriginal young people.

Values *(definition)*: **acts, customs, institutions, regarded in a particular, especially favourable way by a people**

Many First Nations groups have preferred to teach in their own way, in a very select manner, within their own communities. This has served them well in preserving customs which were outlawed for time. However, now that young people are so influenced by a wider world-wide culture, we believe we can assist in spreading respect for the traditional and emerging aboriginal culture. We are certain that we will be doing more good than harm through the writing of this book. Our intention is simply to create greater understanding between nations through art and to make possible a wider dissemination of aboriginal information and skills to assist in that understanding.

Chilkat Dancing Blanket

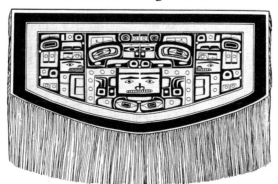

Introduction

Introduction continued

What went into the research and development of this book?

In 1987, as a result of our teaching experience in the Native Indian Education Division of School District #61 (Victoria), we developed and published a beginner's Pacific Northwest Coast aboriginal art book designed for use as a classroom curriculum. *Learning by Doing Northwest Coast Native Indian Art* is a 160 page illustrated book which has now sold over 10,000 copies and is presently used extensively in B.C. schools as well as in some schools in Washington, Oregon and Alaska. Because traditional art apprenticeships and continuous exposure to master carvers is not usually possible within the school system, many students are now taught northwest coast art using this book, whose curriculum is based upon the traditional native apprenticeship system, using original material developed by native artists and teachers.

To date approximately 5,000 students in the Victoria, B.C. area as well as others in the northwest have been taught the basics of the art using this text. Many of these students have become very good artists and now require more advanced, new and specific material.

Many teachers, artists and those interested in learning more about Northwest Coast Native Indian art have requested additional information. With this in mind we have produced *Learning by Designing Pacific Northwest Coast Native Indian Art*, an advanced reference in two volumes containing some step-by-step instruction, but with more emphasis on analysis and illustrated examples of all the art styles on the coast.

In our three years of research, illustrating, and writing we have studied, analyzed and categorized a tremendous amount of written material and two-dimensional art work. It was not easy to choose the definitive boundaries for the four art styles. Cultural areas and art styles on the Pacific northwest coast are constantly changing and in many instances overlap. Also, many Northwest Coast artists do not work solely in the art style or area of their ethnic origins.

Foremost in our minds was the awareness that we are building on the solid foundation of art work produced by First Nations artists, both from the past as well as the present. We are also aware that many of the masterpieces that we have today were produced by artists whose names we will never know. However, we want to acknowledge here some of the many artists of the past whose work we studied and who have left us this rich legacy.

They are: Charles Edenshaw, Charlie James, Mungo Martin, Ellen Neel, Henry Hunt, Willie Seaweed, Henry Speck, Bill Reid, Don Smith, Tom Price, John Robson, Henry Young, Sam Henderson, Joe Peters, Oscar Matilpi, Charlie George Sr., Dick Price, and Arthur Shaughnessy, Sr. Acknowledgments of contemporary artists are on a separate page at the front of the book.

Some of the authors who began to define the art, explore its designs and open up its richness are Franz Boas, G.T. Emmons, B. Inverarity, Erna Gunther, E.L. Keithahn, Wilson Duff, John R. Swanton, Marius Barbeau, and V.E. Garfield. More recent authors are Audrey Hawthorn, Edward Malin, Hilary Stewart, Bill Reid, Bill Holm, Peter Macnair, Norman Feder, George MacDonald, Phil Nuytten, Aldona Jonaitis, Vin Rickard, Margaret Blackman, Edwin S. Hall, Steve Brown, A. Wardwell, F. Dockstader and Roy Carlson.

Eagle Earrings

Introduction continued

We also recognize the tremendous contribution of the restoration and carving programs of the Royal B.C. Museum and the Museum of Anthropology at the University of B.C. We recognize, too, the contribution made by institutions, organizations and educational programs such as the Canadian Museum of Civilization, Ottawa; Burke Museum, Seattle; U'Mista Cultural Centre, Alert Bay; Kwakiutl Museum, Cape Mudge; and the First Nations Education Division of the Greater Victoria School District.

We acknowledge the positive role of funding, provided over the years by the Government of British Columbia and the Government of Canada as well as private and corporate funding, in supporting the growth and ultimate appreciation of Northwest Coast Native Indian art.

Also to be recognized for its contribution to the ongoing life and growth of the art are: Tony Hunt's *Arts of the Raven* artists' training workshops in Victoria (1969-1989); The Kitanmax School of Northwest Coast Indian Art at 'Ksan which has trained hundreds of artists over the past thirty years; The Totem Heritage Center in Ketchikan, Alaska; The Sitka Indian Cultural Center in Alaska; and the Cowichan Native Village (cultural heritage centre) in Duncan, B.C.

This is the first time a book containing this amount of detailed information and illustration in two-dimensional Northwest Coast aboriginal art has been published. We have presented some new ideas and theories and also raised some perplexing questions. We fully expect some of these to generate criticism or controversy, others will be ignored or dismissed entirely, and some may open doors to new thought, understanding and respect as well as creative art based on traditional aboriginal art forms.

Our hope is that as you read and work with this material you will feel free to contact us with your reactions, your experience and your suggestions for the ongoing life of the art.

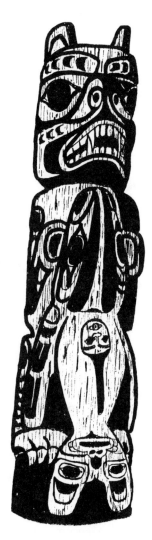

Henry Hunt's Kwagulth Style Pole of a Sea Grizzly Holding an Orca

Introduction

Goals

The goals of this book are:

♦ To aid the non-aboriginal person in acquiring an understanding and appreciation of a culture different from his/her own.

♦ To enhance the sense of dignity, equality and respect in the aboriginal person through an exploration of some aspects of Pacific Northwest Coast aboriginal art.

♦ To promote an understanding of some of the concerns of First Nations people through personal contact between aboriginal and non-aboriginal people and through understanding of the accomplishments of First Nations people in the past and the present.

♦ To have the seeker of art skills become knowledgable about some of the design techniques which were developed and used by First Nations people.

♦ To aid all artists, at all skill levels, to acquire an understanding of and an appreciation for a truly unique, complex art form.

♦ To encourage the person who uses this book to:

- ♦ seek many opportunities for experiences which arouse curiosity and enthusiasm;

- ♦ have adventures and experiment with new ideas and designs;

- ♦ sharpen and use the senses of hearing, seeing and touching;

- ♦ plan, think, make decisions, work, and follow through;

♦ discuss, question, gather, list, label, classify, organize information and draw conclusions;

♦ search for and recognize similarities and differences;

♦ search for sequences and patterns, and predict outcomes.

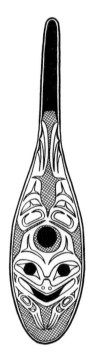

Frog Design on a Spoon

Overview of Learning by Designing

- Introduction
- Aboriginal Cultural Context
- Art Style Descriptions
- Basic Design
- Head Components
- Body Parts and Appendages
- How to Draw
- Glossary
- Bibliography
- Index

Aboriginal Art within a Cultural Context

Long Ago: The Transformation

by Butch Dick

Long ago on the Pacific Northwest Coast, before the first people came, the world was in a constant state of flux. This was a time when animal people walked the earth, swam the seas and flew in the skies. These animal people could shift from animal to person and back simply by donning the skin of one or the other. Earth dwellers only came to be in their present-day forms when the "Transformer changed each into a particular species according to the person's activity, attitude or behaviour at the time of encounter."[1] The ancient First Nations' legends and art reflect these transformations.

On the Northwest Pacific Coast, legends of Raven - trickster, hero and transformer - explain many of the ancient world's phenomena as well as clan traditions and rules of conduct. Coyote of the Interior peoples played the same role. Bear, mink, rabbit, killer whale and many other animals interacted with humans in the stories told by the campfire and in the longhouses or bighouses of the aboriginal people.

Because of the close ties between animals and people in their ancient past, aboriginal people maintained respect toward the animals that offered themselves to the humans to be used as food. If respectful treatment, in the form of proper harvesting and ceremony were not carried out, then the chief of the animals could take his people elsewhere and the humans would starve.

The Meanings

These ideas of mythology clearly influenced Pacific Northwest Coast artists. Human, animal, spirit and supernatural figures became known through readily recognized symbols developed by the artists. However, there were many other representations that only the artist could interpret.

Pacific Northwest Coast art is an abstract, representational art with heavy emphasis on faces and heads. Masks, rattles, headdresses, staffs, totem poles and other items emphasize heads in style and form. Faces can take the form of friendly or fierce creatures.

Animals can be recognized through their teeth, jaws, ears, tails, limbs and other distinctive characteristics. Bears and wolves have short or long snouts with sharp canine teeth. Beavers have the typical two squared front teeth, and often, a rounded crosshatched tail. Whale figures have recognizable blow holes, fins and tail flukes. Bird's beaks are straight like the raven, curved like the eagle or thunderbird, and recurved toward the face like the osprey (sea hawk). Fish and sea animals have fins, scales, spines or other characteristics of that animal.

The transformation found in myth can also be found in two-dimensional design as forms are abstracted, entwined, rotated and placed in unusual places and often constrained spaces. Sometimes the artist puts faces where none exist in nature: in body spaces, in ovoid joints, at the base of limbs or tails, or anywhere a suitable space remains unfilled. "This (placing of faces) may simply be a reminder that the creature has transformed from human to its present form, or that it is able to do so."[2] Humans can have human ears or be in flux or in a transformational state with animal ears on the head above the eyes. A creature may be part human with just a human arm and hand serving the purpose. The subject of the painting also had to be adapted to the size and shape of the area to be decorated.

[1] E.N. Anderson, Editor, *Bird of Paradox, The Unpublished Writings of Wilson Duff*, Hancock House, Surrey, B.C. 1996, p. 233
[2] Ibid., p. 63

Aboriginal Art within a Cultural Context continued

Eagle Transformation Mask

Carved transformation masks that have parts that can open and close, transforming the mask from one face or form to another are also made. Parts can belong to several beings. Animal and human designs represent either crests or spirits.

The Spirituality

"...Respect for that which was provided by the Creator was celebrated ...in ceremony and song, legend and prayer and through the gifted hands of the craftsman and painter. The spirits, man and animal, the natural and the supernatural were all part of the same circle of life."[3] One purpose of the art was to make the supernatural world visible and present. In some cases, a shaman's charm identified a spirit helper through whom power was received.

During dramatic productions, the spirits of the story being told were made visible in mask and dance portrayal. The mask was not worn as a disguise and the wearer did not pretend to be a spirit; rather, when danced, the mask and the man became the spirit in real, visible form.

"... Northwest Coast art is intended to affect the viewer strongly ... The artist is communicating about power (his own or his chiefly employer's); he is also communicating the power itself. To the extent that the artist can strike the viewer, power is literally transferred. There is a clear equation: affecting presence = supernatural power = social power. Emotional power is, to varying degrees, supernatural or spiritual; it can enable the viewer to accomplish great things, or it can merely impress him. ... thus an artist had to have supernatural power to create."[4]

The Crests

Another purpose of the art was to make the social system visible. Crests were used to distinguish different social groups and to symbolize their history and privileges. They could be shown on many material possessions, from robe to totem pole.

The north coast tribes had clear-cut social groups based on kinship traced through the maternal line and each owned the right to display specific crests. Within each group, families or individual chiefs owned different crests or had the right to show the general crests in specific ways. Art provided the highly visible status symbols of the social system.

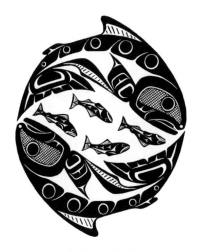

Salmon Cycle

[3] _____*Spirituality in Art*, U.B.C. Chronicle, Vancouver, B.C., 1975, p.30
[4] E.N. Anderson, Editor, *Bird of Paradox, The Unpublished Writings of Wilson Duff*, Hancock House, Surrey, B.C. 1996, p. 64-65

Aboriginal Art within a Cultural Context continued

The Sculpture

Craftsmanship appears to be the basis of the art. Objects representative of a living culture, such as: totem poles, canoes, partition screens, chief's seats, feast dishes, ladles, masks, crest helmets, speaker's staffs, carved cradles, combs, and fish-hooks; all came from the hands of male woodworkers. Sculpture in other media was created by transferring woodworking concepts. Small dishes, ladles, and spoon handles were carved from horn. Tiny shaman's charms and soul catchers were created from bone, antler and ivory. A few items - tobacco mortars, paint dishes and some figures and clubs were worked from stone.

The Painting

At first, flat wooden surfaces such as boxes, chests, partitions, screens, and house fronts were painted. Later, flat skin garments, paddles, canoes, hats and baskets were also painted. Similar designs could then be made by other methods such as bas relief carving on wood, engraving on metal, weaving or applique on textiles.

This combination of sculptor's and painter's skills was to be seen in all aspects of the culture. People lived in an environment created by artists.

The People

Pacific Northwest Coast aboriginal people lived in fairly large villages with permanent wooden plank housing. They used canoes to hunt, fish, trade, visit and make war. Since food gathering did not take all their time, they were able to develop a fine woodworking technology. Their elaborate sculpture and graphic arts were the "written" record and the visual transmitter of social and religious meaning. Today, there is renewed enthusiasm among aboriginal people toward some of the customs and rituals that give meaning to their culture throughout time. Giving traditional potlatches, with accompanying dancing, drama, and ceremonies together with community business, bound the culture inextricably to the art. Potlatches were banned at the beginning of this century. The ban was only lifted in 1951 with some confiscated artifacts restored to First Nations communities only recently.

The Time

The time of European contact saw increased artistic production on the Pacific Northwest Coast. New wealth created through trade expanded the scope and variation of social and business traditions. There was a greater need for crest and spirit representations. Totem poles became larger and more varied in type. New tools and new materials were being imported by traders who saw, in museums and collectors, a new market in so-called aboriginal "curios".

Whole new industries like argillite carving, model-making, silver and gold jewelry engraving were created. The peak of this production in the latter 19th century was represented by master artist Charles Edenshaw. He first carved bowls, spoons, chests, masks, totem poles and other necessities of a living Haida culture then turned his skills to saleable, tradeable items like argillite and silver.

Aboriginal Art within a Cultural Context continued

The Ethnography

Early traders and sailors transported religious, social and trade items - what they thought of as aboriginal "curios" all over the world, thus attracting the attention of curio collectors, museums and anthropologists.

Nuu Chah Nulth Whaler's Hat

The first serious collector of Pacific Northwest Coast art was Captain James Cook who, in his general fact-finding, included ethnographic materials. Spanish captain Alejandro Malaspina began collecting specimens around 1797. Russian captain, Urey Lisiansky, also took specimens home in 1804.

The Wilkes expedition from America from 1838-41 included Pacific Northwest Coast material obtained from a Hudson Bay trader. The son of a member of that expedition, Lieutenant George Thornton Emmons, U.S.N., 1852-1945, became an authority on Pacific Northwest Coast collecting. He and a Victoria, B.C. physician, Charles F. Newcombe, collected many fine specimens which they entrusted only to museums. Prior to 1930, Swann, Jacobson, George Heye, and Franz Boas also had researched and collected extensively.

From 1930-1940, modernist artists "discovered" Pacific Northwest Coast art. Marius Barbeau continued to collect for Ottawa. Frederick Douglas collected for Denver, and Erna Gunther for Seattle. In Mexico, Miguel Covarrubias, Wolfgang Paalen and fellow artists collected and published privately.

Another important collector was Lewis Shotridge, 1886-1937, grandson of the Tlingit noble, Shartrich. He collected treasures from his own culture for Dr. George Gordon, Director of the University Museum, Philadelphia.

Anthropologist Franz Boas wrote about many aspects of the Pacific Northwest Coast, particularly about Kwakwaka'wakw social organization and secret ceremonies. He also collected legends and myths. With George Hunt he wrote *Kwakiutl Texts* and Helen Cordere edited his work to produce *Kwakiutl Ethnography*. His book, *Primitive Art*, is a necessity in a collection of written work about Pacific Northwest Coast art.

Edward Curtis captured in writing and on film the culture of the Southern Kwakwaka'wakw.

The Awakening

Indian Renaissance/ New Life for a Traditional Art by Clive Cocking

"...Why the revival of Indian art today? Well, the importance of the artists' creative drive, of course, cannot be discounted. But clearly it is also tied up with the new pride in being Indian. 'It reflects,' said Ron Hamilton, 'a strong desire in Indian people to announce to the world that we're going to try and get some more Indian things happening ...'

Aboriginal Art within a Cultural Context continued

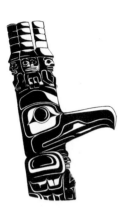

North Coast Art Style Pole Top

"But in the final analysis, the revival was made possible because a few people kept the thread of continuity with the past from breaking completely. Knowledge of the techniques, styles and meaning of the traditional physical arts was consciously kept alive during the long period of decline. Just barely kept alive.

"There was, it is true, a complete break in the artistic traditions of [many of] the Haida and Tsimshian peoples in which for two or three generations nothing was done. Nor was anything [much] done among the Nootka and, what is worse, evidence of [much of] that culture [cultural knowledge] has virtually disappeared. But the Kwakiutl succeeded in keeping alive some semblance of their old artistic and ceremonial practices - occasionally by secretly defying the anti-potlatch law - and this link essentially made revival possible.

"UBC [The Anthropology Department of the University of British Columbia] has played an important part in this process of preservation and revival. But an even more vital role was played by one man, the late Mungo Martin, Chief Nakapenkem of the Fort Rupert Kwakiutl and a famous carver. The university began playing a caretaker role with Indian culture in 1947 with the arrival of anthropology professor Dr. Harry Hawthorn and his wife Audrey, and the beginnings of an Indian collection and a totem pole restoration program.

"In 1949, Mungo Martin, at the age of 70, came to UBC to repair and paint several old Kwakiutl poles and to carve two originals, which subsequently were erected at Totem Park. 'Mungo Martin was a very significant figure in the revival of Indian culture,' said Dr. Duff. 'He never really gave it up. He was one of the few members of his generation who not only valued the old ways, but took it upon themselves to preserve them. He was a kind of thin thread that kept the thing going over that dark period of time and he did it with such pride and dignity that everybody admired it.'"[5]

NB. This article reflects the ideas of the historical period in which it was written. Today, many perceptions are different. However, it provides important background perspective.

Apprenticeship and Learning the Basics

Traditional Northwest Coast formline art is structured upon and within a certain set of principles governing design, composition, and colour; therefore, traditionally, apprentice artists usually worked with a master. Apprenticeship proceeded through a series of levels. Much of the beginner's first works were, at best, poor imitations of the teacher's but, in time, the apprentice's work often reached the point where the copies were, in many ways, indistinguishable from the master's.

After learning the basics, trainees commonly progressed in ability and understanding of flat design rules to begin making subtle changes, using traditional colour, figures and designs. At this point in the training, the creative artist could start experimenting beyond the established and traditional, exploring new ideas and creating totally new designs.

This period, more often than not, resulted in the development of a distinctive personal artistic style. Many masters in the Northwest Coast two-dimensional style art will tell you it

[5] Clive Cocking, *Indian Renaissance/New Life for a Traditional Art*, U.B.C. Chronicle, University of British Columbia, Winter 1971.

Aboriginal Art within a Cultural Context continued

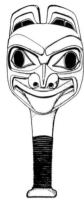

North Coast Art Style Bear Rattle

often took twenty years or more to reach this point. "A good artist understood the power of tradition, he recognized the boundaries between freedom and restraint, conformity and non-conformity, and he trod the thin line between those extremes, searching for his creative style, drawing upon an imagination steeped within his heritage". [6]

During the training period, and throughout their lives, artists are frequently influenced by the work of others. Some aspects of new-found material are accepted and incorporated into their own style. The development of a Pacific Northwest Coast artist is not unlike that of any artist throughout history. The artist is constantly borrowing, adapting to new styles, ideas, forms, subject matter, techniques, and materials. Change is a growing part of any art form and requires, in some instances, a certain amount of courage. Most artists agree that change is necessary in the life and growth of the art form.

In the final stage of productive involvement in Northwest Coast art, and after years of creative and imaginative development, an artist reaches a level of confidence and self-satisfaction whereby it is possible to innovate and push the boundaries to the point that expresses his/her own values and relationship to the world.

Very few contemporary Northwest Coast artists have the opportunity to work under the guidance and direction of a master artist. There are, however, opportunities to learn most aspects of traditional Northwest Coast design. There have been dozens of books and magazine articles written on the subject in the last few years. The Kitanmax School of Northwest Coast Indian art at Hazelton in northern British Columbia offers regular classes in learning the basics of the art form, tool making, and carving.

Recognized as one of the finest artists of this century, in the Northwest Coast aboriginal style, Master Haida artist Bill Reid, when asked about young native craftsmen, stated in an interview:

"There is a distressing tendency to make small things fast and get paid as soon as possible, they are squandering their birthright. The ancestors were remarkably adept. Being Haida is not enough- you have to learn the skills." [7]

Master artist Robert Davidson has stated that, "I feel more people (artists) have to do their homework ... I feel that we all have to go through the training. Before we can start innovating. . . Sometimes we get caught up in sales... so that it governs the direction the art is going in." [8]

Davidson also quoted Bill Reid when he reiterated...

"He (Bill Reid) has a strong belief that you cannot innovate without knowledge." [9]

The Future

Today, contemporary artists working in any of the coastal art styles are experimenting and attempting to expand the art styles and their application. Innovative, new terminology for

[6] E. Malin, *World of Faces*, Timber Press, Portland Oregon, 1978, p. 16
[7] W. Pasnak, *'Artist Extraordinaire Bill Reid*, Air Canada Magazine, 1990.
[8] R. Davidson, *Eagle of the Dawn*, Vancover Art Gallery, 1993, p.67
[9] R. Davidson, *A Tribute to Bill Reid*, Vancouver Sun, Mar. 14, 1998, p. B5

Aboriginal Art within a Cultural Context continued

composition and style are commonplace. The palette of the contemporary artist has expanded with the usage of metallic, pearlescent, and iridescent paints. Modern western style canvases, prepared art boards, specialty papers and fabrics are being used as well as application of gouache, polymer acrylics, alkyd enamels, water colours, oils, pencils, felt pens, inks, and pastels.

The figures in aboriginal art designs are only clues to a whole story or history that an artist may have had in mind. Sometimes the story behind the art is lost in today's culture as art becomes isolated from its traditional place within the context of an aboriginal community. The artist simply may be putting together a design that is pleasing to his/her eye.

However, as Native Indian communities strive to preserve and teach about the traditional culture, art is regaining its previous prominence. Preserving language, tradition and knowledge is a priority for most First Nations cultures. Many transformation masks, in addition to a wide array of other theme masks, are still "danced" in contemporary Native Indian ceremonies. The aboriginal people say that the mask actually dances the dancer. As in the past, today's artists create for aboriginal ceremony and as well as for a world market.

There is such a widespread revival of First Nations culture, it would be difficult to list how many organizations and projects have been created and continue to be active in its vigorous growth. First Nations people have formed partnerships within communities, tribes and many other cultures for the advancement and healing of their culture and are sharing acquired wisdom and experience with us all.

It is sincerely hoped that this book, "Learning by Designing" will help young First Nations people who have the desire to study and learn the basics, to become more knowledgeable about the traditional two-dimensional art styles of the Northwest Coast, as well as help facilitate their understanding, and production of quality, creative, traditional two-dimensional art in the Pacific Northwest Coast aboriginal art style of their choice.

Today's seeds are tomorrow's harvest.
Today's struggle is tomorrow's victory.
Author Unknown

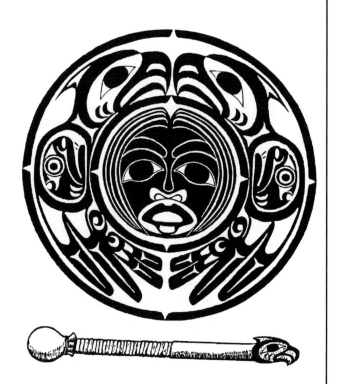

South Coast Art Style
Drum and Drumstick

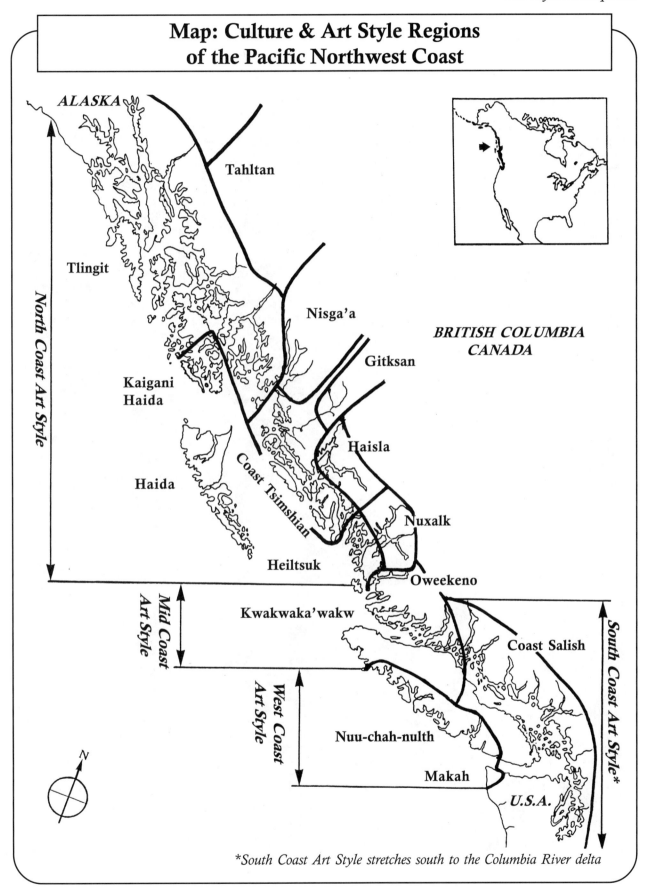

Art Style Descriptions

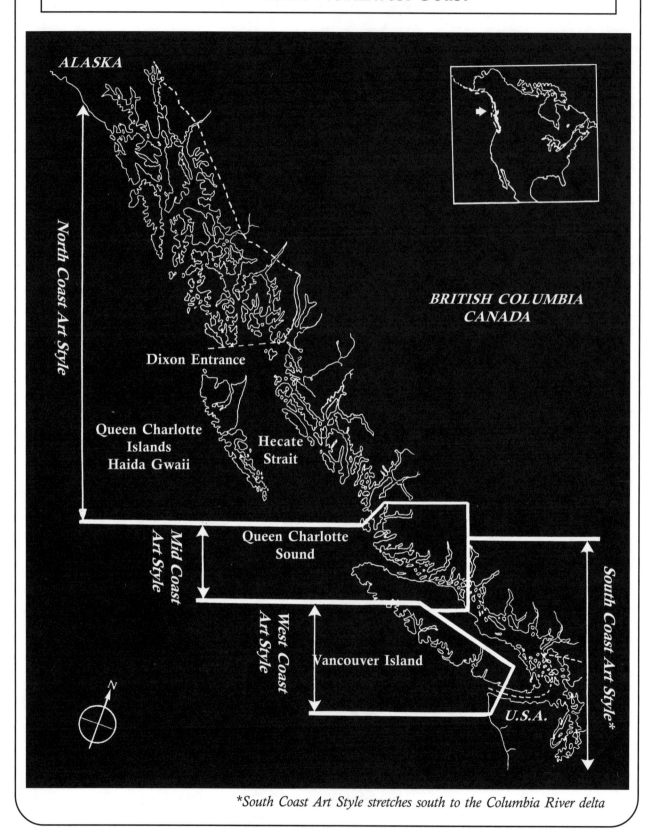

Map: Four Major Art Style Regions of the Pacific Northwest Coast

*South Coast Art Style stretches south to the Columbia River delta

Four Major Art Style Regions of the Pacific Northwest Coast: An Overview

The Art Styles: Introduction

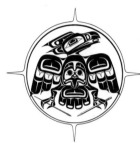

To those unfamiliar with Pacific Northwest Coast Native Indian art, there is a tendency to classify two-dimensional art into one artistic style. While there is no doubt that all coastal art styles share some common characteristics, more familiarity with the arts in general demonstrates that there are distinct differences between many of the coastal cultural groups.

In their two-dimensional designs, aboriginal artists in the area from Queen Charlotte Sound to Alaska, worked within the confines and conventions of a highly developed artistic system.

Because of increased coastal travel in the 19th century, the north coast formline system influenced coastal art styles to the south. Artists in the Kwakwaka'wakw, Nuu Chah Nulth, and Coast Salish regions accepted some features of the north coast style and modified or rejected others. This modification and innovation within aboriginal art is ongoing and contemporary First Nations artists continue to expand the art horizon.

Pacific Northwest Coast art styles, like many aboriginal art styles all over the world, can be analysed and examined in various ways. The kind of analysis that follows in this book is not a traditional aboriginal way of teaching/learning. The traditional mentorship and apprenticeship approaches, which teach art within a total cultural context are often being replaced with the more analytical style schools and classrooms. *Learning by Designing* is also using an analytical style of breaking apart and examining piece by piece to teach what are actually global concepts. Since holistic thinking models with cultural context and contact must be supplied from outside this guide, we sincerely hope that teachers will appear who will act as mentors to help learners to understand and create art when they are using the reference material in this book.

Aboriginal art styles may be regional, tribal within a region, family, and/or individual styles within a tribal group. Based on research and analysis of styles, we have chosen to group Pacific Northwest Coast aboriginal art into north coast, mid coast, south coast and west coast art styles. Boundaries are not as definite as the lines on a map would make them appear. There has been considerable overlap and borrowing over time among all the groups.

North coast art style would include the art of the Tlingit, Haida, Tsimshian, Haisla, Nisga'a, Gitksan, Heiltsuk (and possibly Nuxalk) people.

Mid coast art style would include the art of the Kwakwaka'wakw, Oweekeno, and Comox people.

South coast style would include the art of Coast Salish groups like the Homolco, Sliammon, Nanoose, Qualicum, Se'shait, Sne-Nay-Muxw, Squamish, Quwutsun, Sto:lo, Semiahmoo, Burrard, Musqueam, Tsawwassen, Nanoose, T'sou-ke (Sooke), Esquimalt, Songhees, and Saanich people, then south along the U.S. coast to the Columbia River delta.

West coast art style would include the art of Nuu Chah Nulth groups like the Opetchesaht, Tse-shaht, Kyuquot, Ehattesaht, Nuchatlaht, Mowachaht, Hesquiat, Ahousaht, Clayoquot, Ucluelet, Toquaht, Uchucklesaht, Ohiat, Ditidaht, Pacheenaht, Klahoose and Makah.

Art Style Descriptions

History and Description of the North Coast Art Style

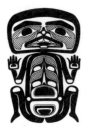

The north coast two-dimensional graphic art style is basically a painter's tradition which was fully developed before the time of contact. The north coast art style is represented by the art of the Tlingit, Haida, Tsimshian, Nisga'a, Gitksan, Heiltsuk, Haisla, and Nuxalk. Today, these artists do not necessarily classify themselves as north coast style artists, choosing instead to state that they are, for example, Haida artists working in the Haida art tradition which happens to fall within the category of north coast style art.

Traditional north coast graphic art works were based upon a strict set of rules and conventions which governed the formline system. North coast flat design had as its main purpose the depiction, mythical or real, of inherited crests. This artistic system was a very formal one and extremely conventionalized.

North coast art was more abstract than realistic. It reduced the subject to a series of essential parts or units which were all bound together with the calligraphic-like formline which defined the shape of the design and delineated every unit of the interior of the design. Exaggeration and distortion of some parts or features of the creature were common. These often became the symbolic features of identity. Splitting of the design in a bilaterally symmetrical manner to show both sides of the body was a dominant feature. Rearrangement and distortion of body parts were often essential in the design in order to "make it fit" into a given space. Traditionally, there was a complete disregard for depiction of perspective. The technique of X-ray vision made the internal structure or body contents visible. Joints, ribs, back bones and skeletal parts were often shown.

Symbolism was a dominant principle and identifiable features of crest creatures or beings were often emphasized and standardized to facilitate quick recognition. The main features of the north coast flat design style are adherence to the rules and principles of form and design, composition, and the use of specific colours and conventionalized design units in specific design areas.

Haida

Some of the best examples of traditional north coast formline flat style art are from the hands of Haida artists. Haida art is an art of line. Four common characteristics of two-dimensional Haida art are: balance, unity, symmetry, and tension within the design. Flat designs are also compact, highly organized, and have a classic highly unified structural appearance.

Haida flat design has, within its structural form, graceful flowing lines and striking colours, and a capability of communicating and making visible many aspects of their social system, particularly the crest system which contained over one hundred creatures. Flat design was applied to almost everything. Painted designs were applied to hats, baskets, apparel, carved objects of wood, metal, horn, bone, leather and other objects. Some of the best examples of traditional north coast formline two-dimensional designs in Haida style were created within the flowing and elegantly balanced designs on bent cedar boxes and chests.

In painted Haida flat design, heads were often one-third to one half the size of the whole creature and usually portrayed frontally, while profiled portrayal was preferred on heads of animals, birds, whales, mythological and supernatural creatures. Bodies of animals and humans were often shown in a squatting position with legs and arms bent up. Human

History and Description of the North Coast Art Style continued

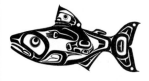

heads often had large hats with many vertically stacked "potlatch rings." Heads had ovoid-shaped eye sockets with the eyeball and eyelid well defined and placed in the medial upper area of the eye socket. There was little realism or naturalism in most drawn forms and almost no attention was given to details of the lower legs and feet.

Complex Haida flat design often had a multitude of large staring eyes; large creatures typically had open mouths exposing rows of teeth and large tongues. Images erupted from other images, for example, faces in the palms of hands, ears, blow holes, tails, flippers, fins, eyes, and torsos. Traditional Haida designs made use of three standard colours - black, red and green. Within any design, blank spaces were seldom left unadorned and bilateral symmetry was a prime objective.

Internal design elements within the formline regularly included elaborate U shaped units that were either single, joined, or stacked to form a multitude of new shapes - many with internally split, double split, reverse split, hatched, or crosshatched areas.

Tlingit

Traditional Tlingit two-dimensional art expression followed the formline tenets of the north coast art style formline system. Paintings on house screens, canoe bows and sterns, paddles, leather garments, and drums was done with the three classic colours of black, red and green. Tlingit flat design is at times very difficult to differentiate from that of its neighbours, the Haida and Tsimshian. In general, however, traditional Tlingit paintings had more angularity in the black formline and the total design filled the space to the point that there was little negative ground area. Negative formline relief areas such as crescents or trigons were tight and narrow, and there was less desire for symmetrical representation. Often, there was a greater degree of realism in painted human faces, particularly on masks. The art was of two types: secular crest art in which creatures are displayed in profile in order to accentuate their characteristics, or shamanistic religious art, in which creatures in some instances were unrecognizable since they were derived from the shaman's spiritual experiences.

Tsimshian

The Tsimshian art style traditionally joined together the art of the Coast Tsimshian and the up-river Gitksan and Nisga'a. Some of the two-dimensional paintings from this general area are in many ways similar to that of the Haisla and Heiltsuk. They all shared common artistic traditions and show similar characteristics to the north coast art style flat design. When comparing similar styles, traditional Tsimshian flat design was often more sensitive, subtle, restrained and a little more rigidly standardized. In many ways, it was more refined than the two-dimensional work of the Haida and Tlingit since it contained more rounded, softer curved and angled formline and internal design elements. Tsimshian art, whether two- or three-dimensional, had a quality which often exhibited deep human sensibility. Humans had a semi-realistic form, with an oversized head, serene faces with large round eyes, and mouths which were usually wide and closed. Chins were given little attention or space in face-on designs. Colours, traditionally, were black, red, green/blue.

Contemporary artists working in this style in serigraphs, paintings or precious metals are expressing themselves in innovative ways by producing art works which are new in style and

Art Style Descriptions

History and Description of the North Coast Art Style continued

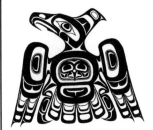

material and yet are soundly based on the old traditional art style.

Coastal Tsimshian, Haisla and Heiltsuk art has a common characteristic of thinning the positive formline, resulting in more expansive design areas being opened for embellishment.

Heiltsuk, Nuxalk, Haisla

The Heiltsuk, Nuxalk, and Haisla are situated in the southern region of the North coast art style area. Since all three nations geographically bordered one another, their art work was often very similar. In the mid-nineteenth century, when movement of people, native and non-native, became increasingly easier, the artists of these areas naturally had more exposure to the formal art style of the north coast Haida, Tlingit, and Tsimshian. The Heiltsuk, Haisla and Nuxalk artistic communities all adopted and modified, to some degree, the significant features of the north coast formline style of painting.

The Heiltsuk artisans of the late nineteenth century used a flat design style on their bentwood chests and boxes which made these virtually indistinguishable from those of the Haida and Tsimshian. Their painted designs were traditionally composed of sweeping, joined formline design units painted black, red and blue/green. Small floating inner ovoids were typically non-concentric and eyelid lines often extended across the eye orbit area. Other characteristic features of the Heiltsuk painted style were secondary filler U shapes with single or crosshatched designs. Bilateral symmetry was emphasized. Salmon head ovoids were common and overall designs were often uncluttered with a noticeable amount of open background.

Nuxalk artists were influenced by the art styles of both the north and the south. Toward the end of the nineteenth century, strong influences of the north coast formline style were evident in their paintings, while at the same time, their subject matter and artistic expression was like that of their southern neighbours the Kwakwaka'wakw and Heiltsuk.

"Nuxalk style is evident in the short, very recurved eyelid lines, prominent eyebrows and the characteristic sculptural echo of the outer eyelid line in the cheeks..."[1]

"Nuxalk artistic tradition has produced a wide range of unusual figures and strong, visually powerful images."[2]

Nuxalk painting showed a distinct preference for dark blue and vermillion red.

Painted Haisla art work is virtually indistinguishable from that of its neighbours.

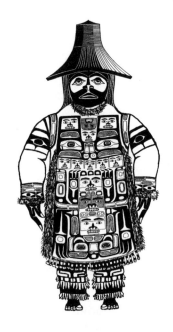

Tlingit Chief

[1] Steve Brown, *Native Visions*, University of Washington Press, Seattle Washington, p.92
[2] Ibid., p.133

History and Description of the Mid Coast Art Style

Mid coast art style, began its development in the pre-contact period, attained the unique style we know today in the period between 1890 and 1920, and is still developing. The style came from a geographic area bounded on the north by the Heiltsuk (Bella Bella) and on the south by the Comox people. This mid coast area included the mainland inlets of Queen Charlotte Strait and Sound as well as the area of the Inside Passage between Vancouver Island and the mainland of B.C. and the northwestern tip of Vancouver Island. Definitive boundaries are difficult to set as territories fluctuated throughout history.

History shows that in the nineteenth century, the mid coast artists were strongly influenced by the north coast art style. They accepted, for the most part, the basic principles and framework rules of the formline and its internal design components but never accepted nor were bound by the confining rules of the north coast painting style.

Mid coast art is characterized today as having an impressionistic simplicity of design and use of a wide range of colour. As a result, the art, based on family or clan crests, exhibited a raw dynamic power. Symbolism and a degree of realism were very apparent. Mid coast art production had its base in the family crest system and was used and displayed mainly in ceremonial functions as validation of ancestral privilege, dances, songs and sites.

The primary formline could vary noticeably from thick to thin, and could also taper dramatically within the length of one line. Ovoids varied greatly in shape, all the way from rectangular box-like structures with angular corners and ends, to squarish units with soft curved sides. They also varied in formline wall thickness and internal construction. An ovoid might have a thinner wall thickness at the top than the bottom or vice versa. The bottom line of the ovoid was usually drawn flat but might also be slightly concave or convex.

Inner ovoids were also handled in a free manner, floating medially anywhere in the formline ovoid's inner space. Inner ovoids might be joined medially to the top or bottom walls of the primary ovoid and rarely did they have an encircling fineline like their counterparts in the north coast art style.

U shaped design units in mid coast flat paintings were generally more elaborate and varied in internal design and colour than those found in the three other coastal art styles. Unique variations appear in the "ears" or head feathers of birds. The thunderbird had a curved spiral-ended horn/plume. The raven or eagle might have a low profile, elongate ear while the kingfisher might have a number of angled upright crest feathers. All of these head designs were based on the formline U shape. Wing feathers were elongated U shapes, usually with pointed ends, while tail feathers were round-ended. Internal filler design units for feathers could be simple, fineline, textured, single or crosshatched, dashed, or any combination of these. Fins, flukes, teeth, appendages and their parts, scales, ears, and beaks were all based on the formline U shape.

Late nineteenth and twentieth century painted designs are generally classified as bold, direct, dramatic and even exuberant. Split designs, in which a part or parts of the primary formline of the bilateral symmetrical design are joined, were common. The X-ray technique, using the internal display of the creature's anatomy, was used frequently but without anatomical accuracy. Ribs were slanted S shapes. Texturing of internal areas of the formline structure was often accomplished by use of angled and parallel fineline hatching or crosshatching, and single or bundled line dashing. Short parallel fineline dashing, internal

History and Description of the Mid Coast Art Style continued

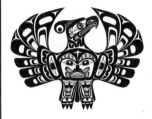

or external to the formline design, could often represent hair, fur, or whiskers.

Like other coastal art styles, the heads were emphasized and usually enlarged in size in relation to the body. The mouth of most animals was open and exhibited ferocity by the display of prominent teeth. The circular eyeball was usually designed in a non-concentric fashion with a floating black pupil encircled by a non-concentric circular black outer line. Eyelid lines might be symmetrical or asymmetrical with the rear eyelid line often being longer towards the ear than towards the nose. Mid coast eyelids of supernatural or mythological birds often had a red fineline inside the black eyelid line.

Profiled human heads usually had long hair and often noses were placed well forward under a strongly browed forehead. Nostrils were flared and prominent while cheek lines were distinctly curvilinear and usually enclosed open mouths which had projecting heavy lips.

Production of flat design painting, like other Native art, increased dramatically after the middle of the nineteenth century due mainly to increased ceremonial activities but also to the availability of commercial paints and brushes.

Unlike the traditional restraint of the north coast art style in using the basic colours of black, red and green, mid coast artists, particularly after the availability of marine paints and enamels, expanded their palettes to include white, gray, shades of blue, green, brown, turquoise, yellow, and orange. Instead of using the bright reds and blue/greens of north coast flat design, mid coast artists began using, as they do today, a brown-red and a dark green or dark blue. A unique mid coast technique that developed early in the 1900's was the use of a light coloured base coat over the entire form. A mask, totem pole, dance screen, rattle, or other art piece could be painted first with white or gray then the formline design applied over this foundation colour.

Creatures in mid coast designs were often drawn alone in open spaces and unlike the north coast style, often had open, non-designed areas within the formline interior.

Contemporary mid coast artists were at the forefront of the artistic revival in the 1960's when they pioneered and helped develop production of limited edition prints. Limited edition prints, the economic "bread and butter" of many of today's artists, makes the art available to the public in an affordable form. The limited edition print, new to Northwest Coast Native art, has again proven an artistic truism: a new medium introduced to artists will result in a new work being specifically designed for that medium's production.

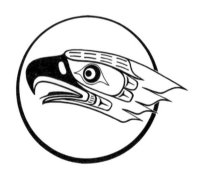

Mid Coast Art Style
Contemporary Eagle Head Logo

History and Description of the South Coast Art Style

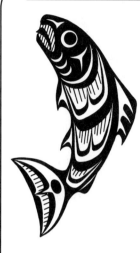

The south coast art style of the Salish peoples came from an area bounded on the north by the Comox people and on the south by the First Nations of the Columbia River delta. This south coast area included the mainland inlets of the Gulf of Georgia and Puget Sound as well as the area of the Inside Passage between Vancouver Island and the mainland of B.C. up to the middle of Vancouver Island. Again, definitive boundaries are difficult to set as territories fluctuated throughout history.

The peoples of the south coast area lived in a society which was not clan-based; therefore, the display of crests was not necessary and production of art works was minimal. "The Salish did not have much in the way of decorated, ceremonial paraphernalia."[1]

The basis for the limited amount of art production from this area was religious. Decorated, personal ritual objects such as dance regalia usually had symbolic images whose full meaning and significance was kept secret by the owner.

Any type of traditional flat design brush painting was practically nonexistent. The relatively few examples of early south coast flat design are in the form of incised, shallow carvings on wood and horn. These designs usually exhibited symmetry and balance. In the shallow carved, non-painted art works, it is often difficult to read the design and pinpoint the form and parts of the creature depicted. The human eye has a tendency to focus and concentrate on the carved out lines or areas rather than on the positive surface formline between these lines or lower areas. "Shallow relief carved designs... implied positive forms by partially or wholly defining them with negative recesses."[2]

Traditional south coast designs were usually made up of simple, standard, soft-curved design units such as ovals (ovoids), circles, U shapes (solid or split) and negative crescents, trigons, slits and T forms. Seldom did this design style display the tightness, tension and formality of the north coast art style.

South coast "ovoids" were really oval-like in appearance, seldom with anything other than convex bottoms and bilaterally symmetrical composition. They were often bordered on their ends (sides) by negative crescents. The ovals represented joints in appendages, tails, wings, etc., and standard eye shape, as well as overall head and palm shape. Concentric circles and ovals were interchangeable in function and purpose. Most south coast designs of ovals or circles had floating inner units. In this publication the term 'oval' is used to describe south coast ovoids.

Typical U shapes, whether short forms representing fish scales or elongated ones representing wing feathers, commonly had soft-curved open splits and rounded ends. As in other coastal art forms, U shapes could represent feathers, fins, flukes, tails, fingers, gills, scales, and ears.

As in the other coastal art styles, heads were exaggerated in size. Human heads were rarely shown in profile and were usually circular, earless and hairless. The face had a pronounced brow line made up traditionally of medially joined, low arched eyebrows. A narrow bridged nose with small nostrils was standard, as was a mouth with parted lips which rarely displayed a tongue or teeth. Negative crests and slits in

[1] Wayne Suttles, *Coast Salish Essays*, Talon Books, Vancouver, B.C., 1987, p.105
[2] W. Holm, *Art - Handbook of American Indians*, Smithsonian Institution, Washington, D.C., 1990, p. 611

History and Description of the South Coast Art Style continued

the face area showed facial fold lines and defined the eye orbit, cheek, mouth, and chin areas.

South coast peoples in general believed that "some animal species are the descendants of people but people are not descendants of animals."[3] Most creatures were portrayed fairly realistically in open design spaces and, unlike humans, were shown in profile, emphasizing the head and its identifiable and symbolic features. Humans and creatures in traditional south coast art style were often depicted in simple one colour, silhouette-like designs. Animals were usually shown in a non-aggressive state. The use of the X-ray technique of displaying inner body parts was common in both human and animal designs.

Animal and bird bodies were displayed in profile while the human body was shown face-on with the arms and legs drawn in and folded alongside the body. Joints in most appendages and moving parts contained positive or negative shaped circles or ovals. All eyes were bilaterally symmetrical and oval eyeballs were typically enclosed by upper and lower convex eyelids which terminate in pointed ends.

"The stark simplicity of Salish art is a reflection of a closer spiritual relationship between the individual and his guardian spirit as compared to the social domination of the arts of the north."[4]

South coast peoples generally kept the spiritual content and meaning of their lives, stories and ceremonies secret. Personal experiences with supernatural spirit powers, particularly those involving individual guardian spirits, were never disclosed, for fear that divulging one's spirit helper could result in its loss.

Early in the era of artistic Northwest Coast Native art rebirth in the 1960's and 70's, many south coast Native artists moved away from their traditional art style and design and produced flat design in the art style of other coastal style areas. Many Salish artists are actively employed in reviving the ancient and unique features and principles behind the south coast two-dimensional style.

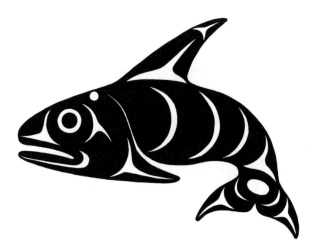

South Coast Art Style Killer Whale

[3] Wayne Suttles, *Coast Salish Essays,* Talon Books, Vancouver, B.C., 1987, p.105
[4] Erna Gunther, *Northwest Coast Indian Art Exhibit Catalog,* Seattle World's Fair, 1962, p.14

History and Description of the West Coast Art Style

The Nuu Chah Nulth two-dimensional designs are recognized by many people to be unique and distinctive. These aboriginal people live close to the Pacific ocean, from Brooks Peninsula on Vancouver Island's West Coast, south to Makah country on the U.S. Olympic Peninsula. We usually refer to this art style as 'west coast' including the Makah in the U.S.A. Some stylistic variations are found in the art style, dependent mainly on the artist's geographic location.

Few west coast painted designs from the pre-contact period survive today. Flat design production did not really begin until the nineteenth century and by the middle of that century, its production flourished. West coast artists were also influenced by the formal north coast formline art system of graphic representation; however, they used only some of its principles, structures, design elements and colours.

Traditional west coast flat design was characterized by being bold, uncluttered and sometimes natural. The art often depicted supernatural beings in human, animal or mythical creature form. West coast designs, unlike any other on the entire Pacific Coast generally tended to be less elaborate. They often had more angular design components, less detail, and more internal and external open areas. West coast painted designs often tended to flow with flexible formlines.

"...two-dimensional art did not always conceive of interconnected positive design forms in the precise, highly conventionalized manner of the northern formline tradition."[1]

There was little compression of design into given spaces. Simple animal, human, and creature designs, often drawn as silhouettes, tended to float unobstructed in an area surrounded by geometric border designs.

Large, traditional ceremonial painted house screens showcased some of the finest examples of Nuu Chah Nulth flat design. The designs on these screens often showed mythological characters and/or semi-realistic animals, humans, and other creatures which might combine to tell a story (legend or myth) in graphic form. Common subject matter for these screen designs were thunderbird and lightning serpent, wolf, whale and various human forms. The borders of the screens often had geometrical straight-edged, right-angled design units. West coast artists, unlike their coastal counterparts, were usually not concerned with symmetry or with filling a design.

Traditional painted crest designs were of two types: semi-realistic and representational or abstract and geometric. These designs depicted incidents or creatures such as birds, animals, whales, fish, humans, mythological and supernatural beings. The features of these subjects were generally natural and recognizable.

Abstract and geometric designs using hard-edged units such as rectangles, lines, and squares were unique to the art of this area. These design components often formed the base or perimeter border of the design. It is possible that these abstract and geometrical design units may relate back to the traditional use of similar designs on items such as woven baskets, mats, and hats. Much of the symbolic meaning of these designs has been lost. Contemporary west coast artists are using these geometric design elements to represent clouds, water, mountains, rocks and other natural elements.

[1] Steve Brown, *Native Visions*, University of Washington Press, Seattle Washington, p.135

History and Description of the West Coast Art Style continued

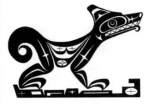

Openness of design was a noticeable feature of the west coast art style, along with straight-sided, soft, round-ended U forms, rows of dots, and the unique west coast design element - the four way split or fineline cross within ovoids and circles. The north coast style taut, formal formline shapes, elaborate U shapes and ovoid complexes, or crosshatched elements, finelines surrounding inner ovoids, and fierce mouths with large teeth and tongue were seldom seen.

Contemporary west coast paintings express a feeling of depth more than any other coastal art style. A perspective view of a creature is often accomplished by depicting all four appendages with those in the background often shown as being smaller. Profiled heads may have quite realistic features such as strong down-sloping brows, pronounced, elongate, arched eyebrows, strong noses, natural looking full heads of black hair, and even moustaches and beards. Eyes are usually large and round and have long tapering eyelids which differ in shape from any others seen in the coast art styles. Eye orbits, as well as eyes, often exhibit a unique reverse positive/negative design coloration. Mouths are usually full lipped and open.

The painting on faces often includes colourful geometric designs such as horizontal or diagonal lines. Along with the traditional black and red, west coast artists use white, yellow, orange, green and a brilliant blue. Early European traders and sailors on the west coast of Vancouver Island provided the artists with the dry blue material, "Reckitts Blue", produced in England and used for whitening laundry. This material was originally mixed with salmon eggs and saliva to produce a blue paint.

Today's Nuu Chah Nulth artists are producing very robust and imaginative designs. The art style is constantly changing, growing and cutting new paths, which often parallel the traditional paths of the past.

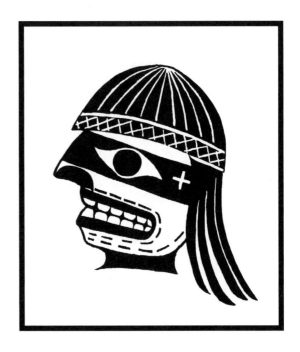

West Coast Art Style Man's Head

Formline: An Introduction

The two-dimensional formline art styles developed by the aboriginal peoples of the Pacific Northwest Coast are highly developed art systems for the organization of space and form.

The north coast style formline system is based on the principle that a creature's shape or form and its main parts can be represented by a continuous outline - the primary formline. Contained within this primary formline are design units or elements which usually represent the creature's body parts, although they may be simply decorative. These interior design units, of secondary importance to the overall design, are delineated by secondary formlines.

In most designs, the primary formline is constantly curving and varying in width and length. At junctures or divisions within the design, this line can taper and fair to form a flowing, smooth joint. It may also enlarge and incorporate weight-relieving negative transitional units such as crescents, trigons, and circles. These within the formline negative spaces also help in delineating the positive formline or the design units surrounded by it.

> "The use of swelling and constricting formline delineating design units, is one of the most important characteristics of the Art and should be considered a principle of it."[1]

Design composition using primary and secondary formline techniques features one or more of the following: abstraction, simplicity, stylization, symbolism, symmetry, non-concentricity, and semi-angularity of curves.

The most common formline design building blocks are the ovoid and the U shape. Modifications of these elements, together with a limited number of other design units, can be combined to form the foundation of a given design.

The north coast formline design system is unique in that it is based on a traditional set of rules and principles that govern the organization of the form as well as the composition and colour.

> "The rules of formline art may appear rigid and limiting, but in fact the opposite is the case. Haida master artist, Robert Davidson, has compared the formline system to the alphabet: 'after learning its essential individual elements, the artist can use them expressively... in an endless number of combinations... The only limitation is the creative imagination of the artist, not the system.'"[2]

Many contemporary master artists view the visual system as constantly changing and maturing. They consider it a privilege and a challenge to expand the traditional and proceed beyond it.

The traditional colours used in north coast art style designs are black, red and blue/green. Designs can be painted in one colour, either black or red; in two colours, black and red; or in all three colours, black, red and blue/green. Black is the predominant colour used for the outer primary formline, while red is used for the secondary formlines which make up the inner design filler units. In some designs, black and red are reversed, the primary formline being red and the filler units black.

The formline art system of the Pacific Northwest Coast was first researched, analyzed and the results published using a new art vocabulary by Northwest Coast art historian, and author/artist, Bill Holm, in his now classic 1965 publication, *Northwest Coast Indian Art: An Analysis of Form*.

> "The formline is the basis for all the art. It is the essential element that sets the art from the Northwest coast apart from any art in the world. If you don't conform to it, [the rule system] you are doing something else."[3]

[1] Bill Holm, *Northwest Coast Indian Art: An Analysis of Form*, University of Washington Press, Seattle Washington, 1965, p. 84
[2] L. Averil and D. Morris, *Northwest Coast Native and Native-style Art*, University of Washington Press, Seattle Washington, 1995, p. xxxv
[3] Bill Reid, *Legacy Dialogue (lecture)*, Museum of Anthropology, University of British Columbia, Vancouver, B.C. 1982.

Basic Design - Formline

Formline

Formlines are swelling, curving lines which join over a given area to outline the main form intended to be represented. One principle of Pacific northwest coast primary formlines is that they are continuous. One can follow all primary formlines from any point continuously throughout the whole artistic piece without interruption, much as people do pencil puzzles and mazes where a two-dimensional path requires the pencil not to jump a gap or cross over a line but to go from start to finish without lifting the pencil from the paper. Secondary formlines also delineate design units such as ovoids, U shapes and S shapes, which are incorporated within the primary formline. We will illustrate this concept using the human body.

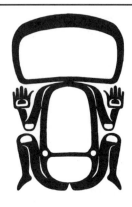

North coast art style human primary formline delineating body outline

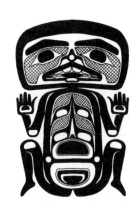

North coast art style human

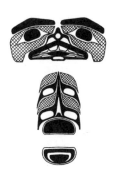

North coast art style human secondary formline internal design units

Learning by Designing: Pacific Northwest Coast Native Indian Art, Volume 1

Basic Design - Formline

Examples of Formline

When drawing a design, formlines are made by drawing the outline of a unit with two finelines then filling in the space between the two lines with colour. There is no perspective or overlap in a traditional northwest coast design. Templates made of thin tree bark were used to trace ovoid and U shapes if they were going to be used repeatedly.

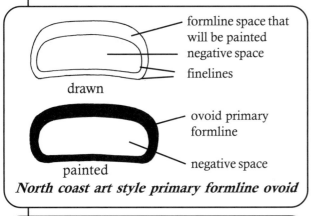

North coast art style primary formline ovoid

The ovoid is one of the basic building blocks of Northwest Coast Native Indian art. The background space in the interior of the formline ovoid is called *negative* space. In this case, the negative space is white, like the paper. If wood were the background, the negative space would be brown, like the wood. Ovoids often shape the primary formline, delineating main body and head parts.

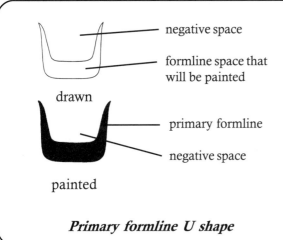

Primary formline U shape

Another basic building block is the "U" shape. These shapes can be inverted, rotated, lengthened, widened or otherwise modified in a design to represent cheeks, joined to represent lips, and in other designs, to represent fins, feathers, relieving spaces, tail flukes, fingers, and tails. *Primary* formline U shapes are usually painted black and joined to the primary formline at its leg ends. When the U shape is *secondary* or inside another shape, it is usually painted red.

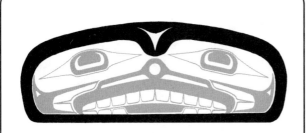

Primary formline ovoid modified to create a head outline

A primary formline ovoid can create the form or outline of a head design. Here, the ovoid has been modified at the top centre to suggest eyebrows. The secondary design units are found within the negative space of the primary formline ovoid. These filler design units are painted black or red.

Learning by Designing: Pacific Northwest Coast Native Indian Art, Volume 1

Basic Design - Formline

Examples of Formline continued

Ovoids and U shapes are often used in combination to create the primary formline of most major designs in Pacific northwest coast Native Indian art. Designs can be a single colour, traditionally black or red. There are also two- colour designs with black primary formlines and red secondary "filler" design units.

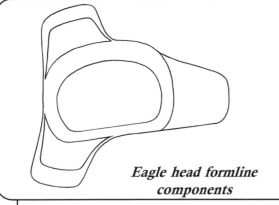

Eagle head formline components

A simple profiled bird head can be formed by combining primary formline ovoids and U shapes. The top U shape represents a feathered "ear" and the bottom U shape symbolizes the body. The stylized and modified U shape at the right side of the head represents the beak. The formline will later be painted, usually black.

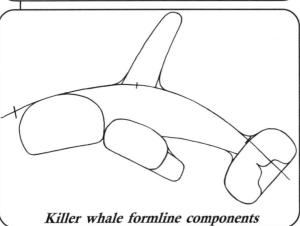

Killer whale formline components

This initial sketch of a killer whale shows how the formline of a figure can be blocked out to use the optimal space on a background. This outside formline will later be widened with an inside pencil line and the space between the lines will be painted. The formline is usually painted black.

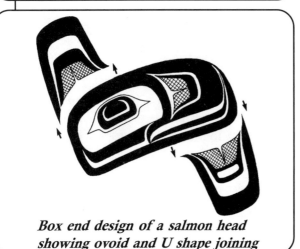

Box end design of a salmon head showing ovoid and U shape joining

The two U shapes and the central ovoid will join to create the new formline of this bentwood cedar box or chest end design. In this case, the formline has been painted black. The crosshatched areas and the internal filler U shapes in designs are often painted red.

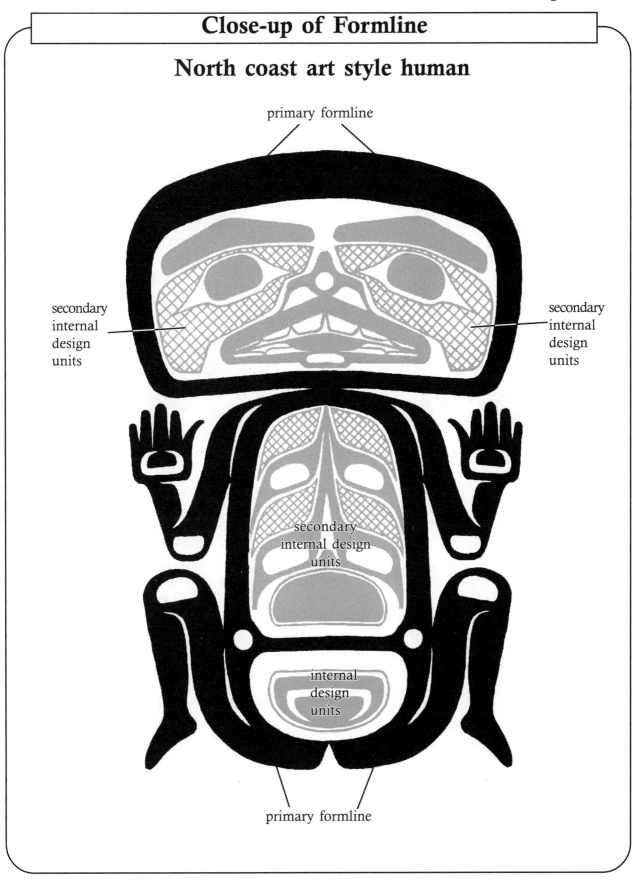

Basic Design - Formline

Comparing Formlines Across Art Styles

Formlines vary in structure from the rigid, almost square/rectangular shapes of the north coast art style areas to the free-flowing style of the south coast art style areas. Major delineating ovoids become formline ovoids when they are joined to the formline.

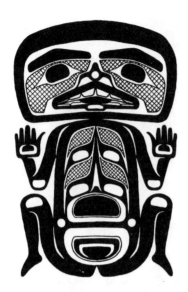

North coast art style human

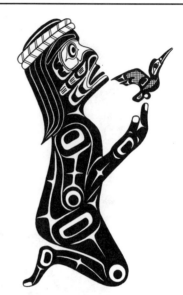

Mid coast art style human

The formline of north coast art style designs is exact, has continuity, and is often highly stylized and abstract. Many times, in order to fill a given space, a north coast artist will distort or rearrange body parts. This makes it difficult for anyone other than the artist to recognize the creature the design is intended to represent.

The artists are working with ovoids and U shapes, circles and S shapes.

The colours are black, red, green and natural or white.

In mid coast art style, there is less formline continuity, the design units vary more, there are additional design units and there is freer use of colour than in north coast style.

Artists are working with ovoids, U shapes, S shapes, circles, slashes, crescents and irregular relieving shapes. Many design units and formlines vary in width, being thickest in the middle and tapering on the ends. This causes the design to be lighter and less rigid.

The colours are black, red, white or natural, blue-green and yellow.

Comparing Formlines Across Art Styles

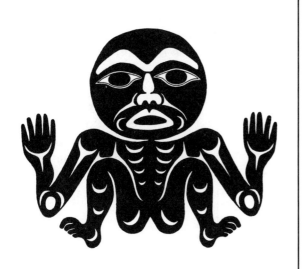

South coast art style human

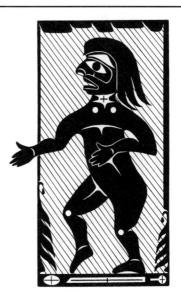

West coast art style human

The south coast art style formline reflects more realism, is rounder and more flowing with fewer rules. The designs are simpler and more easily recognized than other art groups.

Two-dimensional art is relatively new to the south coast people since art tended to be relief carving on spindle whorls, looms and other tools. Artists carved welcome poles. Weavers created designs as well.

Artists today use many colours in their designs, most notably brown or reddish-brown.

On the west coast, formlines flow, varying in thickness and direction. Colours of formlines are often blue as well as black.

Artists are working with ovoids, U shapes, circles and irregular shapes but there is a noticeable use of star shapes or slanted crosses within ovoids.

The colours are black, red, green, blue, yellow and reddish/brown, orange.

Basic Design - Formline

Drawn and Painted Formline

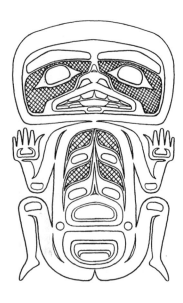

Fineline drawing of a north coast art style human

This north coast art style human is drawn with a continuous outer formline, making extensive use of positive and negative ovoid shapes. The large ovoid head has internal ovoid eyeballs and a lip labret indicating that the figure is female. The internal units also contain many positive and negative ovoid shapes.

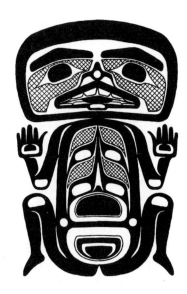

Completed, painted north coast art style human

In this painted design, the primary formline colour is black. Black is also used to paint the eyeballs, eyelid lines, teeth outlines, and the floating inner ovoids of the lower body. Red is used to paint in the secondary internal design elements of cheeks, lips, tongue, nose, as well as crosshatched ribs and eye orbits. The finelines encircling the floating ovoids may be black or red.

Basic Design - Ovoid

Ovoid

Ovoids are design units, often described as bean-shaped or loaf-shaped, that are like rectangles with the corners rounded off. Ovoids are a prime basic building block of Pacific northwest coast art style design and can have many variations.

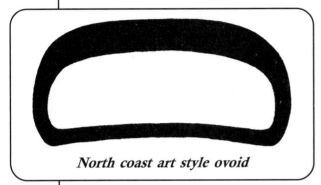

North coast art style ovoid

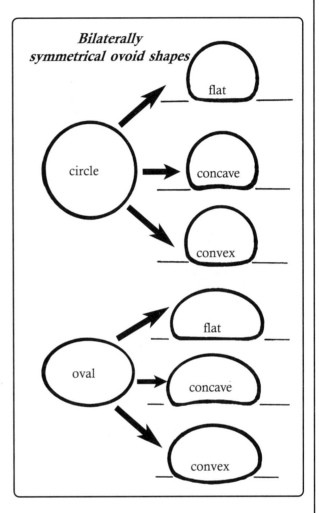

Bilaterally symmetrical ovoid shapes

Where did the ovoid shape come from? Coastal First Nations were often called 'the people of the salmon' and salmon was very important in the lives, culture and mythology of the people. We suggest the possibility that the formline ovoid shape is linked to the salmon; more specifically, that the ovoid is a visual metaphor for the salmon egg.

It has also been suggested that the ovoid is modelled after the elliptical or circular markings on the pectoral fins (wings) of the Pacific big skates. Others have advanced the theory that the ovoid shape is identical to the outer shell profile of a spineless red sea urchin, while some suggest the ovoid form is based upon the growth rings of a tree or a broken branch scar. Whatever the source of the ovoid form, we can only speculate as to whether any of these theories serve as a model.

For a more detailed exploration of the salmon egg theory, please see Learning by Designing, Volume 2.

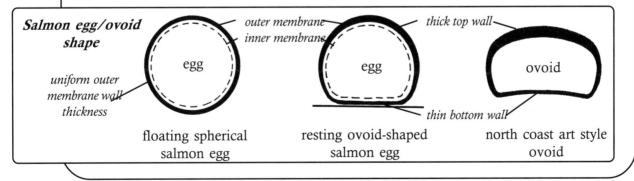

Salmon egg/ovoid shape

floating spherical salmon egg — resting ovoid-shaped salmon egg — north coast art style ovoid

Learning by Designing: Pacific Northwest Coast Native Indian Art, Volume 1

Basic Design - Ovoid

Examples of Ovoids

Although all First Nations groups on the Pacific Northwest Coast used ovoids in their designs, shapes varied from one art style area to another. The curved-sided two-pointed negative shapes that often relieve the blackness of the eyeball are called crescents, or "C" shapes. Three-pointed shapes are called *trigons* and four-pointed shapes are called *quadrons*.

North coast art style formline ovoid

This typical north coast art style ovoid with a concave bottom is surrounded by a fineline that is not usually found in the other three styles. Floating inner ovoids in the north coast art style are always surrounded by a fineline which may represent an eyelid line. Ovoids often represent eyes and eyeballs.

Mid coast art style formline ovoid

Ovoids are often found in joints, eyes, ears, feet, tail bases, fin bases, flukes, nostrils, legs, arms, and wings. Inner ovoids can float or join the primary formline ovoid at the top (common) or the bottom (rare). This mid coast art style formline ovoid has a floating solid inner ovoid.

West coast art style formline ovoid

Ovoid eyes can show emotion, expression or a reduction of a symbolic human face represented by nothing but an eye. This west coast art style formline ovoid has an inner quadron design unit. This centre unit can be viewed as two mirrored split U shapes or four joined U shapes, leaving the star shape as a negative form.

South coast art style formline ovoid

This south coast art style ovoid is more like an oval. It is symmetrical horizontally. Formline thickness varies in this example and the inner floating ovoid is non-concentric. Inner ovoids are usually non-concentric within an outer primary ovoid. Note the lack of dynamic tension. This ovoid is quite relaxed and undisciplined.

Examples of Ovoids continued

Inner Ovoid Variations - Internal negative space can relieve colour weight in a solid ovoid. This space can be created by using relieving shapes or one ovoid inside another. The ovoids on this page are mid or north coast art style. North coast style ovoids usually have a slightly concave bottom.

Inner ovoid

- joins to the top line of outer ovoid

Ovoid

- with downturned relieving crescent

Ovoid

- with relieving crescent that has been modified to become a trigon

Floating ovoid

- with a narrow relieving crescent surrounded by a fineline

Ovoid

- with solid inner floating ovoid surrounded by a negative ovoid space
- outer ovoid is surrounded by a fineline

Ovoid

- with inner solid ovoid joined to bottom outer formline

Basic Design - Ovoid

Examples of Ovoids continued

Inner Ovoid Variations - North coast art style, west coast art style, south coast art style. Note the line thickness of formline ovoids. The north coast art style has a thicker line at the top than at the bottom. Note the straight, concave and convex shapes of bottoms, and the non-concentric placement of the inner ovoids.

North coast art style ovoid

convex bottom

- shape that is nearly circular

North coast art style ovoid

concave bottom

- shape that is elongated

North coast art style ovoid

flat bottom

- elongated with inner eye design

North coast art style ovoid

convex bottom

- tall and narrow, relieved by negative circle

West coast art style ovoid

concave bottom

- elongated with negative eyelid relieving shape
- black circle eyeball within negative space relieved by negative crescent

South coast art style ovoid

convex bottom

- rounded rectangle with inner circles

Learning by Designing: Pacific Northwest Coast Native Indian Art, Volume 1

Examples of Ovoids continued

Inner Ovoid Variations - Inner ovoids often contain heads or faces. They can be placed wherever plain inner ovoids would be used. For example, a joint or eyeball might contain a face.

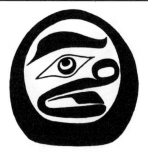

South coast art style face within an ovoid shape

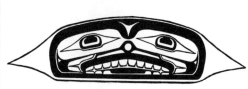

North coast art style face within an ovoid eyeball shape

North coast art style salmon head used as an eyeball without an eyelid line

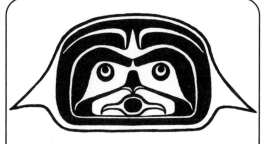

Mid coast art style face used as an eyeball

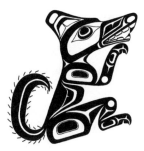

Inner ovoid shoulder and hip joints in a north coast art style wolf

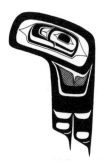

North coast art style salmon head eyeball with an eyelid line inside a wing joint ovoid

Basic Design - Ovoid

Close-up of a Generic Ovoid

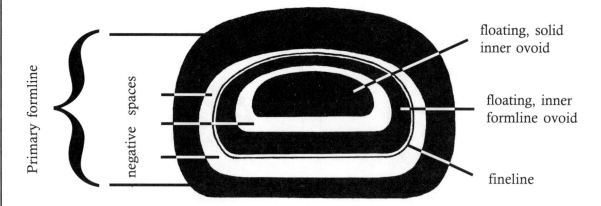

Primary formline widest at the top - curved line

floating, solid inner ovoid

floating, inner formline ovoid

fineline

Primary formline

negative spaces

Primary formline narrowest at the bottom - straight line but could also be convex or concave

- This generic ovoid design unit has a non-concentric design formation.

 The formline which defines the primary ovoid is wider at the top than at the bottom.

- The ovoid contains an inner floating ovoid design unit with a solid internal floating ovoid.

- A fineline surrounds the entire inner ovoid design unit.

- The inner ovoid lines and negative (background) spaces have greater width at the bottom than at the top. Formlines taper in width as they curve to the top.

- Negative background space units help to lighten up an otherwise heavy, solid design.

- Ovoids of varying shapes such as tall, convex bottomed, concave bottomed or elongate, may occur in the same formline design.

Basic Design - Ovoid

Comparing Ovoids Across Art Styles

Ovoids vary in structure from the almost rectangular shapes of the north coast art style areas to the free-flowing circular style of the south coast. The ovoid is considered the base or foundation from which the rest of the design is built. Primary ovoids are joined to the main formline, seldom occurring independent of it.

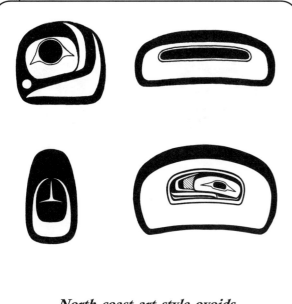

North coast art style ovoids

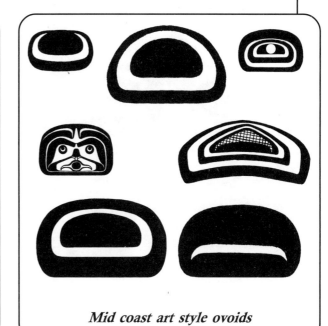

Mid coast art style ovoids

In general, the classic north coast art style ovoid usually has a curved, slightly concave formline at the bottom. The top of the ovoid is moderately convex and thicker than the bottom. The greatest depth and width of the ovoid is at the vertical and horizontal centre of the design unit.

When inner ovoids are attached to the upper outer primary ovoid formline, there is no encircling fineline. Inner floating ovoids, however, have an encircling fineline.

Ovoid shape and structure in mid coast art style range in shape from traditional formal north coast art style to flamboyant rectangles to near triangles. The formline is often opposite to north coast art style by being thicker at the bottom than at the top. It can also have a uniform thickness all around the design unit. The formline at the bottom of the ovoid can be straight, slightly convex or concave.

Inner ovoids can float within a formline ovoid, or they can be attached to the top or bottom of the primary ovoid formline. Finelines encircling floating inner ovoids are rare, except for eyeballs which always have encircling eyelid lines.

Learning by Designing: Pacific Northwest Coast Native Indian Art, Volume 1

Basic Design - Ovoid

Comparing Ovoids Across Art Styles

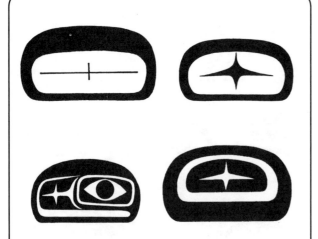

West coast art style ovoids

South coast art style ovoids

In the west coast art style, ovoid shape and structure range from traditional formal north coast art style ovoids to the many variations found in mid coast art style. Many primary formline ovoids in this art style have a more geometric structure than those of any other coastal style.

The formline at the top and bottom of the ovoid is often straight or only slightly concave with soft, evenly curved sides. Unique inner fineline crosses or quadron stars are often found inside the ovoids.

The south coast art style ovoids vary from nearly circular, to oval, to softly rounded rectangles. Formline thicknesses vary.

Inner floating ovoids or circles are usually concentric but can also be non-concentric. Contemporary south coast artists are using some north coast art style design principles in their art; therefore, head and face designs as well as relieving shapes can now be found within what used to be solid ovoids.

Basic Design - Ovoid

Drawn and Painted Ovoids

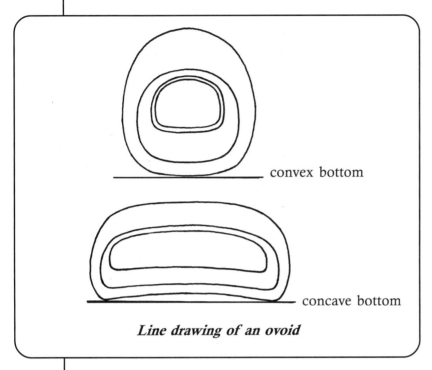

Line drawing of an ovoid

These line drawings of ovoids show two very different shapes. The upper north coast model has an inner ovoid with an encircling fineline.

The lower mid coast art style elongated concave bottom model has no fineline surrounding the floating inner ovoid. Lines and defined spaces between lines are all drawn in spacial harmony with one another.

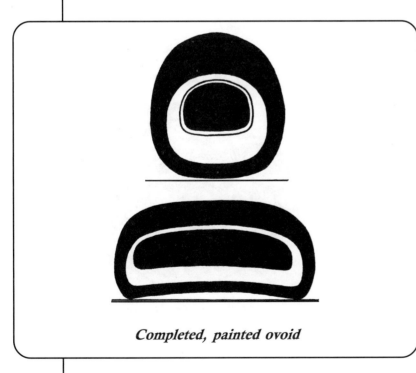

Completed, painted ovoid

Painted ovoids are rarely used by themselves. They are usually the major building blocks of the design itself and/or the internal units in designs or design extensions. They are usually painted black but may be red in some traditional designs. Inner floating ovoids are usually black.

Learning by Designing: Pacific Northwest Coast Native Indian Art, Volume 1

Basic Design - U shape

U shape

U shapes are design units that are shaped like the letter "U". Together with ovoids, U shapes are basic building blocks of Pacific northwest coast design and can have many variations. U shapes are used to delineate feathers, claws, beaks, cheeks, ears, nostrils, mouths, arms, legs, toes, fingers, wings, and tails.

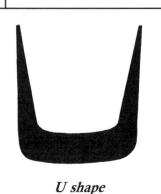

U shape

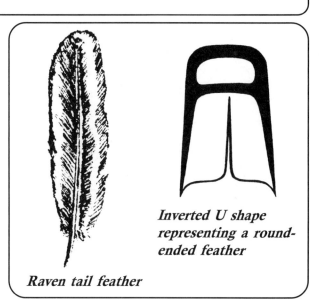

Inverted U shape representing a round-ended feather

Raven tail feather

Mid coast art style raven "The Artist"

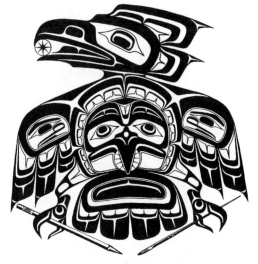

U shaped feather variations

- head feathers with pointed ends
- short body feathers around the head
- elongated and pointed outer wing feathers
- short, round-ended, inner wing feathers
- rounded tail feathers

Basic Design - U shape

Examples of U shapes

U shapes vary greatly and can be rotated or flipped depending on what the shape is representing. U shape differences among the four Pacific northwest coast art styles are not as area-specific as are ovoids. A plain U shape has the widest part of the formline at its curved end and the side legs taper where they join other shapes.

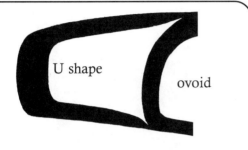

Plain formline U shape joined to side of ovoid

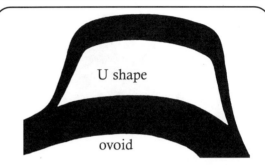

Formline U shape joined to top of ovoid

Formline U shapes

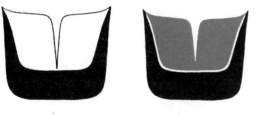

fineline split inner solid red split U

The fineline and inner split U shapes are joined at the pointed leg ends to the formline. In designs of two or more colours, the pointed U leg ends just touch, or lay close to, the main formline.

Formline U shape with an inner reverse split U

The pointed U leg ends of the reverse split point away from the widest part of the black formline of the U. The secondary filler U is painted a solid red and "floats" (does not touch the outer formline black U shape).

Learning by Designing: Pacific Northwest Coast Native Indian Art, Volume 1

Basic Design - U shape

Examples of U shapes continued

U Shape Variations - U shapes can be lengthened, shortened, inverted or rotated in a design in order to represent cheeks, or joined to represent lips, fins, feathers, tail flukes, fingers, claws, paws, and tails. Notice that the reverse split U creates two smaller U shapes contained by the larger. Northwest coast aboriginal art is full of visual puns like these.

Solid U shape

- can represent fish scale or feather

Solid split U shape

North coast art style reverse split U shape

- inner crosshatching
- can represent beaver tail

South and west coast style soft split U

- shape can represent whale fin

Mid coast art style U shape

- with internal reverse split
- elongated with pointed extension
- trigon relieving shape
- horizontal dashing can represent feather

West coast art style head within formline U shape

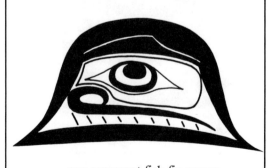

- can represent fish fin or ear

LEARNING BY DESIGNING: Pacific Northwest Coast Native Indian Art, Volume 1

Examples of U shapes continued

Many artists use negative background (often white) shapes to reduce the weight or heavy look of black and any other solid colour in designs. These relieving shapes can be found in the primary formline or in secondary filler units.

U shape

- can represent an ear or dorsal fin
- contains a trigon relieving shape forming two more U shapes

Split U shape

- has a negative ovoid shape in the curved part of the black primary formline

U shape

- with solid filler U
- both with crescent relieving shapes indicating more U shapes

Split U shape

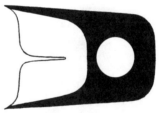

- with circle relieving shape

U shape

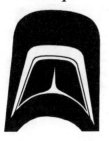

- "floating" secondary inner split U
- split U shape does not touch formline even at the pointed leg ends

U shape

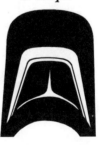

- inner split U shape is joined at the pointed leg ends to the formline
- this is usually seen in one colour designs

Basic Design - U shape

Examples of U shapes continued

U shapes can contain textures like crosshatching, lines or dashing. Crosshatching is often black but there can be red crosshatching within a black formline. If the texture is joined to the formline, it could be either red or black. U shaped design elements such as dorsal fins or feathers can become an integral part of the primary formline of the design.

North coast art style

- crosshatched split U shape contained within a solid formline U shape

Mid coast art style

- "stacked U" wing feather
- with either red or black dashing

West coast art style

- whale dorsal fin

Mid coast art style

- elongated wing feather

Primary U shape

- contains stylized head

South coast art style

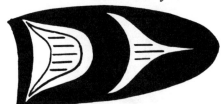

- tail feather with dashing in negative trigon
- red inner soft U shape with black dashing

48 *LEARNING by DESIGNING*: Pacific Northwest Coast Native Indian Art, Volume 1

Basic Design - U shape

Close-up of a U shape

Complex U shapes such as this wing feather design below are rare in Northwest Coast art. This complex design unit of "stacked" U's was drawn to show how detailed a formline U shape and its internal design units can become.

Mid Coast Art Style Wing Feather

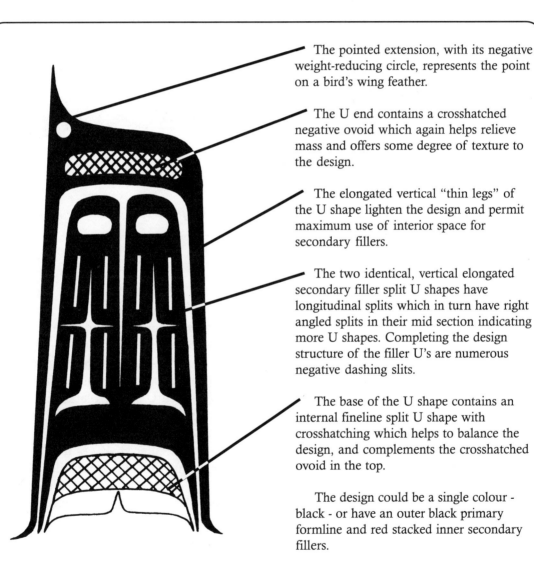

The pointed extension, with its negative weight-reducing circle, represents the point on a bird's wing feather.

The U end contains a crosshatched negative ovoid which again helps relieve mass and offers some degree of texture to the design.

The elongated vertical "thin legs" of the U shape lighten the design and permit maximum use of interior space for secondary fillers.

The two identical, vertical elongated secondary filler split U shapes have longitudinal splits which in turn have right angled splits in their mid section indicating more U shapes. Completing the design structure of the filler U's are numerous negative dashing slits.

The base of the U shape contains an internal fineline split U shape with crosshatching which helps to balance the design, and complements the crosshatched ovoid in the top.

The design could be a single colour - black - or have an outer black primary formline and red stacked inner secondary fillers.

Learning by Designing: Pacific Northwest Coast Native Indian Art, Volume 1

Basic Design - U shape

Comparing U shapes Across Art Styles

North coast art style U shapes tend to have a more rounded end than mid coast U shapes which may at times be flat ended. North coast style inner U shape legs usually join the formline while mid coast U shapes may join or float within it without touching.

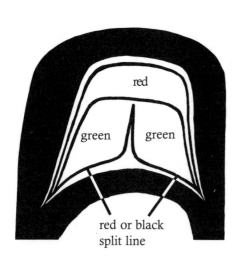

U shape in north coast art style design

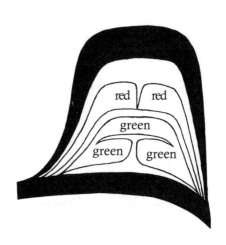

U shape in mid coast art style design

Inner secondary and tertiary split U shapes are often drawn as a fineline outline shape and are the same colour as the formline. A green U tertiary split U shape is found here within secondary red U shape. Black, red and green are used for U shapes in north coast art style.

Inner secondary U shapes may be crosshatched, or contain parallel slanted finelines. Fineline texturing seldom touches the formline and the textured design unit is surrounded by a perimeter fineline. Artists working in the north coast style often stack U shapes one above another for complex filler designs. The north coast style U shapes may have a curved top formline U shape.

In this mid coast style inner secondary split U complex, shapes are more elaborate and generally use fewer fine lines than in the north coast art style. In this design, a green U shape with a horizontal split is used within a secondary red U shape. Black, red, green, yellow and blue can be used for U shapes in the mid coast art style.

Mid coast filler U shapes usually have characteristic thin side legs. Filler U designs also often contain bundled dashing, horizontal and parallel slits, negative circles, ovoids, crescents, and trigons. The mid coast art style U shapes usually have a somewhat flat end.

Basic Design - U shape

Comparing U shapes Across Art Styles

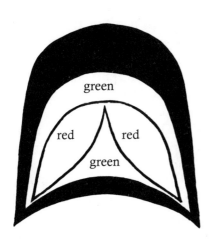

U shape in south coast art style design

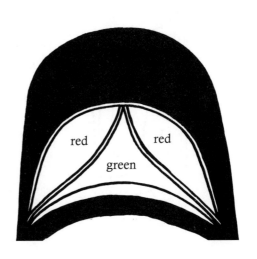

U shape in west coast art style design

This contemporary south coast art style U shape has a rounded end and a rounded top internal secondary split U that has an open soft split. The green colour touches the red.

Today's south coast artists use much variety in drawing their U shapes. Structure varies from geometric square ends to soft curved ends. Splits are usually soft, but some are geometric and look like triangles. These triangular splits are often negative.

Artists today use black, red, yellow, green, blue and reddish-brown colours.

In the west coast art style, U shapes usually have rounded ends. In this design there is a secondary split U that is red with a green inner filler in the U split. These red and green units do not touch one another or the outside formline. Secondary filler units inside formline U shapes are less elaborate than mid coast designs.

Feather U shapes usually have solid, full rounded formline ends and narrow side legs. Soft, curved fineline splits are used frequently.

Artists use black, red, yellow, green, and blue colours.

Learning by Designing: Pacific Northwest Coast Native Indian Art, Volume 1

Basic Design - U shape

Drawn and Painted U shapes

Line drawing of a U shape

This typical mid coast art style U shape has thin, tapered legs allowing maximum space for an elaborate inner split U filler unit. Horizontal splits coming off the vertical U split are common in mid coast art.

The outer formline U may be one colour while the inner filler is another.

Pointed ends of the filler unit legs may touch, join or float free from the outside formline. Once one style of joining is chosen, it should be constant throughout the design.

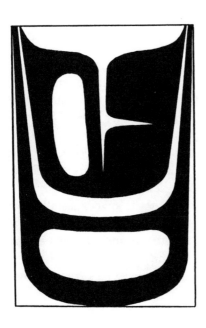
Completed, painted U shape

When painted, this U shape shows a balance between coloured (positive) and negative spaces. The horizontal negative ovoid in the primary formline is echoed by the vertical negative ovoid in the split U filler. The vertical negative split in the solid U filler has an additional horizontal split, indicating two more U shapes and providing a balancing echo.

Negative spaces help to relieve the heaviness of solid colour mass in this U shape design.

S shape

S shapes are primary formline and secondary design units that are shaped like the letter "S". S shapes can be found reversed or rotated as well as in a regular "S" shape. S shapes provide design variety and may be solid or textured.

S shape

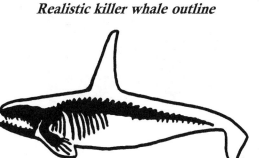

Realistic killer whale outline

This diagram shows internal skull and skeletal make-up.

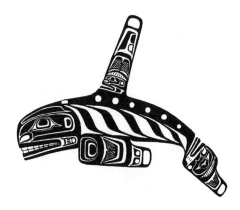

Mid coast art style killer whale

In this design, using traditional aboriginal 'X-ray vision technique', the ribs of the whale are shown as reversed S shapes. The ribs are further defined by the repeated negative reversed S shapes between the formline S ribs.

Learning by Designing: Pacific Northwest Coast Native Indian Art, Volume 1

Basic Design - S shape

Examples of S shapes

S shapes can be primary formlines, secondary fillers or negative design units. As formline shapes, they often represent ribs, skeletal complexes, arms, legs, fins and muscle masses. Reversed, flipped or rotated, S shapes are common when the X-ray design technique is used. Negative S shapes are often used to relieve heavy formline weight.

Mid coast art style upper torso of a human

The S shapes rotated upward in this human body design are used to represent ribs joined to a central sternum. Again, the X-ray technique is used. The spaces between the formline S shapes are repeated in negative (white background) S shapes.

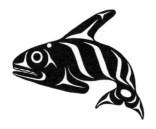

South coast art style killer whale

The S shapes in this south coast art style killer whale design are used to create negative or open space within a field of black. The open (relieving) space reduces the weight of the black body. The S shapes represent ribs or muscle block areas of the body.

Mid coast art style arm

North coast art style salmon back

In this design, a reversed elongated S shape represents an arm with a profiled hand. The formline S shape has its weight reduced by using an elongated negative quadron.

In this design, a section of the back of a salmon shows secondary filler S shapes with internal negative circles representing the vertebrae of the backbone.

54 *Learning by Designing*: Pacific Northwest Coast Native Indian Art, Volume 1

Basic Design - S shape

Examples of S shapes continued

S shapes can be inverted or rotated in a design. They can be short, long, thin or wide, and can be a solid colour or contain internal negative relieving designs, crosshatching, hatching, or dashing.

Formline S shape

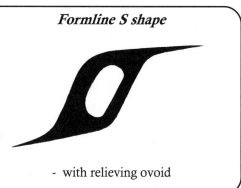

- with relieving ovoid

Formline S shape

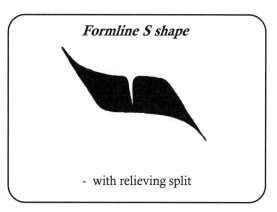

- with relieving split

Formline S shape

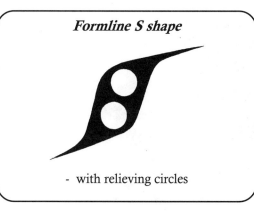

- with relieving circles

Formline S shape

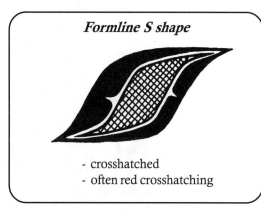

- crosshatched
- often red crosshatching

Formline reversed S shape

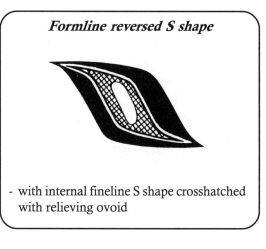

- with internal fineline S shape crosshatched with relieving ovoid

Formline reversed S shape

- with relieving split
- plus an internal negative S shape with dashing

Learning by Designing: Pacific Northwest Coast Native Indian Art, Volume 1

Basic Design - S shape

S shapes in a Design

In this mid coast art style design of a dancing Tsonoqua who is squatting and calling, S shapes are reversed, rotated and textured. They represent hair, ribs in the lower body, and muscles in the limbs. They are formlines, filler designs and negative space shapes. In the hair, positive formline and negative background spaces result in two different uses of S shapes. The S shapes on the left side of the head are reversed. A negative S shape in each upper arm is crosshatched.

Mid Coast Art Style Dancing Dzunukwa

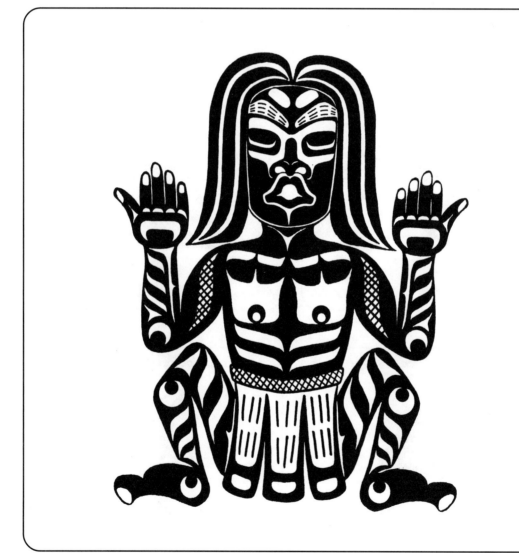

Drawn and Painted S shapes

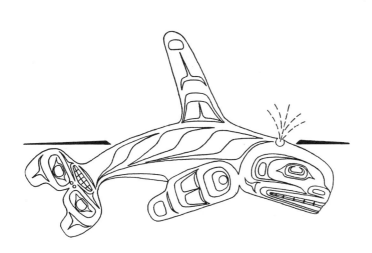

Line drawing of a mid coast art style killer whale using S shapes

In this mid coast art style design, a killer whale is shown surfacing and blowing. The top formline of the whale's back is relieved in weight by repeated insertions of negative S shapes.

The design impact of the formline S shapes and negative S blocks is not as apparent and dramatic as when the design is painted.

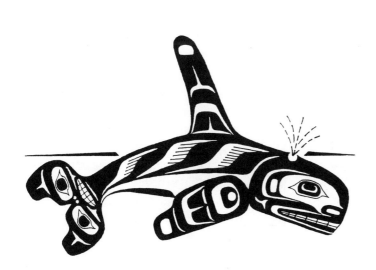

Completed, painted mid coast art style killer whale using S shapes

When the killer whale is painted, the full thickness of the top formline of the whale's back is more evident. Dashing has been added to the negative S shapes for design variety.

The water is represented in two different ways: the horizontal lines represent the water surface and the dotted finelines represent the water spray that the whale is spouting from its blow hole. Sometimes water is shown using S shapes or trigons.

Basic Design - Joining Design Units

Joining Design Units

Designs are formed by joining formlines with formline design units. Excessive line weight is avoided by tapering or *fairing* the joining line when forming a straight or curved joint. Also, if an expanded or heavy juncture results when joining formlines, negative units can be placed in the juncture to relieve the line mass. These negative relieving shapes are usually crescents, trigons, quadrons or circles. The tapering and the negative shapes help to delineate major formline parts. When major formline units are drawn adjacent and touching, short *joiner* formlines facilitate joining.

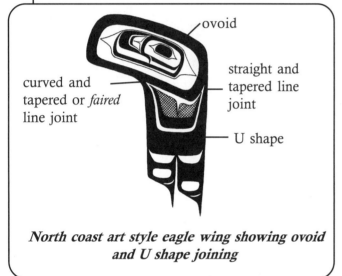

North coast art style eagle wing showing ovoid and U shape joining

Realistic bald eagle

Mid coast art style profiled flying eagle

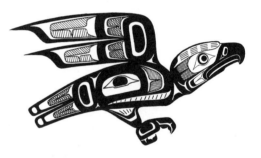

The wing, head and tail design units are joined to the formline body ovoid with short *joiner* lines. These joiner lines result in small negative areas being formed. The U shape legs taper and curve or *fair* when joining the ovoid formline.

Learning by Designing: Pacific Northwest Coast Native Indian Art, Volume 1

Basic Design - Joining Design Units

Examples of Joining Design Units

When U shape formlines join a primary ovoid, the ovoid shape usually remains intact and the joining design formlines are modified, narrowed and tapered at the points where they contact. When two ovoids join or overlap, joiner lines may be used. When the formline join is wide, it is usually relieved by a negative circle, crescent or trigon.

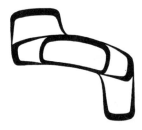

Joining formline U shapes to ovoid formline

This north coast art style box end design (incomplete) has four formline U shapes and a central ovoid, all joined in one design complex. At all junctures, the legs of the U shapes are tapered. Six junctures are straight, two are curved and faired.

Ovoid end joining ovoid end

In these tail flukes of a mid coast art style whale, the two ovoids are touching while an upper joiner line maintains formline flow. A negative trigon shape defines ovoid shapes and relieves the line weight between the ovoids.

Ovoid end joining ovoid end with the two central lines overlapping

This north coast art style face-on design shows overlapping ovoids. An upper joiner line ties the formline ovoids together, resulting in a negative trigon between the ovoids. This also relieves line mass at the junction. A lower negative circle helps relieve the heavy formline weight which resulted from overlapping the ovoids.

Basic Design - Joining Design Units

Examples of Joining in a Salmon Head Design

The following salmon head designs are often found on chests or bentwood box ends. The head front (snout) is usually inclined slightly upward giving the design an animated quality.

North coast art style salmon head design

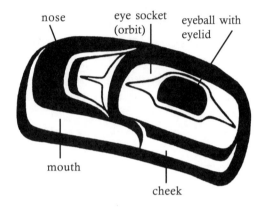

– this is the foundational design upon which all three salmon head complexes are based

Ovoid salmon head with two U designs added horizontally

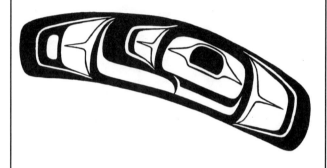

– two U shape designs are added to the front and rear of the ovoid salmon head
– all inner U designs have a fineline U split
– bottom line of the whole design is curved

Mid coast art style salmon head with two U designs added vertically

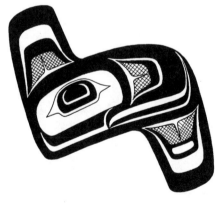

– formline U ends fair into ovoid top and bottom lines
– all three inner U designs are floating and have crosshatching
– the mouth has an elongate tongue
– ovoid eyeball has a negative crescent

Complex ovoid salmon head with four U designs added

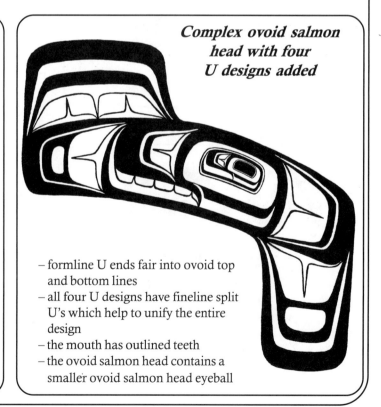

– formline U ends fair into ovoid top and bottom lines
– all four U designs have fineline split U's which help to unify the entire design
– the mouth has outlined teeth
– the ovoid salmon head contains a smaller ovoid salmon head eyeball

Examples of Joining Design Units continued

Negative shapes often help define the edges of joined formlines. Depending on the art style, these negative shapes can have two to five points joined by curved sides and may be crescents, trigons, quadrons, and quintons, depending on the number of points.

Mid coast art style hand

- joining solid U shapes (fingers and thumb) to primary ovoid palm with delineating negative crescent shapes at junctions

South coast art style legs and feet

- joined, stacked negative crescents defining ribs and muscle groups

South coast art style whale head and human arm

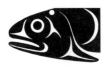

- negative trigon shapes in a whale head and fin and in a human wrist and shoulder joints

North coast art style wing

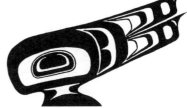

- negative quadron shape at the joining of a wing ovoid joint to a bird's body formline

West coast art style human head

- negative quinton shape with a filler four point fineline cross at the joining of head to body

Mid coast art style wolf head

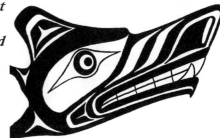

- two negative trigon shapes at the joining of head to body formline

Learning by Designing: Pacific Northwest Coast Native Indian Art, Volume 1

Basic Design - Joining Design Units

Close-up of Formline Formation and Joining

Mid Coast Art Style Killer Whale - One Colour Design

1. Primary formline design units are situated adjacent to one another and to the body formline perimeter

2. Primary formline design units join whale body formline perimeter lines to create one unit

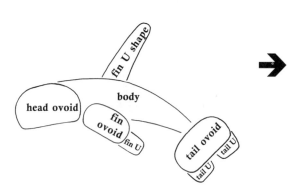

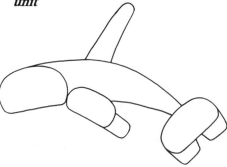

3. Formlines are curved or faired at junctions and primary ovoid head and pectoral fin are joined by lines

4. Inside lines of primary U formlines are drawn and coloured. Note the resulting negative shapes, U's, crescents, and trigons. The heavy dorsal formline of the whale is relieved by negative trigons delineating muscles in the whale's back.

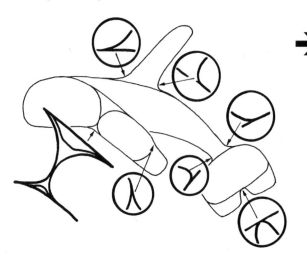

5. Joiner lines between formline ovoids are painted. Note the resulting negative trigons which relieve the black mass.

6. Completed one colour formline design of Killer Whale

Dorsal fin (elongate U) lightened in weight by internal negative design units such as terminal quinton and lower U with split U filler

Negative crescent at primary ovoid top eliminating heavy solid joining of dorsal formline

Two lower negative crescents help define terminal flukes of tail

Negative trigon in U extension of pectoral fin helps delineate ovoid shape and relieve heavy solid U shape

62 *Learning by Designing*: Pacific Northwest Coast Native Indian Art, Volume 1

Basic Design - Joining Design Units

Comparing Joining Design Units

Adjacent joining units may float, touch, or overlap. Resulting negative relieving shapes help delineate the major design units. On this page, the variations in this north coast art style eagle head with adjoining one-feathered wing show these design principles.

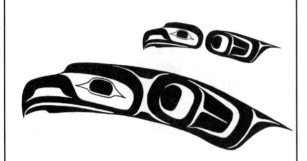

Joining adjacent floating design units resulting in a negative quadron

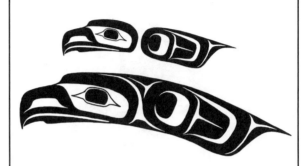

Joining adjacent floating design units resulting in two negative trigons

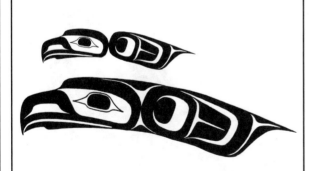

Joining touching design units resulting in two negative trigons

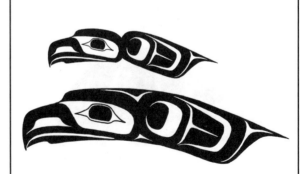

Joining/overlapping design units resulting in two negative trigons. Line width at overlap is reduced.

Learning by Designing: Pacific Northwest Coast Native Indian Art, Volume 1

Basic Design - Joining Design Units

Comparing Joining Design Units Across Art Styles

Formlines in all coastal art styles join with or without joiner lines with the resultant negative areas between major units. Below are four different examples of joining a killer whale formline head unit with its pectoral fin and body. Note that the north and mid coast styles are most wolf-like, the south style is salmon-like and the west coast style is most whale-like.

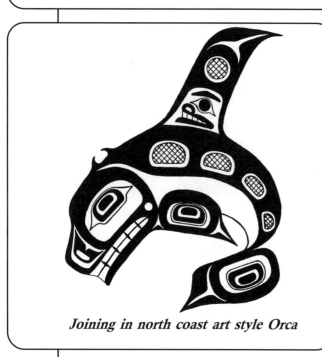

Joining in north coast art style Orca

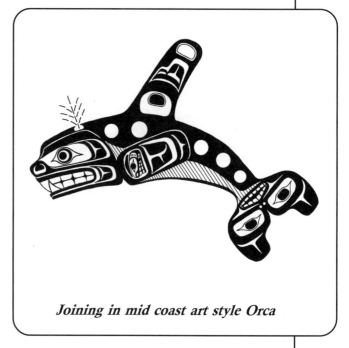

Joining in mid coast art style Orca

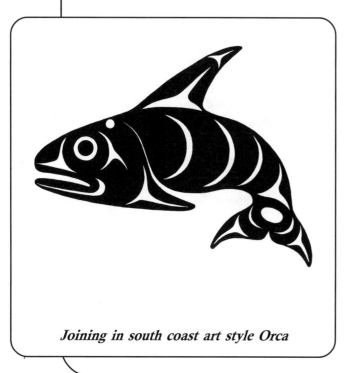

Joining in south coast art style Orca

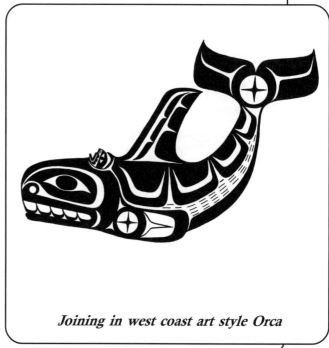

Joining in west coast art style Orca

Basic Design - Joining Design Units

Joining Profiled Heads

Many profiled head designs can be joined, and with slight formline modifications, result in a full face-on design of the same creature. Most designs need short joiner formlines or design units in the forehead. These face-on designs are bilaterally symmetrical and are often called *split designs*. All designs below are variations of a north coast art style bear design.

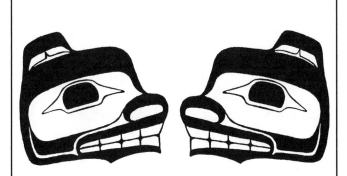

- two profiled formline bear head designs facing each other

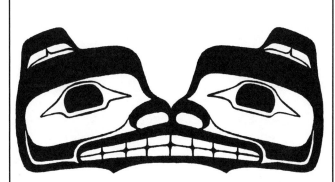

- two profiled formline bear heads are joined, slightly modifying the formline around the nose, mouth, teeth and lips

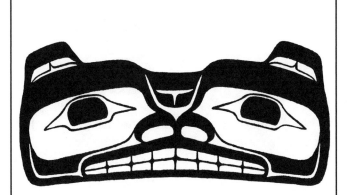

- forehead area has a solid formline U shape filler with an internal negative trigon

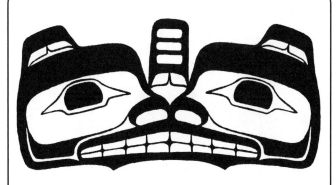

- depression between the bear heads is filled with a vertical U shape with three negative ovoids and a split
- ovoids in the vertical U shape represent traditional potlatch rings often found on totem pole figures
- rings indicate the high social status of the bear crest owner

Learning by Designing: Pacific Northwest Coast Native Indian Art, Volume 1

Salmon Head Design

Salmon head design units vary a great deal in shape and complexity. All salmon heads have a black eyeball and eyelid line and a snout/nose. If there is a mouth/jaw, it may be empty or contain teeth and/or a tongue. A cheek design often appears at the rear of the mouth.

Realistic chum salmon

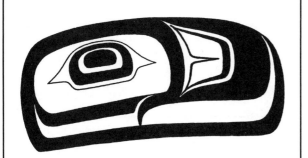

Basic salmon head design

Complex salmon head design

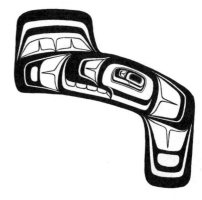

North coast art style salmon heads commonly have a fineline enclosing them. The salmon heads usually float unattached inside formline circles or ovoids. They are seldom a primary formline component on their own. West and mid coast style salmon heads differ. They seldom have encircling finelines and are commonly included or joined directly to the primary formline.

Examples of Salmon Head Designs

The following salmon heads show a wide range of design shapes. Salmon heads are often found in eyeballs, joints, or box end designs. This degree of abstraction is clear evidence of the sophistication of these artists.

North coast art style circular salmon head

In this north coast art style salmon head design, there is an encircling fineline around the main salmon head and around the eyeball. There is a crescent defining the nose/snout and another crescent defining the mouth.

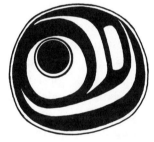

North coast art style ovoid salmon head with convex bottom

In this north coast art style salmon head design, there is an enclosing fineline around both the eyeball and the main design. The snout is a U shape with a negative relieving ovoid. The mouth is defined by a negative area that resembles the bottom of an ovoid.

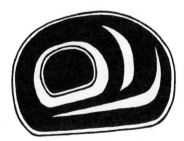

North coast art style ovoid salmon head with flat bottom

This north coast art style salmon head has an encircling fineline around both the eyeball and the main design. The snout is a thick U shape and the mouth is defined by a negative shape that follows the top jaw line.

Examples of Salmon Head Designs continued

The following salmon head designs have a more elongated ovoid shape than the previous designs. The first two designs have no encircling fineline; therefore, they are not necessarily part of an inner ovoid design. They can be used as a formline component and joined into the primary formline.

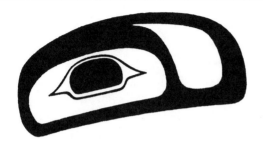

Elongated, simplified, ovoid salmon head

In this simplified salmon head design, a modified U shape joins an ovoid to form snout and head. There is a simple ovoid eyeball with an eyelid line around it. There is only a top jaw and no mouth.

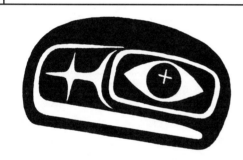

West coast style salmon head with flat bottom

In this west coast style design, there is a negative design unit in the nose that resembles a typical west coast "star." There is a typical west coast negative cross in the eyeball. It is also common in west coast style to define the eyelid area within a coloured eye orbit by a negative space around the eyeball.

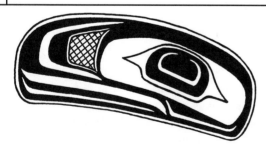

Complex, elongated ovoid salmon head with concave bottom

This north coast art style design has an enclosing fineline. The black eyeball has a relieving crescent defining the pupil. There is a fine eyelid line around the eyeball and a negative space defining the cheek. The mouth contains a tongue and the snout has a crosshatched filler U shape.

Basic Design - Salmon Head

Examples of Salmon Head Designs continued

The following salmon head designs show additional variations.

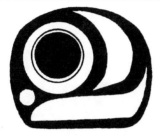

Rounded ovoid salmon head with flat bottom and thin formline

In this salmon head design, a round eyeball with encircling fineline is placed within an ovoid primary formline head. The nose is a simple U shape and the mouth is defined by a negative space resembling an S shape. There is a negative circle at the jaw joint.

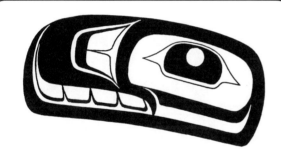

Ovoid salmon head with concave bottom

In this design, the salmon head ovoid has a long curved concave bottom. There is a split U in the snout and teeth in the mouth. The ovoid eyeball has a relieving circle. The cheek is represented by the bottom of the eye orbit line and a modified negative U shape.

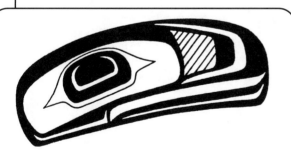

Complex, elongated ovoid salmon head with concave bottom

This salmon head design has a black ovoid eyeball with a relieving crescent defining the pupil. There is a fine eyelid line around the eyeball and a negative space defining the cheek. The mouth contains a tongue and the snout has fine diagonal lines in the filler U shape.

Learning by Designing: Pacific Northwest Coast Native Indian Art, Volume 1

Basic Design - Salmon Head

Salmon Head Design Complexes

Formline U shapes can be added to the top, bottom, rear, and/or front of a salmon head design. This salmon head design unit is often found on bentwood box or chest ends and is sometimes called a box end design. Internal filler units can become very complex. The designs may be black only, black and red, or three colours - usually black, red and green. The following designs have in common a black eyeball with a weight relieving negative crescent and a negative mouth with a long tongue.

Salmon head design complex with U shapes added to the front and rear sides of the salmon head

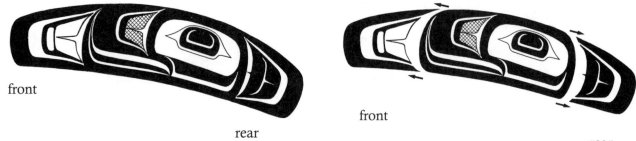

– salmon head ovoid has crosshatched split U shape in the nose
– front primary U shape has a split U filler with a fineline split and a relief ovoid
– rear primary U shape has a solid U filler with a relieving negative trigon

Salmon head design complex with U shapes added to the top and bottom sides of the salmon head

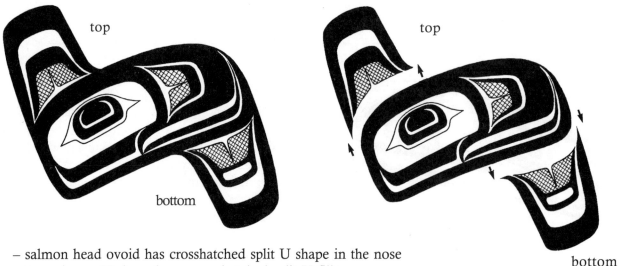

– salmon head ovoid has crosshatched split U shape in the nose
– top primary U shape has a crosshatched split U filler
– bottom primary U shape has a crosshatched U filler with a relieving negative ovoid
– crosshatching spread throughout the design helps to unify the design

LEARNING BY DESIGNING: Pacific Northwest Coast Native Indian Art, Volume 1

Basic Design - Salmon Head

Comparing Salmon Heads Across Art Styles

Formline salmon head designs appear in all coastal designs. Design placement, shape, size, rotation, and colour vary a great deal. The following designs are typical of the four art styles but are not definitive.

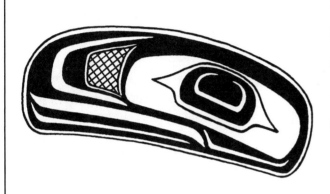

North coast art style salmon head design

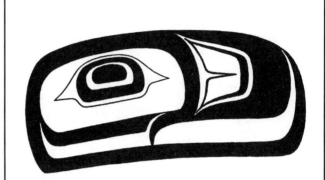

Mid coast art style salmon head design

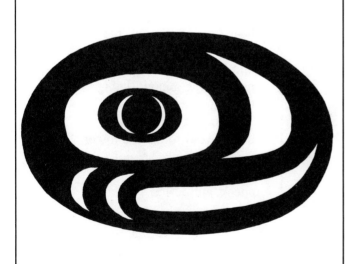

South coast art style salmon head design

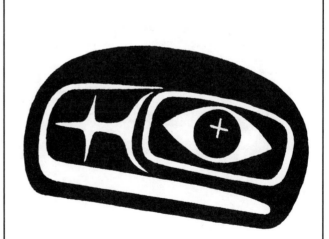

West coast art style salmon head design

Learning by Designing: Pacific Northwest Coast Native Indian Art, Volume 1

Basic Design - Salmon Head

Drawn and Painted Salmon Heads

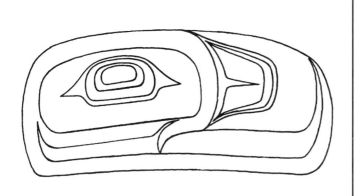

Line drawing of a salmon head

The salmon head design is usually found in north coast and mid coast art styles. This unit was traditionally outlined using bark or leather templates shaped like ovoids. The ovoid eyeball in this design has a free-floating pupil, while the nose/snout area has a split U filler design.

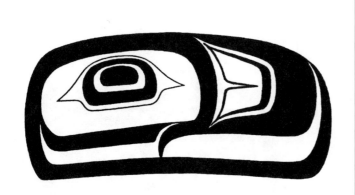

Completed, painted salmon head

When painted, this salmon head clearly shows features common to most salmon head designs. The head/eye orbit ovoid has a gill cover-shaped rear wall and forward U shaped nose/snout. Below this is the negative mouth area. The bottom line of the main ovoid forms the lower jaw and mouth, behind which is an elongated cheek/gill design.

Heads

Two-dimensional human heads in traditional north and south coast art styles are usually shown face-on, while those of the mid and west coast art styles are profiled. Most human heads feature eyebrows, eyes, nose with nostrils and mouth. Fish, bird, whales and other animal or creature designs are usually shown in profile and display, often exaggerated, distinctive or symbolic features such as eyes, ears, noses, mouths/snouts, spines, blow holes, hair, tongues, teeth, beaks, and gills.

profile face-on

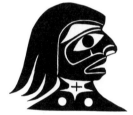 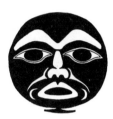

West coast art style head profile and south coast art style head facing forward

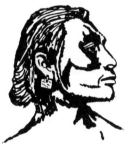

This drawing of Tai tats-toe, a Nuu Chah Nulth First Nations man who lived in the 1800's, is from a photograph by C. Bentile in 1864.

 Mid coast art style Copper Chief

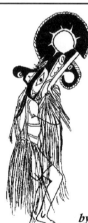 *Masked Hamatsa Dancer*

by Karin Clark

In all coastal art styles, the head is the focal point of any design and is the most important component. The head may range from one third to one half of the size of the total design. The head is often the symbolic metaphor for the whole creature and as a result, the body or its parts are often de-emphasized or even omitted. Many aboriginal people, when seeing a head design, easily visualize the whole animal. The idea of the head design being symbolic of the entire creature may come from viewing a masked dancer. The mask and the dancer become one entity during the dance; they transform, becoming a spirit in visible form.

Basic Design - Heads

Examples of Heads in Design Units

Heads may be drawn in a variety of formline shapes: ovoid, circle, U shape and free form. North coast art style heads tend to be more stylized and formal than the mid and west coast styles. The separate head designs below would normally be part of a complete formline design.

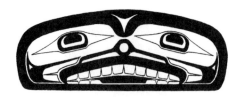

North coast art style face in an ovoid

This human head is totally contained within a formline ovoid. Eyebrows are implied. Eyes and eyelids are placed within ovoid eye sockets. The nose has broad nostrils with a negative circle in the bridge. Cheek designs start at the mouth corners. The top lip is wider than the bottom. The open mouth shows tongue and teeth.

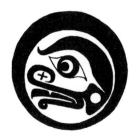

West coast art style face in a circle

This head has been reduced to a basic eyebrow, cheek, top and lower lip, and nose all as one formline unit within a circle head formline. Distinctive eyelid lines and fineline cross in the nostril are typical west coast art style.

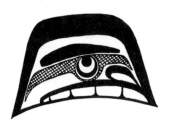

North coast art style face in a U shape

This stylized head profile is placed within a formline U shape which could represent a fish or whale dorsal fin. Eyebrow, textured eye orbit, circle eyeball, top lip and nostril are all common north coast art style features. The mouth design with only the top lip and top teeth showing is unusual.

Examples of Heads in Design Units continued

Most often, heads are drawn in profile since they fit more easily into smaller design units than face-on head designs. Profiled designs usually show more distinctive and identifiable features, except in designs where specific symbolic design features are best displayed face-on.

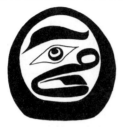

South coast art style face profile in a vertical ovoid

In this contemporary south coast art style design, the profiled face within the ovoid shows some characteristics of mid coast art style design. The eyeball and eyelid design shape are traditional south coast art style.

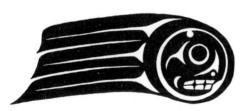

South coast art style killer whale head profile in a circle

In this south coast art style thunderbird wing design, a whale head is contained within the circle formline. The elongated negative trigons, crescents, and circles are characteristic of the south coast art style. They help to delineate the positive lines of the head and wing design.

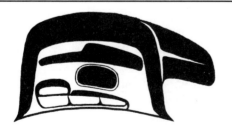

North coast art style head profile in a U shape

In this north coast art style design, the head profile is in the dorsal fin of a killer whale. The upper top part of the fin is folded down and bent to the rear. A split in the solid formline U helps delineate the fin as well as lighten the design mass. Head/face components are typical except that only the top lip and teeth are shown.

Basic Design - Heads

Examples of Free Form Heads

The following heads are free form in shape. Because of design extensions like beaks, feathers, blow hole spray, snouts and ears, these designs would be difficult to fit into a formline ovoid, or U shape.

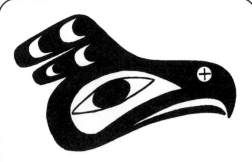

West coast art style thunderbird

In this profiled design, the beak and head feathers make it difficult to contain within a formline design unit. Therefore, it becomes a free-form stylized head with the necessary identifying features of curved beak containing a nostril cross, two head plumes, and typical west coast art style eyelid and eyeball.

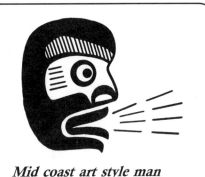

Mid coast art style man

This free form profiled human head has a blowing mouth similar to a whale's blow hole. The straight lines represent the spout. Typical mid coast art style features are the arched, textured eyebrow, large eye orbit with non-concentric eyeball, rear parallel dashing, and free-floating lips.

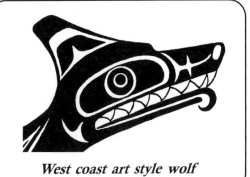

West coast art style wolf

This profiled west coast art style wolf head has a characteristic sloped ear, long snout with negative nostril, large mouth with sharp teeth and extended tongue, and a large ovoid eye orbit with central circular eyeball.

Head Components - Beaks and Bills

Bald Eagle

These two birds are the most important bird crest and clan figures of the mid and northern sections of the Pacific Northwest Coast.

Raven

West coast art style eagle

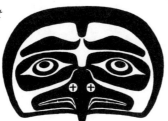

The eagle in front view usually has a more heavily designed beak than a raven. The top beak end is drawn extending below the lower beak. It is identified face-on by top beak point position.

Mid coast art style raven

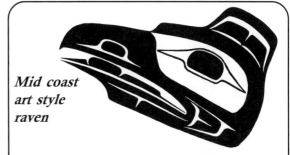

The raven has a straight, pointed top beak with a slight curve at the end. The open beak shows a long pointed tongue with a central ovoid representing the sun.

- Beak or bill shapes are important characteristics used to identify birds. Most birds in Northwest Coast Pacific art styles are drawn in profile.

- Beaks tend to fall into two general categories when drawn in profile - short and curved or long and pointed.

- Birds with short, curved pointed beaks are the eagle, thunderbird, Kulus, falcon, fish hawk (osprey), owl and other raptors. Birds with elongated, basically straight bills are the loon, heron, hummingbird, woodpecker, kingfisher and songbirds.

- The raven's bill is long, straight and curved at the tip but not recurved back under the lower bill. A raven's bill is always pointed at the end.

- The eagle's beak usually has curvature over most of its length. The pointed tip is often curved down or back beyond and below the lower beak end.

- Profiled bird heads should have a beak with a nostril in the top/base. Nostrils are usually indicated by negative areas shaped as ovoids, circles, and U shapes. Nostrils can have internal design units.

Examples of Head Components - Beaks

Examples of Beaks and Bills

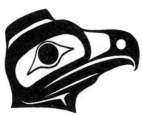

North coast art style eagle
- curved top beak with point curved back below the lower beak end

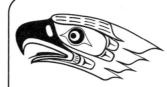

Mid coast art style eagle
- contemporary
- curved, pointed beak
- open mouth shows tongue

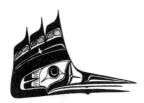

Mid coast art style kingfisher
- long pointed beak, often open showing the tongue

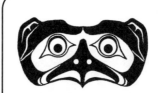

North coast art style owl
- heavy top beak curves down to a point at its end

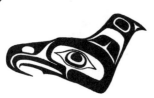

North coast art style thunderbird
- recurved, long, pointed top beak that lies under the lower beak tip

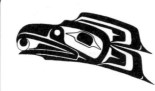

North coast art style mythical raven
- has curved end beak which holds a symbol of a sun, moon or star

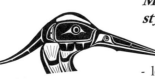

Mid coast art style blue heron
- long pointed bill and curved rear head feather

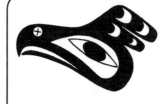

West coast art style thunderbird
- typical curved beak that can also be found on eagles, ospreys, hawks or owls

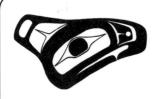

North coast art style osprey
- top beak recurves to touch lower beak or teeth

Mid coast art style hummingbird
- elongated, thin, slightly curved beak

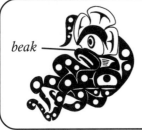

beak

Mid coast art style octopus
- top beak recurves below bottom beak

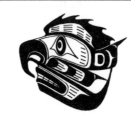

Mid coast art style osprey
- top recurved beak returns to mouth area and is often associated with sun designs

Head Components - Cheeks

Cheeks are those areas of the side of the face below the eye orbit. Cheek design units appear frequently in north coast art style faces where the eye orbit is generally an ovoid shape. The top lines of cheek designs often form the bottom line of the eye orbit. In mid coast art style cheek designs are found between the eye orbits and the top lip as well as at the mouth sides. West coast artists use few cheek design elements. South coast traditional cheek designs include curved negative crescents.

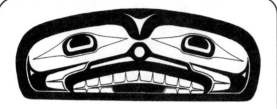

North coast art style human face with U shaped cheek design

The north coast art style has the greatest variations in cheek designs. These are used in faces on box/chest designs. They are usually based on the U shape design and have elongated pointed vertical extensions. Internally, they may contain ovoid formline units, be crosshatched or finelined. They are usually black and red.

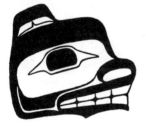

North coast art style bear head

This north coast art style profiled bear head has a simple, solid U shaped cheek design which is situated behind the mouth area. This cheek unit defines the general boundaries of the lower orbit shape. Cheek designs in profiled faces can be elaborately designed units, with negative slits, crescents, and circles, as well as formline shapes in red or black.

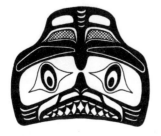

North coast art style dogfish head

These north coast art style dog fish cheeks contain gill slits on either side of the mouth. The stacked negative crescents help to lighten the black mass of the side of the lower face. In mid coast art style design, cheeks in face-on designs of marine creatures and fish often have a U shape or series of horizontal U shapes beside the mouth. These usually represent gills.

Examples of Head Components - Cheeks

Head Components - Cheeks continued

Mid, south, and west coast art style facial cheek designs are much freer in artistic expression than those of the north. In birds, cheeks may have dashed U shapes or crescents representing feathers. Animals may have U shaped design units with internal dashing symbolizing hair or fur. Fish often have design complexes at the rear of the mouth or head. These designs can represent gills or scales.

Mid coast art style centre head of Sisiutl

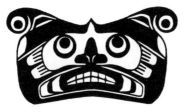

- U shapes represent scales and gills

West coast art style human

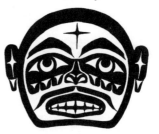

- U shapes on the cheeks represent feathers

Mid coast art style salmon head

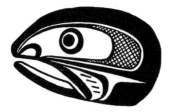

- U shaped design unit behind the mouth represents gills

Mid coast art style bear

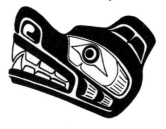

- U shapes with dashing in the cheeks represent hair

Contemporary south coast art style heron

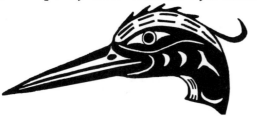

- negative crescents and a trigon shape represent feathers

Mid coast art style osprey transforming into a man

- elongated U shapes under the eye orbit and dashed U shape behind the mouth represent feathers

Head Components - Ears

Realistic Human Ears

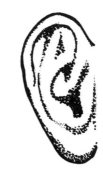

right ear/side view left ear/front view

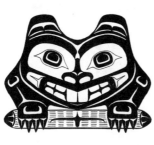

West coast art style human and north coast art style beaver

Variations in ear designs occur in all coastal art styles. Creatures of the land, air or sea as well as humans have ears that can be simple or complex in design. Ears can be ovoid, round, oval or free-form. They may contain U shapes, splits, and many negative relieving shapes. Ears can be short or long, slanted or erect, and placed on the top rear or sides of the head.

Realistic, elongated, erect, hair-covered ears of a young wolf

Examples of Head Components - Ears

Comparing Human Ears Across Art Styles

Human ears vary a great deal across the coastal art groups. Artists draw shapes which vary from non-realistic U shapes with inner split finelines to semi-realistic curved formline shapes with curved inner design units that have shapes that represent realistic holes. Ears are usually placed on the sides of the head rather than on the top as is the case for other creatures.

Traditional north coast art style heads

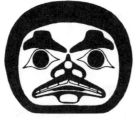

- human ovoid head has eyebrow humps representing ears

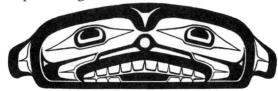

- representational U shaped ears extend out from the sides of the head
- found in some box or chest designs

Traditional mid coast art style design of a Dzunukwa (Geekumhl)

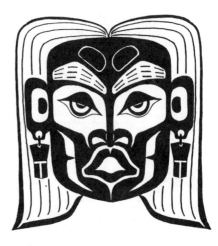

- large formline ovoid shaped ears from which hang earrings shaped like miniature coppers

Traditional west coast art style head

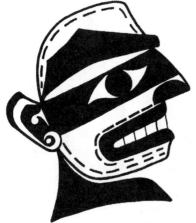

- elaborately constructed ear of curved formlines and negative areas
- ear is atypically placed at the rear of the side of the head

Contemporary south coast art style head

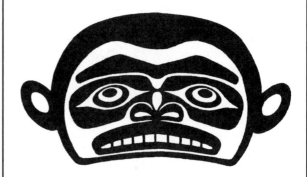

- ears are traditionally shaped rounded ovoids with inner negative relieving ovals

Learning by Designing: Pacific Northwest Coast Native Indian Art, Volume 1

Examples of Animal Ears

Ears are found in all coastal art styles and often are characteristic of a particular creature. Large ears may indicate that the creature has special auditory power. Ears can be drawn as simple formline U shapes, elaborate curved plume-like units or as U shapes containing heads or bodies of other creatures.

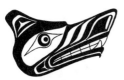

Mid coast art style wolf

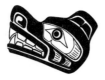

Mid coast art style bear

Wolf ears are commonly drawn as elongated formline U shapes which slope from the rear top of the head. Bear ears are usually shorter, more rounded, smaller, and not sloped like those of the wolves. Both creatures' U shaped ears have secondary filler units which are also U shaped and are usually painted red.

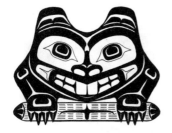

North coast art style beaver

Ears, whether drawn in profile or face on are usually U shaped. The ears on the beaver are rounded and small and have two reverse split U design units in each ear. These are painted red.

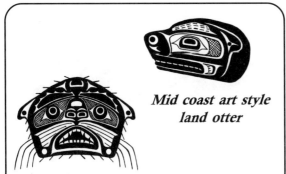

Mid coast art style land otter

Mid coast art style sea otter

Otters, like sea lions, have small ears at the sides of the head. Seals do not have external ears. In both types of Pacific otters, the ears, whether in profile or face on are drawn in a modified U shape. The ears drawn here show a small circle (red) depicting the ear hole. The otters' ears are placed in a realistic position on the head top/sides.

Examples of Head Components - Ears

Examples of Animal Ears continued

Animals, mythological or supernatural creatures, insects, as well as inanimate objects may all be drawn with ears. Profiled animals with horns have the ears placed behind the horns. The north coast art style has the greatest diversity of decorative ears, with all manner of heads and bodies emerging, sitting, crouching or standing within the formline U shape ear.

North coast art style

- head and hands within the formline U shape ear

North coast art style

- mountain goat with ear placed behind the horn on top of the head

West coast art style

- mythological mouse with large rounded ear covering the entire head top

North coast art style

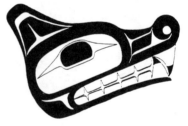

- wolf with typical elongated U shape, tapered and sloped ear with a red filler unit

Mid coast art style

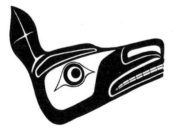

- doe deer with semi-realistic, upright, pointed ears with internal negative slits

North coast art style

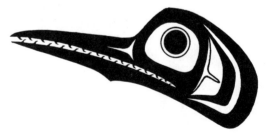

- mosquito with a formline U shape ear placed at the rear/top of the head, containing a red filler split U shape

Examples of Head Components - Ears

Examples of Bird Ears - Feathers/Plumes

All northwest coast art styles have birds with external ears. The position and design styles of these ears are often the determining factor in the bird's identification. Below are four identical mid coast style bird heads, but ear, plume, and feather additions help identify them as different creatures.

Mid coast art style eagle

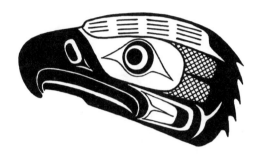

- has no external ears
- has pointed (wet) feathers which hang from the back of its head
- natural eagles and ravens have head feathers which can stand up, out and appear separated

Mid coast art style eagle

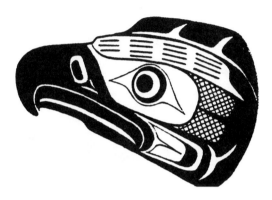

- has an elongated modified U shaped ear with two internal slits, which lies along the top of its head
- north coast art style eagles and ravens often have U shaped ears

Mid coast art style thunderbird

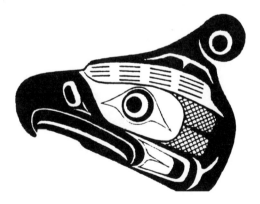

- usually has rather large plume/ears terminating at the top in a spiral design unit
- spiral design unit indicates it is a mythological/ supernatural bird that has exceptional hearing

Mid coast art style mythological Kulus

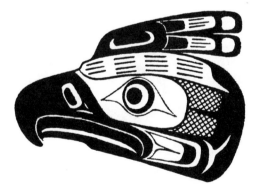

- this relative of the thunderbird, usually has the distinguishing characteristic of straight crest style head feathers or plume ears with no curved or spiral circle ends

Learning by Designing: Pacific Northwest Coast Native Indian Art, Volume 1

Examples of Head Components - Ears

Examples of Bird Ears - Feathers/Plumes continued

Examples of head feathers, plumes, and ears on birds follow.

North coast art style osprey - fish hawk	Mid coast art style osprey - fish hawk 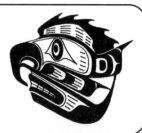
North coast art style raven 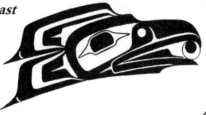	Mid coast art style kingfisher 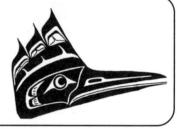
Mid coast art style jay 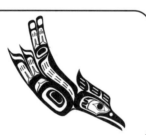	South coast contemporary art style blue heron 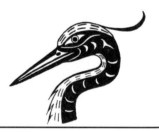
North coast art style owl 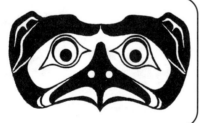	North coast art style raven 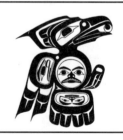
West coast art style crow 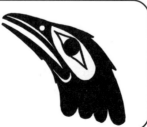	Mid coast contemporary art style eagle 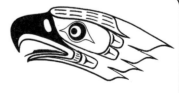

Examples of Mythological Ears - Plumes/Horns

Examples of head feathers, plumes, ears and horns on mythological/supernatural creatures follow.

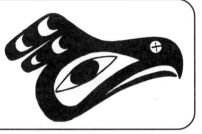
West coast art style thunderbird

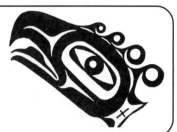
West coast art style thunderbird

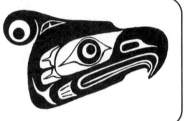
Mid coast art style thunderbird

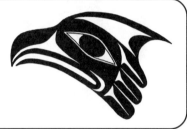
South coast art style thunderbird

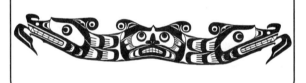
Mid coast art style Sisiutl

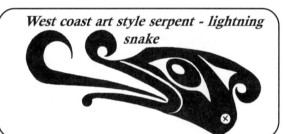
West coast art style serpent - lightning snake

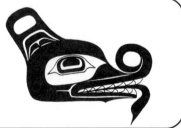
North coast art style Wasgo

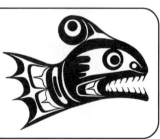
Mid coast art style supernatural fish

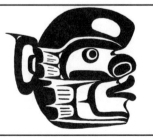
Mid coast art style Sea Dzunukwa

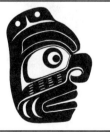
Mid coast art style Bookwus

Examples of Head Components - Eyebrows

Head Components - Eyebrows

Eyebrows appear in all coastal art styles, on most creatures and including inanimate objects. Eyebrows are drawn on human heads and on most creatures that have fur or hair. Amphibians, sea mammals and fish are often drawn with no eyebrows.

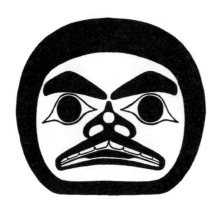

North coast art style face within a formline ovoid head with typical eyebrow shape

Curved or angular eyebrows are drawn within or above eye socket areas. Eyebrows are usually not found on north coast art style faces that have defined formline ovoid eye sockets. Eyebrows may be drawn as solid units, negative design units in a formline, cross-hatched, dashed or they are relieved of mass by including internal negative areas such as ovoids or U shapes. The west and mid coast styles show the most diversity in composition and shape, with ends that may be abruptly curved and drawn to points. The south coast art style has eyebrows that are soflty curved and often joined at the centre of the face.

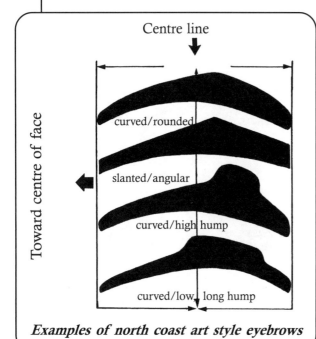

Examples of north coast art style eyebrows

Eyebrows are usually curved on the lower edge and can follow the curvature of the top of the eye orbit. The curvature, thickness and ends of eyebrows vary a great deal. Eyebrows usually have the widest area at the centre or rear of centre. From the widest point in the eyebrow, the top lines taper toward the ends, with the narrowest end being in the centre part of the face. Tapered top eyebrow lines may be curved or near straight. Humps on the eyebrow can represent the ears of a creature. North coast art style eyebrow ends may be curved, rounded or straight.

Examples of Eyebrows

Eyebrows can contribute to the "character" of a creature. North coast art style faces can have animal ears defined by adding a hump (with or without internal negative areas) to the top of the eyebrow, usually directly above the eyeball.

North coast art style dogfish
- cross-hatched eyebrows

South coast art style human
- negative, joined eyebrows

Mid coast art style sun
- eyebrows with humps and negative split trigons

Mid coast art style osprey
- negative space eyebrows with bundled dashing

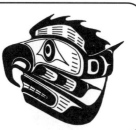

West coast art style human
- negative space eyebrows

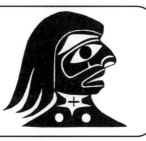

Mid coast art style sea otter
- negative area which surrounds eyebrows is scalloped at the top of the eyebrow
- represents wet hair

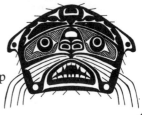

West/mid coast art style

face centre →

- angular eyebrow with pointed ends

North/mid coast art style
- humped eyebrow with internal negative ovoid

face centre ←

Mid coast art style

face centre →

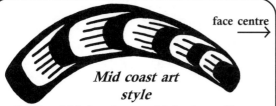

- feathered bird eyebrow with horizontally stacked negative, internal dashed U shapes

Contemporary mid/south coast art style

face centre →

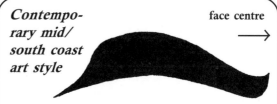

- soft curved eyebrow, pointed ends with medial end curved up

Examples of Head Components - Eyes

Head Components - Eyes

As the viewer's focal point, eyes are often the most important design feature in a head. Eye structure, shape and position in the eye orbit vary within the coastal art styles but all groups paint the eye and eyelid black.

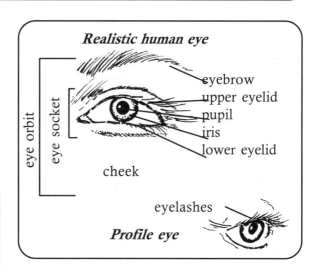

North coast art style eyeball with eyelid line

- typical north coast art style eyeball with bilaterally symmetrical eyelid line
- eyelid line lengths are usually of equal distance from the eyeball regardless of eyeball shape

The pictured classic north coast art style ovoid eyeball shows an ovoid eyeball, and a fineline eyelid which is symmetrical from the centre line. The eyelid line is sometimes longer at the back end toward the ear in mid coast art style. There is a larger space between the eyeball and the eyelid line at the bottom than at the top. Front and rear pointed ends of the eyelid are usually equidistant from the lower ovoid bottom or bottom line of the eye orbit. Eyeballs and eyelid lines are usually painted black.

Bird and fish eyes are usually circles. Eyes with no eyelids are often found in fish and whales. Mythological creatures in north coast art style usually have ovoid eyeballs.

Examples of Eyes

Most eye designs are based on a circular, ovoid or oval eyeball. Size, shape, and interior design of the eyeball, as well as thickness, shape and length of the eyelid lines all provide variety in eye designs.

Mid coast art style ovoid eyeball

This non-concentric ovoid eyeball has a floating solid ovoid pupil. The top eyelid line has a slight concave curve over its length. The lower eyelid lines slope up slightly to the pointed ends. The pointed eyelid ends are slightly below the horizontal centre line of the eyeball.

West coast art style circle eyeball

This non-concentric circular eyeball has a pupil floating in the lower portion of the negative space of the eyeball. This placement makes the eye appear to be looking down. All eyelid lines are concave and meet at pointed ends which are level with the centre of the eyeball.

South coast art style oval eyeball

This solid black oval eyeball has the eyelids attached to it. The top eyelid is convex while the bottom eyelid is concave. The bottom lid curves up and in.

Examples of Eyes continued

Eyeballs can be painted solid black or have internal negative relieving design units. The pupil of the eyeball can be attached to the eyeball formline or it can float and be positioned anywhere within the eyeball's negative space. Most eyeballs and pupils have non-concentric design characteristics.

Mid coast art style circular eyeball

In this mid coast style design, there may be a red line inside the black eyelid line, particularly in supernatural birds. The eyeball is usually placed in a flat bottomed eye orbit. Eyelid lengths are usually equal but in some designs the eyelid line is shorter in front of the eyeball and longer toward the ear. The pupil usually faces forward in a profile.

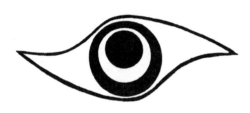

West coast art style circular eyeball

This eyeball has a typical west coast eyelid line. The line changes direction over the centre of the eyeball. The eyelid line is the same length on both sides of the eyeball. The pupil may be placed non-concentrically in the eyeball, either up, down or forward.

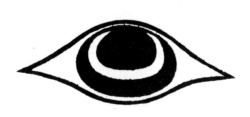

Round bottomed ovoid eyeball

This eye has a round bottomed ovoid eyeball. It has similarities to both north and south coast art styles. The eyelid line is symmetrical. The pupil is joined to the top of the eyeball formline. The eyeball is relieved in mass and the pupil is defined by using a negative crescent.

Examples of Eyes continued

Eyeballs, regardless of their shape, frequently contain elaborate designs. Bentwood box and chest designs often use salmon head ovoids or circles, or large double ovoid human heads as eyes. Eyeballs can take the form of creatures exiting the eye socket or have tears streaming from their lower lids.

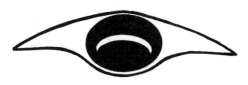

South coast art style oval eyeball

The eyeball in this south coast art style design is oval. The eyeball may touch the eyelid line. The top eyelid line is the continuous arc of a circle. The solid colour of the eyeball is relieved by a centred negative crescent.

West coast art style circular eyeball

The circular eyeball in this west coast art style eye is placed within an eye orbit that is a positive (black) geometric ovoid. Negative space within the ovoid forms the top and bottom arc of the eyelid line. The solid weight of the eyeball is relieved by a typical west coast negative quadron "star."

North coast art style circular eyeball

Many coast art styles use eyeballs without the familiar lens-shaped eyelids. North coast art style designs often use circle or ovoid eyeballs with a tight encircling fineline, symbolic of eyelids. Here, the pupil overlaps the eyeball formline at the top and is delineated by a large negative crescent.

Examples of Head Components - Eyes

Examples of Eyes continued

Eyes can be placed in various shaped and textured eye orbits. Eyelid lengths are usually equal but in some mid and west coast art style designs the eyelid line is shorter in front toward the nose and longer to the rear of the eyeball toward the ear.

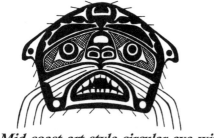

Mid coast art style circular eye with crosshatched eye orbit

In this sea otter head design the eyeball is placed in a flat bottomed eye orbit. Crosshatching, surrounded by an outer and inner perimeter fineline, permits design variation in the eye orbit. Eye orbits can also be *bundle dashed*, partially hatched, finelined, or fineline dashed around their perimeter.

West coast art style eyeballs with eyelid lines that have reverse arcs

These eyeballs, one circular, the other oval, have typical west coast art style *reverse swing* eyelid lines. The eyelid lines reverse arc at the vertical centre of the eyeball. In the top shark eyeball, the opposite point swings up near the nose; the point swings down near the ear. The lower eyeball has eyelids which reverse the upper design. Both eyeballs are attached to the eyelid line but can also be drawn as floating unattached.

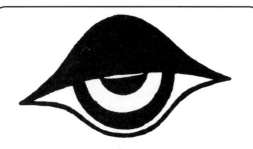

Mid coast art style eyeball with heavy top eyelid line

This contemporary mid coast art style eye design has a heavy top eyelid line. This could express the feeling of sleepiness, mystery, sensuality, winking or blinking.

Examples of Eyes continued

Many artists use negative relieving shapes to reduce the weight of black and any other solid colour. These relieving shapes can be crescents, trigons, quadrons, ovoids, or circles. The pupil can be attached or not attached to the eyeball line, but the eyeball line closest to the pupil is always the thinnest. The pupil can be placed to show where the creature is looking. Rarely does an eyeball not have a surrounding fineline eyelid.

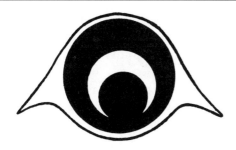

Mid coast art style circular eye with solid pupil

In this eye design, the pupil is not at the centre of the eyeball. The pupil is attached to outer circle at a point to show that the creature is looking down. The pupil is delineated by a negative crescent.

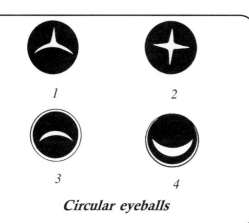

Circular eyeballs

1. Eyeball has relieving trigon
2. Eyeball has relieving quadron
3. Eyeball has crescent that indicates weeping
4. Eyeball has crescent that indicates sleeping

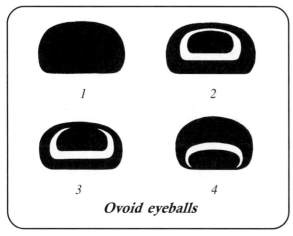

Ovoid eyeballs

1. Solid ovoid eyeball
2. Mid coast art style eyeball with floating solid ovoid pupil and resultant negative ovoid space
3. Eyeball with ovoid pupil joined at top with crescent relieving shape
4. West coast art style ovoid eyeball with pupil attached to the ovoid's bottom line suggests looking down

Examples of Head Components - Eyes

Examples of Eyes continued

Below are continuing examples of ovoid and oval eyeball shapes with several different internal relieving shapes. Vertical, oval eyeballs are found in shark and dogfish heads. Horizontal oval eyeballs are usually found in the south coast art style.

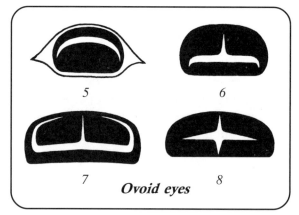
Ovoid eyes

5. North or mid coast art style ovoid eyeball with negative relieving crescent and short eyelid line
6. North or mid-coast art style solid ovoid eyeball with negative relieving trigon
7. North coast art style ovoid eyeball with a negative crescent and vertical medial line
8. West coast art style solid ovoid eyeball with relieving quadron shape

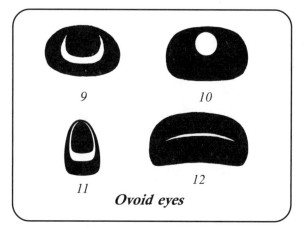
Ovoid eyes

9. South coast art style solid ovoid eyeball with deep crescent relieving shape
10. Mid coast art style convex bottom solid ovoid eyeball with relieving circle
11. North coast art style vertical, round-bottom ovoid eyeball with internal negative crescent
12. North and mid coast art style concave-bottom ovoid eyeball with horizontal crescent relieving slit

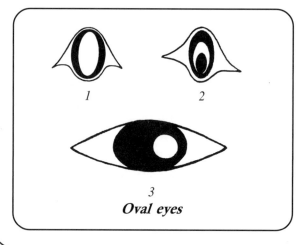
Oval eyes

1. North coast art style oval eyeball with eyelid line - has an oval negative interior representing the realistic oval eye of the dogfish
2. Mid coast art style, vertical oval dogfish eyeball with oval pupil
3. Contemporary south coast art style solid oval eyeball with relieving forward circle - both upper and lower eyelid lines are convex

Examples of Head Components - Eyes

Circular Eye Variations Within the Same Design

Within the identical shaped north coast art style eagle heads below, the use of various sizes of eyeballs and a variety of eyelid shapes creates variation in each design's overall appearance. Examples 1, 2, and 3 use different sized eyeballs, while examples 4, 5, 6, and 7 use the same size circular eyeball but varied eyelid lines.

North coast art style eagle head

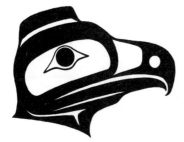
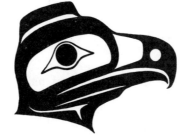
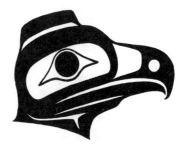

1. Small eyeball *2. Medium eyeball* *3. Large eyeball*

Variations in an eagle head using different sizes of identical shaped round eyeball and eyelid

The north coast art style eagle heads below have the same size circular eyeballs situated in the same position in identical eye orbit designs. Design variation are the result of different eyelid sizes, shapes, and lengths. Eyes are always in the upper area of an eye orbit.

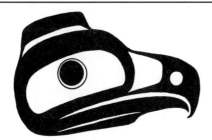
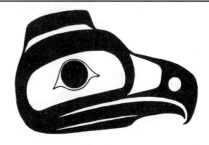

4. Circular eyelid design *5. Short length eyelid design*

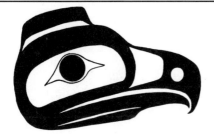
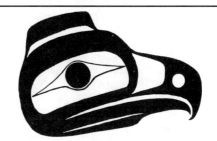

6. Medium length eyelid design *7. Long eyelid design across entire eye orbit*

Learning by Designing: Pacific Northwest Coast Native Indian Art, Volume 1

Examples of Head Components - Eyes

Variations in Eyes

Variations on these next two pages can be applied to any eye, eyelid, or eye orbit design. All the ovoid eye orbits are taken from the north coast art style wolf head design.

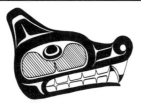
North coast art style wolf

Convex bottom ovoid eyeball with simulated lower eyelid fineline which extends around the eye orbit. The area within this fineline is hatched with angled parallel lines.

Mid coast art style

This flat bottom ovoid eyeball with medium length eyelid line is surrounded by a fineline/solid split U design complex. Eyelid ends are equidistant from bottom formline. Eye orbit fineline and U designs are often green, red or black.

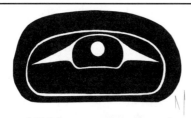
Mid/west coast art style

This concave bottom ovoid eyeball has an internal relieving negative circle. Elongated negative eyelid shape results from painting the eye orbit area. Mid coast style eye orbits are usually painted green, blue, yellow, gray, or brown.

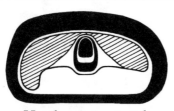
North coast art style

This flat bottom, vertically oriented ovoid eyeball is surrounded by a fineline eyelid line continuing partially around the eye orbit. The eye orbit is partially textured with finelines. Finelines are usually black, red or blue.

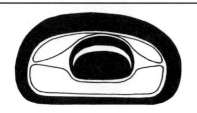
Mid/north coast art style

This slightly convex bottom ovoid eyeball has a negative relieving crescent. The eyelid line is two separate units of red, blue, or black fineline.

Examples of Head Components - Eyes

Variations in Eyes

Within the identical formline ovoid shapes below are variations in eyeball designs. These variations can be applied to any eye, eyelid, or eye orbit design.

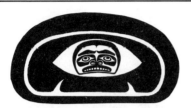
West coast art style

This is a concave bottom ovoid eyeball containing a human face with bilaterally symmetrical convex eyelid lines enclosed in a painted eye orbit. This orbit does not touch the primary formline and has two slits in the bottom. The painted eye orbit could be blue or green.

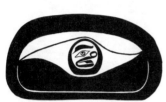
South and west coast art style

This is a tall ovoid eyeball with a formline that is thin at the top and thicker at the bottom. A human face is enclosed. The eyelid ends are reversed in curve. The lower eyelid is defined by the painted colour; the top eyelid line is a black fineline.

North and mid coast art style

This is an elongated, slightly concave bottom ovoid eyeball with an internal negative quadron and fineline eyelid line. The eye orbit is textured with crosshatching which extends from eyelid line to outer perimeter fineline. Finelines are usually black.

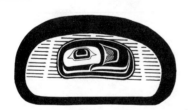
North and mid coast art style

This salmon head ovoid eyeball has a surrounding fineline. The eye orbit is textured upwards from the eyeball bottom area with stacked parallel bundled dashing. Dashing can be red or black.

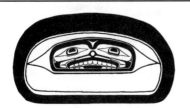
North and mid coast art style

This ovoid contains an eyeball which is a stylized human head surrounded by a fineline eyelid line. The eye orbit has a perimeter fineline which can be black, blue/green or red.

Learning by Designing: Pacific Northwest Coast Native Indian Art, Volume 1

Examples of Head Components - Eyes

Variations in Eyelid Design

All four coastal art styles use variations in fineline and paint to form eyelid lines and eye orbit delineations. The following variations can apply to any design regardless of shape, colour, size of eye orbit or enclosed eyeball. Eye orbit colours vary depending on the art style and range from traditional colours like blue/green to many other colours.

North coast art style bear

- painted eye orbit
- eye orbit paint extends to and touches black formline
- negative space defines eyelid area

North coast art style bear

- painted eye orbit
- negative fineline surrounds eye orbit; eye orbit paint does **not** touch black formline
- negative space defines eyelid area

North coast art style bear

- painted eye orbit
- eye orbit paint extends to and touches black formline
- negative space defines eyelid area
- eyelid area is surrounded by a black fineline that touches the eye orbit paint

North coast art style bear

- negative fineline surrounds eye orbit; eye orbit paint does **not** touch black formline
- negative space defines eyelid area
- eyelid area is surrounded by a black fineline that does **not** touch the eye orbit paint
- negative fineline surrounds black eyelid line

Examples of Head Components - Eyes

Comparing Eyes Across Art Styles

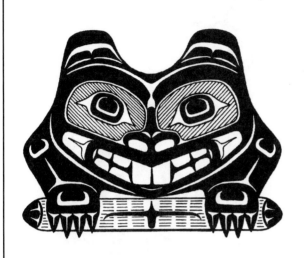

Beaver head in north coast art style design

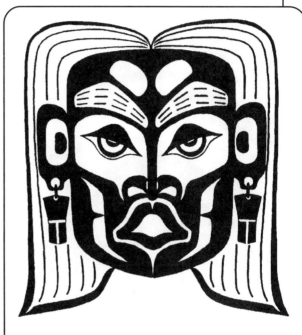

Dzunukwa (Geekumhl) head in mid coast art style design

The eyes in the beaver head above follow north coast art style formal rules and principles of structure. The ovoid eyeball design is black and bilaterally symmetrical. The eyeball pupils are joined to the upper formline ovoid of the eyes. Negative crescents delineate the pupils.

There is a crosshatched eye orbit, often green in colour, enclosed by a perimeter fineline. Negative spaces are found between the eye orbit and the head formline of eyebrow, cheeks, lips and nose.

The eyes in this Dzunukwa have a heavy upper eyelid and show drooping, half-closed lids. The eyelid lines are medium length and symmetrical in this design but can be asymmetrical, longer toward the ear than the nose.

These typical mid coast art style eye orbits are a modified ovoid shape. They appear white because this paper is white. The negative space of the eye orbits may be left as the background colour of the medium that is being used for the design, be it wood, paper or cloth. Mid coast art style eye orbits can also be crosshatched, perimeter line dashed, or painted a solid colour.

Examples of Head Components - Eyes

Comparing Eyes Across Art Styles

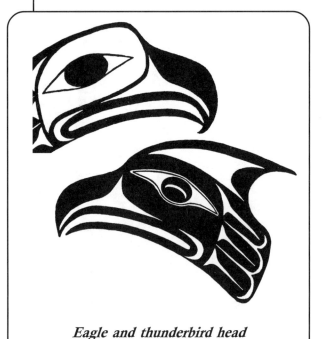

Eagle and thunderbird head in south coast art style

Human and salmon head in west coast art style

In the top south coast art style eagle design, the eyeball is a solid oval. Eyelid lines are medium in length and joined to the eyeball. The lines are equal distances from the centre of the eyeball.

In the bottom design of a thunderbird, the oval eyeball contains a crescent relieving shape. There is a negative space between the eyeball and the head formline delineating eyelid lines.

South coast art style eyeballs are traditionally oval or round. Eyelids can touch or not touch the eyeball.

In the profiled human head design, the normally circular eyeball is drawn in perspective, resulting in a vertical oval with a centre negative oval pupil. The centre negative oval is placed forward in the eye indicating that the human is looking forward. The eyelid line is longer toward the ears and shorter toward the nose. The painted eye orbit has a negative space that delineates the eyelid lines. The eye orbit joins the nose and flows around as the head formline.

The eye orbit shape of the salmon head is a negative ovoid. The eyeball is oval with a solid circular pupil. The eyeball line is heavy above and fine below. There is no eyelid line in many fish designs.

Head Components - Foreheads

Across most coastal art groups, decoration appears in the forehead area above the eyebrows. Many designs are bilaterally symmetrical. Painted forehead designs such as spines, feathers, beaks, and fins may represent the crest figure of the human face on which they appear. Central forehead ovoids and circle designs often represent an X-ray concept of the brain. Many design units such as U and S shapes, slits and dashing are simply decorative to fill an otherwise blank space.

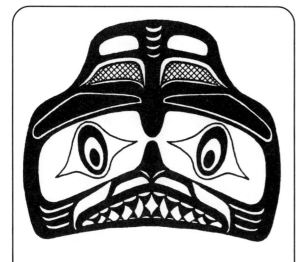

Mid coast art style dogfish

The high tapering forehead of the dogfish or shark make it one of the easiest creatures to identify in the iconography of Northwest Coast art. The dogfish head is viewed from below with the snout up. The mouth and snout nostrils are in a semi-naturalistic position but the artist has transposed the eyes and facial features. In this design, the forehead has two negative ovoid units representing the nostrils between which are four negative gill slit crescents. These gill slits also appear in the lower cheek area. The crosshatched U shaped units in the forehead are decorative.

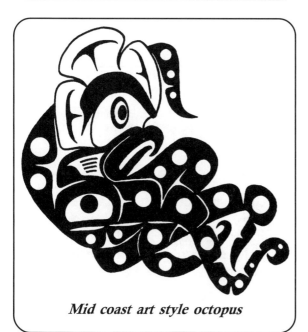

Mid coast art style octopus

The octopus has a large area classified as forehead on its soft bulbous shaped head. Northwest Coast First Nations artists often draw ovoid shaped brains, ear shapes and internal negative design units and slits in the forehead. Here the forehead, like the head, is drawn as a fineline which defines curved flesh blocks with internal positive curved trigons. Human foreheads displaying the octopus as a crest figure will simply have rows of tapering circles representing the octopus arm with attached suction discs.

Examples of Head Components - Foreheads

Head Components - Foreheads continued

Mid coast art style sea otter

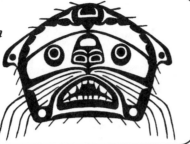

On the forehead of this sea otter, a formline ovoid with an attached inner ovoid represents an X-ray capability to depict the internal brains of the creature.

Mid coast art style Dzunukwa

Dzunukwa's two forehead depressions may portray wounds to the skull that she has suffered in the past.

Mid coast art style human

This circular mid coast art style human head has a large formline forehead area which is relieved of mass by having eyebrows with U shaped humps and three vertical negative slits in the black forehead mass.

West coast art style humans

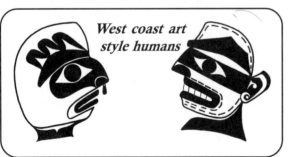

The two west coast art style humans exhibit typical high foreheads, usually sloping to the rear with slightly convex or concave fronts. The feather designs and dashing above the eyebrows help decorate the foreheads.

West coast art style killer whale

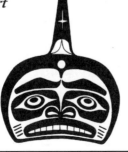

In many Northwest Coast face designs, the forehead of a whale or porpoise has a blow hole design unit. A negative circle, ovoid or human face with pursed lips (blowing) represents the single, medial blow hole. A large dorsal fin and blow hole in a design indicate a killer whale.

Head Components - Gills

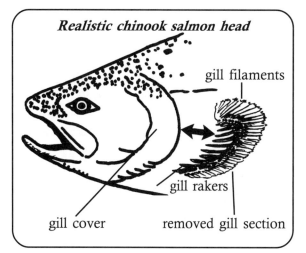

Realistic chinook salmon head

gill filaments

gill rakers

gill cover

removed gill section

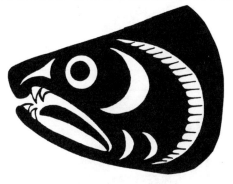

South coast art style dog salmon X-ray design showing gill filaments

All fish have gills and most Northwest Coast fish designs have some type of stylized gill. Fish such as salmon, cod, sculpin, and halibut often have an elongated crescent shape situated at the rear of the head representing the gill cover. Some X-ray designs show gill rakers and filaments. Many fish and some marine animals have a horizontal U shape or series of crescents at the sides or rear of the mouth. These positive or negative design units may be cheek designs but often represent gills. Mid coast art style may use a pointed U shape gill design in the area at the rear or corners of the mouth. Sharks, dogfish and skates all have gill slits - usually drawn as crescents. Some marine mammals such as whales, porpoises, seals, sea lions and otters often have gill-like designs, possibly in recognition of their ability to swim underwater. Mythological undersea people/animals and sea monsters also often incorporate gill-like designs.

Examples of Head Components - Gills

Comparing Gills Across Art Styles

Designs from all areas include U shape design complexes, simple vertical crescents, negative or positive shapes, with or without parallel internal dashing to represent gills. North coast art style dogfish head designs often contain two sets of gill slits, those at the corners of the mouth and the others unnaturally situated in the forehead (representing the snout if viewed from below).

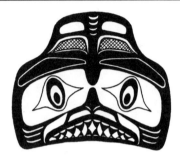

North coast art style dogfish with gill slits on forehead and cheeks

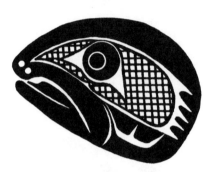

Mid coast art style salmon head

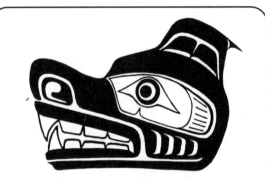

Mid coast art style mythological sea bear

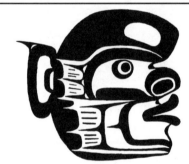

Mid coast art style mythological sea Dzunukwa

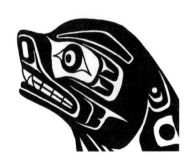

Mid coast art style sea lion

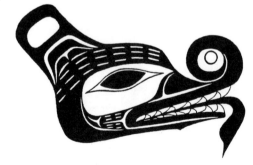

North coast art style mythological sea monster

Head Components - Hats, Headbands, Hair

Heads can be embellished in a multitude of ways using hats, headbands, and hair.

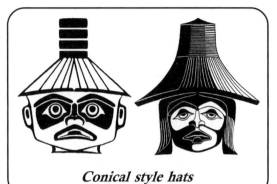

Conical style hats

Cone shaped hats, woven from cedar bark, spruce roots or sea grass were common to most cultural groups on the northwest coast. Many hats were painted with a design and decorated with fur, feathers or woven cylinders called *potlatch rings*.

Mid coast art style man with head ring or band

Ceremonial cedar bark head rings were worn by most Northwest Coast peoples. Rings were usually made of split cedar bark that was woven or braided and often decorated with ermine fur or pieces of abalone shell.

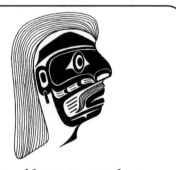

Hair on mid coast art style man

Hair is usually portrayed in semi-realistic fashion in mid coast or west coast art style designs. Mid coast art style hair is often drawn as simple parallel fine lines or blocks of wider lines while west coast style hair is usually a solid black unit.

Examples of Head Components - Hats, Headbands, Hair

Head Components - Human Hair

Human hair is often found on west coast and mid coast art style humans, but seldom, if ever, on south or north coast style designs. Dry hair is drawn as a series of parallel finelines whereas wet or matted hair is drawn in thick lines with pointed ends.

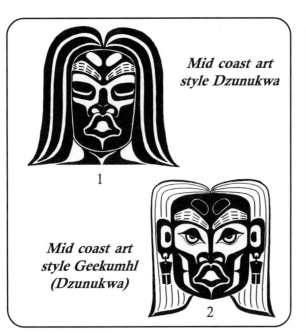

Mid coast art style Dzunukwa 1

Mid coast art style Geekumhl (Dzunukwa) 2

The hair of the mythological giantess, Dzunukwa 1 is drawn as partially covering her face. Regular or reversed stylized S shaped formline design units are separated by regular or reversed S shaped negative areas to show strands of hair. Her hairy eyebrows are drawn as negative areas with stacked fineline dashing.

Geekumhl (Dzunukwa 2) has hair which hangs behind and exposes her ears. The stylized hair is drawn using finelines only. Hairy eyebrows are again represented by fineline dashing.

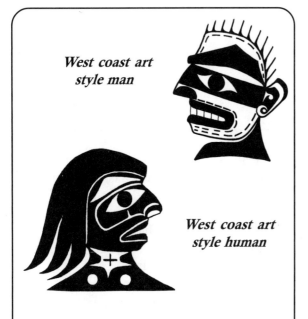

West coast art style man

West coast art style human

The west coast man has spike-like hair strands that stand straight up from the top of his head.

The west coast human is drawn here with hair that is a solid black unit with the ends separated in pointed strands, simulating wet hair. West coast artists often draw hair incorporating random use of elongated negative areas in the black hair mass, while others terminate the hair in sweeping curves.

Head Components - Moustaches, Fur

Mid coast art style man with a moustache

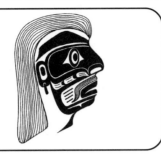

The moustache of this profiled head is drawn on the upper lip and is formed of parallel finelines which taper and join at the end.

West coast art style man with a moustache

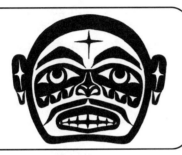

The moustache of this west coast art style man is drawn as a solid black line above the top lip which tapers at the ends as well as in the middle.

North coast art style wolf

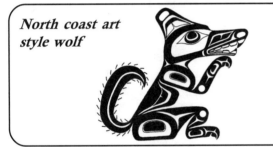

Fur or hair on the wolf's tail is outside the primary formline. Finelines are at natural angles to the tail and may or may not be attached to the primary formline.

Mid coast art style sea wolf

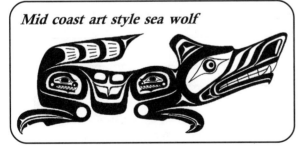

The hair of this mid coast art style sea wolf's tail is drawn as stacked finelines situated in negative U shapes inside the formline.

South coast art style wolf

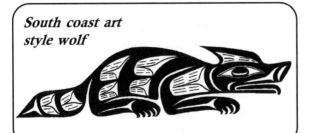

In this south coast art style wolf, the hair over the head and body is drawn as bundles of finelines situated in negative areas inside the primary formline.

Examples of Head Components - Moustaches, Fur, Whiskers, Beards

Head Components - Whiskers, Beards

Heads of north coast, mid coast and west coast style creatures may be drawn with the faces having whiskers, beards, fur or hair. These features can be attached or separated on the primary formline (goat), internal within the formline (mouse), or internal, external and overlapping the primary formline (sea otter).

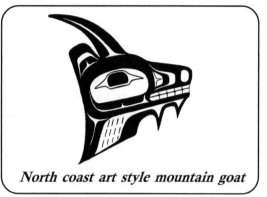

North coast art style mountain goat

This mountain goat has a goatee beard formed of two pointed formline design units. The fineline dashing in the throat area represents the body hair or wool which was used in weaving.

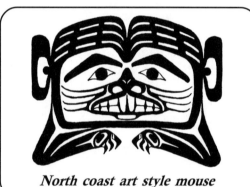

North coast art style mouse

North coast art style mythological mouse woman, with the labret in the lower lip indicating that she is female, is drawn here in typical mouse pose. Her tiny feet are drawn up under the chin, fineline whiskers curve up from either side of the cheeks, while her black hair is dashed with negative lines.

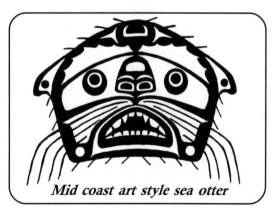

Mid coast art style sea otter

Finelines angled to represent fur surround the formline head of the sea otter. The eyebrow tops have scalloped edges simulating wet matted fur. Fineline whiskers droop and extend out and down from the cheek areas on either side of the mouth.

Learning by Designing: Pacific Northwest Coast Native Indian Art, Volume 1

Head Components - Mouths

In all coastal art styles, animals and creatures are drawn with a prominent mouth. The design and shape of the mouth and its parts can help in identifying the creature. The lips are usually depicted parted, exposing the teeth and often a tongue. Non-human teeth have a variety of shapes. The tongue can be drawn between the teeth and also extending out beyond the lips. Teeth may be shown on both or only one jaw.

Profiled snout of a timber wolf skull

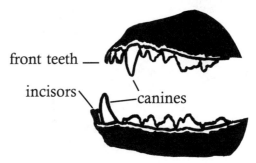

North coast art style wolf nose and mouth design units

- mouth with front canines and rear molars

- mouth includes lips, two teeth types and tongue

North coast art style frog

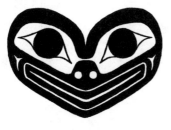

- wide, toothless mouth, with a tongue that often extends out over the bottom lip

Land and sea animals, fish and many mythological creatures are drawn with exaggerated features. Lips can be thick or thin, narrow or wide. Tongues are often wide and curled. Frogs, bears, wolves and some mythological beings have tongues which extend well out of the mouth. Teeth range in design complexity from single parallel, slanted finelines to pointed, curved, elongated, cone, rectangular, triangular or rounded. In some designs, the mouth may contain two or more different shapes of teeth. Teeth are usually a negative shape outlined by a fineline, or may be partially or completely filled like a formline.

Examples of Head Components - Mouths

Examples of the Human Mouth Area

The mouth, composed of lips, tongue, and teeth is usually shown in a semi-realistic manner in most coastal art styles. The human mouth, face-on or profiled, can exhibit just lips or show teeth, tongue or a lower lip labret (signifying female). Some designs show facial expression or convey mood and feeling. Variations in the same human head design are shown below.

- squared teeth result from the use of straight finelines
- teeth are drawn clenched
- top lip is joined at the nose

- semi-realistic squared teeth with rounded bottom corners
- space between the top and lower teeth
- top lip and nose are drawn as one (red) design unit

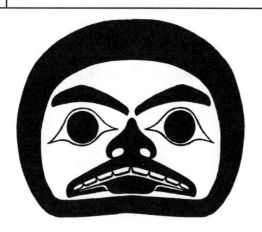

- moderately heavy, outlined upper teeth with projecting tongue below
- tongue covers the lower teeth and overhangs the central area of the lower lip

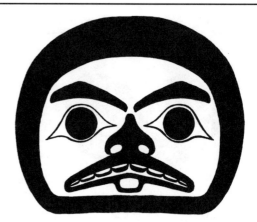

- nose, lip, upper teeth and labret design unit all in one
- teeth are defined by heavy curved lines
- negative ovoid shape in the lower lip represents a labret, a decorative lower lip plug (stone, bone, ivory) used by women

Examples of the Human Mouth Area continued

Little expression was traditionally seen in most northwest coast First Nations design styles. Today's artists, however, are using the eyes and mouth as a means of expressing a feeling or a mood. Human mouths, whether profiled or face-on, stylized or semi-realistic, attached to the nose or not, with or without teeth or tongue, can portray a great range of expression.

Profiled head demonstrating large pursed lips

Face-on head with pursed lips

Mythological Dzunukwa pursed lips

These are probably the most distinctive lips in all flat design styles. Dzunukwa is a sleepy, slovenly giantess who utters through her pursed lips the sound Hu! Hu! Hu! She is constantly hungry and seeks children to eat.

Grinning mouth

- slightly curved upturned mouth showing lower and upper outlined fine line teeth

Laughing, singing, yelling mouth

- open mouth with only the top heavy fineline teeth showing
- tongue is shown inside the mouth above the lower lip
- a fineline slit breaks the tongue mass

Talking, singing, crying mouth

- partially opened mouth with both upper and lower teeth separated and outlined against the black mouth cavity

West coast art style profiled human head

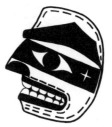

- profiled upper and lower teeth

Examples of Head Components - Mouths

Examples of Bear Mouths

Human and animal designs differ in teeth structure. Human mouths rarely contain canines. The bear heads below show only some of the styles of teeth found in animals and creatures in the First Nations coastal art styles. Incisors are rarely drawn in profiled heads. Top jaw canines usually overlap those on the lower jaw. Tongues may be drawn as finelines, as wide tapering lines between the teeth or appear in front of the teeth, curving and tapering up or down.

West coast art style bear

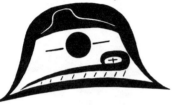

- highly stylized bear head drawn within a formline U shape
- teeth are represented by slanted, parallel finelines below the top lip

North coast art style bear

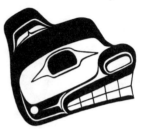

- clenched teeth are negative rectangular areas outlined by straight finelines

North coast art style bear

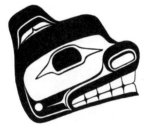

- negative teeth, defined by straight and curved finelines

North coast art style bear

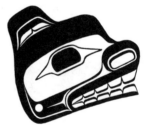

- open jaws show parted teeth outlined by curved lines which are thicker at the tooth cap

North coast art style bear

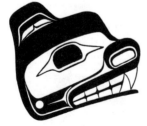

- two tooth types in the same mouth: the frontal canines (curved and conical) and rear molars (rectangular).

North coast art style bear

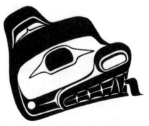

- three types of teeth: incisors, canines and rear molars
- tongue extends out between the front incisors.

Examples of Head Components - Mouths

Examples of Dogfish and Beaver Mouths

In most of the coastal art styles, two creatures have particularly distinctive teeth, the dogfish (shark) and the beaver. Dogfish teeth are conical and pointed. The beaver has two prominent, elongated incisors that originate from the top jaw and fill the front of the mouth cavity. The south coast art style uses few teeth in designs, but tongues are very common. Mouse designs usually have two long narrow front incisors.

North coast art style dogfish

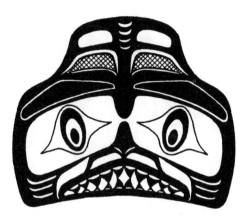

- black, curved, conical, pointed teeth
- mouth cavity is negative background colour

West coast art style dogfish

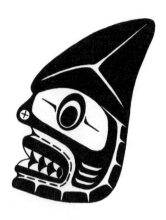

- profiled dogfish with high forehead (snout)
- typical back-slanted, pointed teeth in both jaws
- black mouth cavity defines teeth shape

North coast art style beaver

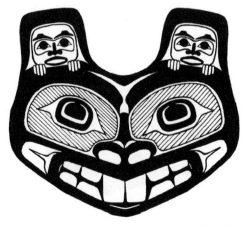

- the beaver in all coastal styles has a pair of elongated incisors
- the negative weight teeth are defined by the black mouth cavity

North coast art style beaver

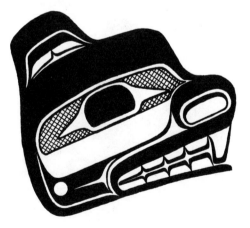

- in profile, large frontal incisor and small ear identify the beaver
- rear teeth are outlined by a heavy line.

Learning by Designing: Pacific Northwest Coast Native Indian Art, Volume 1

Examples of Head Components - Mouths

Examples of Bear and Killer Whale Mouths

In all coastal art styles, bears are usually drawn with the lips or jaws parted. Teeth are always shown, and two pairs of canines are often seen in face-on designs. U shaped tongues are characteristic of most bear mouths. Killer whales, like bears, are usually drawn with teeth. Teeth are often in both jaws but in some designs extend only from the top jaw. Mid and west coast art style killer whale designs frequently display teeth sets with frontal curved canines. North coast art style killer whale designs seldom have conical canine teeth. Traditional south coast designs seldom show teeth.

North coast art style bear

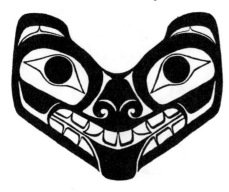

- front view of bear shows prominent projected tongue between the teeth
- tongue overlapping central lower incisors
- curved, short, pointed canines in top and bottom jaw
- teeth are outlined by fairly heavy line

North/mid coast art style bear

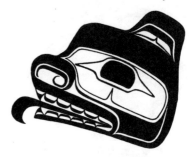

- profiled bear with a thick top lip
- jaws apart
- tongue lays between teeth, extends out and curves down in front
- small pointed canines are the front teeth on both jaws
- teeth are outlined with a heavy fineline that is thickest at the top

Mid coast art style Orca (killer whale)

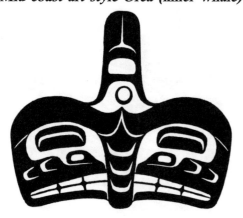

- front view killer whale head
- characteristic dorsal fin
- teeth present in both jaws
- snout in front of mouth
- central circular blow hole

West coast art style Orca (killer whale)

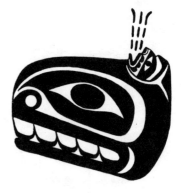

- profiled Orca head with a spouting human head blow hole
- rounded bottom teeth originate from the top jaw only
- teeth have a heavy line at the curved end

Examples of Head Components - Mouths

Comparing Mouths of Creatures Across Art Styles

- elongated, curled-up tongue extends from the mouth
- stylized teeth represented by slanted finelines

West coast art style mythological serpent

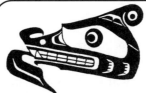

- tongue protrudes out and down from front canines
- back teeth are defined by finelines
- red lip design unit floats independently in the head

Mid coast art style mythological sisiutl serpent head

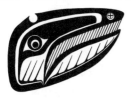

- baleen, in the form of parallel finelines, fills the mouth cavity
- lines in the lower head are throat grooves

West coast art style humpback (baleen) whale

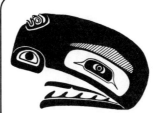

- sperm whale teeth are only in the lower jaw
- blow hole is in the form of a human head

Mid coast art style sperm whale

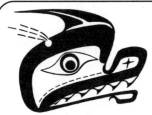

- sea mammals and monsters often have curved, pointed teeth in the top jaw only

West coast art style mythological sea monster

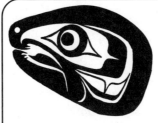

- spawning chum (dog) salmon males develop a "hooked nose" with canine-like teeth on the front of both jaws

Mid coast art style salmon

- stylized ovoid mouth has lips and pointed incisors and canines
- all teeth are outlined by heavy lines

Mid coast art style sea otter mouth

- spawning sockeye males develop a curved snout and a mouth with sharp teeth

Mid coast art style salmon mouth

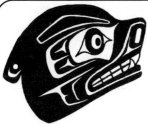

- typical set of teeth, consisting of front canines and squared rear teeth
- this design could be found in bear, wolf, Orca or sea otter

Mid coast art style sea lion

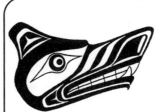

- mid coast art style wolf head designs all show teeth

Mid coast art style wolf

Examples of Head Components - Noses

Head Components - Noses

In all four coastal art styles, the shape and design of the nose, snout, or beak can help identify the creature. Profiled nose designs are often a combination of human and bird or animal features and can indicate transformation activity. All profiled noses, snouts and beaks usually have a recognizable nostril area. Face-on nose design, includes nose bridge, beak or snout with wing flares and nostrils.

Realistic Human Nose

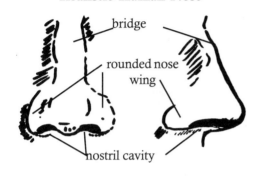

Variations in nose and nostril designs occur in all coastal art styles. Creatures as well as humans have noses which range from simple to very complex in design. Nostrils can be negative slits, crescents, ovoids or circles. Nose wings can be narrow or wide. Rounded, curved or spiral nose bridges are drawn low or high, narrow or wide. They may contain negative nose wing delineating crescents, or weight reducing design elements usually placed centrally on the lower bridge area. These are often a negative circle or ovoid.

Nostrils are routinely represented as negative areas. However, if the formline nose is black in colour, filler units (ovoids, circles, finelines) can appear in the nostril area. These units are commonly red.

Most noses in both face-on and profiled designs are joined in some manner to the top lip. Profiled faces drawn within a formline ovoid or U shape design unit have the nose and lip joined. Faces in complex designs, such as those found on boxes and chests, have a standard type nose which is usually drawn with a small bridge and wide formline nose wings which join the top lip.

Profiled west coast art style human

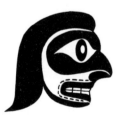

- semi-realistic nose and nostril joined to the top lip

Face-on north coast art style human female

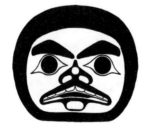

- stylized nose made up of a bridge, wings and ovoid nostrils
- nose and lips are drawn as one unit containing labret
- bridge has a negative relieving circle

Examples of Head Components - Noses

Comparing Noses Across Art Styles

The artistic freedom of northwest coast artists in creating nose designs is virtually limitless. In two or more coloured designs, the nose design unit is usually red, as are the lips. Face-on noses in the north coast art style, as well as other styles, are rarely drawn floating; nostril ends and lower bridge areas are regularly joined to the mouth area at the top lip.

Contemporary south coast art style

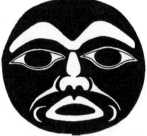

- negative nose defined by positive formline facial features

Contemporary south coast art style

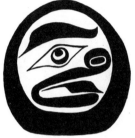

- ovoid nose is joined to the front lip
- nostril area has an internal ovoid

Mid coast art style

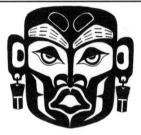

- straight nose bridge joined to the formline of the face at the top and bottom
- negative splits separate the bridge and the nose wings

Mid coast art style

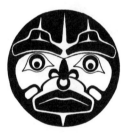

- nose ring in the septum of the nose

North coast art style

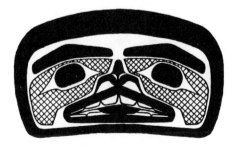

- small nose bridge on top of two flaring nose wings defined by two negative crescents

West coast art style

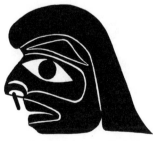

- wing flare and negative nostril cavity separated from the bridge by a negative crescent
- nose septum holds a dangling ring

Learning by Designing: Pacific Northwest Coast Native Indian Art, Volume 1

Examples of Head Components - Noses

Examples of Animal Snouts and Noses

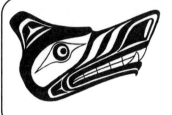

Mid coast art style wolf

- large nose area and elongated snout

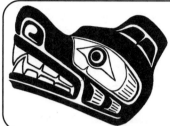

Mid coast art style bear

- short snout and curled nostril

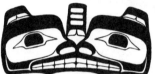

North coast art style bear

- rounded nostrils attached to top lip

- stylized nose bridge/snout with potlatch rings

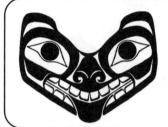

North coast art style grizzly bear

- spiral nostrils on wide-bridged nose

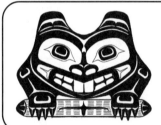

North coast art style beaver

- rounded nostrils on a narrow-bridged nose

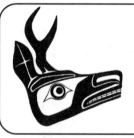

Mid coast art style deer

- large nose/nostril area on the top front of snout

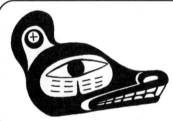

West coast art style mouse

- sloped long pointed snout with ovoid shaped nose/nostril

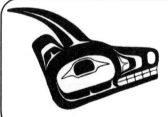

North coast art style goat

- medium snout with negative ovoid nostril

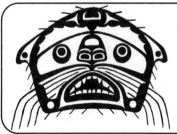

Mid coast art style sea otter

- wide-bridged snout and inner ovoid nostrils

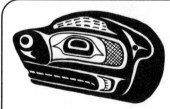

Mid coast art style land otter

- large nose area with nostril high on the snout

Learning by Designing: Pacific Northwest Coast Native Indian Art, Volume 1

Examples of Head Components - Noses

Whale Heads- Nose, Nostril, Blow Hole Designs

These mid coast profiled whale heads have different shaped foreheads, snouts, nostrils and blow holes. Whale heads are usually drawn with nostrils even though whales do not actually have nostrils, only a blow hole. The blow holes of dolphins and porpoises are usually placed on the top/rear area of the head. The blow hole identifies whales.

Mid coast art style whale head (Orca)

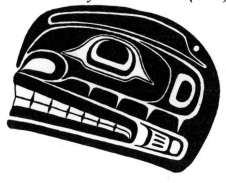

- overhanging snouted face has a negative closed circular blow hole
- flaring nose/nostril designs joined to the top lip
- ovoid nostril design is drawn separate from the top lip

Mid coast art style whale head (Orca)

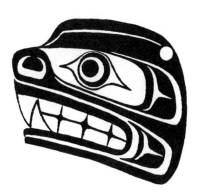

- head profile has a rear negative circular blow hole that is closed
- ovoid nostril design is drawn separate from the top lip

Mid coast art style whale head with baleen

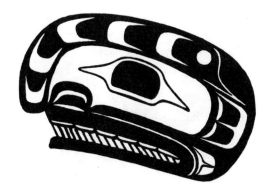

- rounded overhanging forehead/snout which extends down to the top lip
- heavy head formline is relieved by negative U shapes, closed blow hole and eyebrow end lines

Blow holes

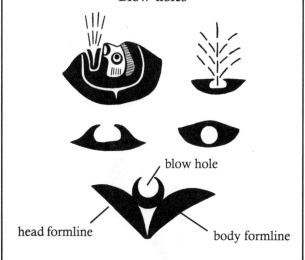

- can be drawn as a human head, as an ovoid or circle, in or above the head formline
- can be drawn open or closed
- an open blow hole often is seen spouting

Learning by Designing: Pacific Northwest Coast Native Indian Art, Volume 1

Examples of Head Components - Noses

Mythological Beings - Snout/Nose

Mythological creatures in the mid and west coast art styles are often drawn with elongated snouts whose end is thrust up and back into a curled, spiral-like nose. Nostril cavities are usually negative but can have internal design units like ovoids and circles. Oversized, spiral, curved noses are regularly seen in north and south coast art styles. On these mythological beings, the nose is on the top end of the snout. Many nose designs in all styles are joined to the top lip line.

Mid coast art style Sisiutl

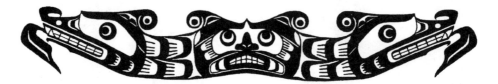

- Sisiutl is a Kwakwaka'wakw mythological creature, part human (centre head) and part sea serpent
- serpents usually have scaled bodies made of horizontal, dashed U shapes, large snouts and tongues, curled nostrils and spiral ended head horns

North coast art style Wasgo

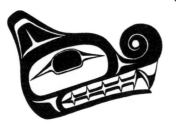

- mythological sea monster, part wolf/part whale
- drawn here with a large spiral nose

West coast art style serpent

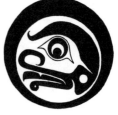

- mythological sea serpent has a typical serpent-like nose attached to the top lip at the front

West coast art style mythological sea monster

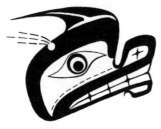

- sea monster with an upthrust and rear curved nose
- has a head fin and a blow hole

West coast art style mythological lightning snake

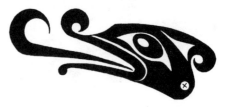

- this snake is often associated with thunderbirds
- curled nose, ear and a long tongue are features of mythological or supernatural creatures

Examples of Head Components - Noses

Horns and Spines

Horned animals are uncommon in two-dimensional Northwest Pacific Coast art. The mountain goat (mythological one-horned) and the natural two-horned goat, as well as deer, are only occasionally seen. The sculpin with head spines is common to north and mid coast art style, as are some other fish with head spines. Profiled animals usually are drawn showing only one ear and one horn.

North/mid coast art style mountain goat

- drawn with one horn
- horn has a weight-relieving negative elongated trigon

North/mid coast art style sculpin

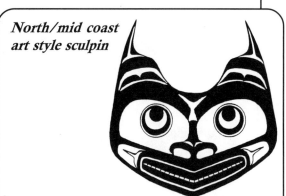

- identified by spines on the top of its head or by its gills
- large size and wide-toothed mouth are also sculpin characteristics

Mid coast art style deer

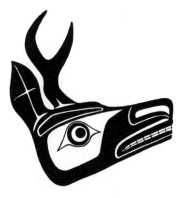

- is common as a mask but two-dimensional designs are rare
- horns are drawn ahead of the ears

North, mid, and west coast art style sea urchin or sea egg

- has a body/head
- is basically an ovoid in shape in any cross-section
- is covered over its upper surface with movable spines
- mouth is central on the bottom

Examples of Head Components - Noses

Insect Proboscis/Beak and Fish Nose/Snout

Various creatures, including some insects and fish have very definite features which are used in design and help identify them. A few insects have elongated proboscises or snouts. Some fish have characteristics like individual nose/snout shapes, which identify them.

North coast art style butterfly

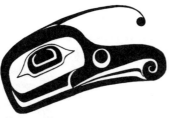

- has an identifying curled-end proboscis and head antenna
- butterflies do not bite like mosquitoes thus designs usually show no teeth

North/mid coast art style mosquito

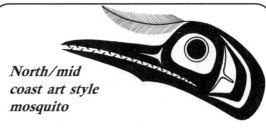

- has characteristics of a mosquito with an elongated pointed proboscis/beak
- mouth full of biting teeth
- antenna

Mid coast art style dog fish (shark)

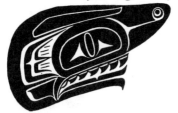

- shown in profile
- has an undershot mouth and projecting snout with a circular nostril

Mid coast art style skate

- shows a top view with a pointed, elongated snout

Mid coast art style salmon

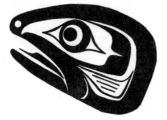

- an ocean type salmon with rounded snout and a nostril

Mid coast art style salmon

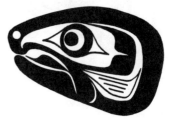

- a river spawning salmon with a hooked snout

Body Parts and Appendages

Realistic outline of a human

The human body is made up of the head, torso and adjoining arms and legs.

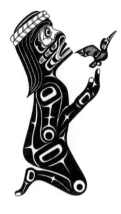

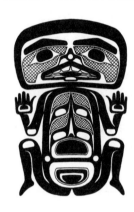

Profiled mid coast art style human male showing one arm and leg

Front view of a north coast art style human female showing two arms and legs

A characteristic of Pacific Northwest Coast art is that the head is given more prominence than the body. In many simple symbolic designs of creatures, the body may be omitted altogether. The human body in most design styles is treated in a semi-realistic fashion. The most naturalistic human bodies are seen in west coast designs and most abstracted human bodies are to be found in the north coast art style.

In all art styles, profiled human bodies usually show one arm and leg. In front view, human bodies display all appendages. Legs and arms are often drawn folded in against the body; however, arms are often seen alongside or across the chest or body sometimes holding coppers, creatures, sticks, clubs, and knees. A profiled arm can be drawn in many positions, and palms may be shown exposed with fingers and thumbs towards the body. Human legs, knees and feet are usually given less detail than arms and hands.

Sexual differences are seldom seen with the exception of mid coast art style Wild Woman, Dzunukwa, who often displays huge, pendulous breasts. Faces that show mouths with labrets also indicate females. North coast art style black human formline designs often have red appendages.

Body Parts and Appendages

Body and Appendage Designs

In all art styles there are great variations, from basic single primary formline to complex rearranged designs. Body parts can be folded, bent, exaggerated, reduced or eliminated. Body shapes are often organized to fit a given space with balance and bilateral symmetry being the desired goal.

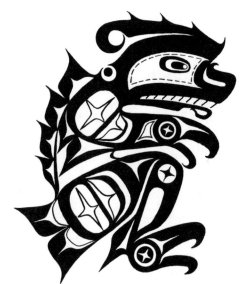

West coast art style sea monster

This sea monster displays most of the features found in any animal, mythological or real. This profiled design shows main appendages attached to the body. Sea monster body features are a blow hole on the top of the neck, four pointed fins along the back and a tail attached to the rump.

The fore and rear limbs have attached rear fins. Both legs end in a stylized flipper-like two-clawed foot. Leg joints of either ovoids or circles are found at the shoulder, hip, knee and flippers. Internal four-point design units at the joints are characteristic and unique to west coast art design.

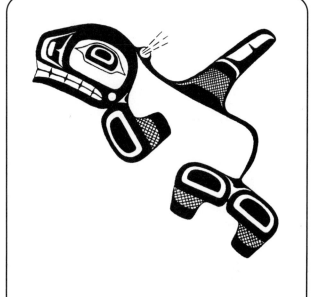

Mid coast art style killer whale

This stylized, leaping and blowing killer whale contains the main symbolic features of a large head with adjoining pectoral fin, a mouth with many teeth and a body with blow hole, dorsal fin and bifurcate tail. The whale's formline body is reduced to its simplest form, a single curved line whose purpose it is to unite all the main features of the design.

Design uniformity and balance is accomplished by repeating formline ovoids of similar shape and line weight. The repetitive use of similar crosshatched primary formline U shapes also helps create uniformity.

Split Body Designs

Perspective designs in traditional Northwest Coast art are rare, since the shape and space to be decorated dictate the design form. First Nations artists developed a unique method of showing the body and all its parts, even internal features such as backbones, viscera, uterus, ribs, and stomach contents. This was accomplished in most designs by splitting the body and folding it open. Split designs are usually balanced and bilaterally symmetrical.

Mid coast art style split raven design

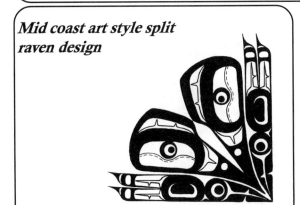

This simple split raven corner design is bilaterally symmetrical because the raven is split from the head top down. The beak ends join the two halves. Below the head is the wing joint with two rear feathers. A foot joint with two pointed toes joins the wing. There is no body, only head, wings and feet.

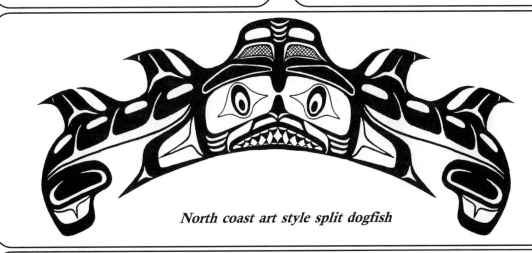

North coast art style split dogfish

Some may view the above design as two creatures, but in fact, it is a balanced split design in which the entire body and its appendages are split in half and joined on each side of the head. It is as if the dogfish head were cut off, the body split down the middle and the two halves rejoined to the now upturned head. The dogfish head in most designs is viewed from below with the snout becoming a vaulted forehead. Here the snout contains two negative ovoid nostrils and (decorative only) four gill slits. Dogfish designs often unrealistically contain three sets of gill slits and four nostrils.

The human-like face has a somewhat realistic down-turned mouth with pointed black teeth. At the mouth corners are negative crescent gill slits. Artistic licence moves the eyes to the underside of the head. Two sets of spined dorsal fins and an asymmetrical tail in which the top tail fin lobe is larger than the lower are typical dogfish design characteristics.

Body Parts and Appendages

Split Body Designs continued

Splits often occur down the back, stomach or head of many humans, mammals, birds, sea animals or insects, with two symmetrical halves splayed open. Split body halves may join a front view of a head. The horizontal format of a design may split at the nose or beak tip or tail. The split in any design may occur anywhere in the body, head or tail and usually results in a bilaterally symmetrical design.

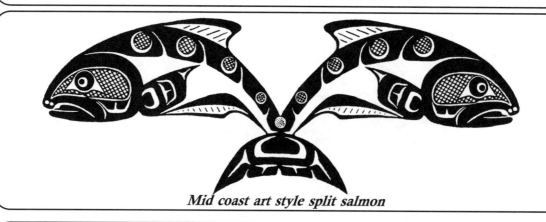

Mid coast art style split salmon

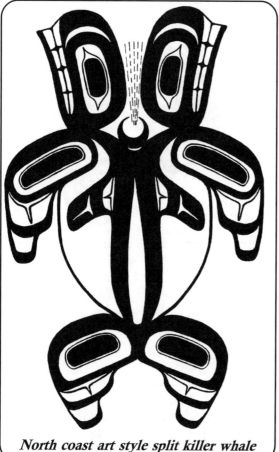

The split salmon design above shows identical body halves split down the middle and joined with one common tail. The design may well fit on a wooden chest front.

The killer whale design is split down the ventral area and folded out. There is a common spouting blow hole and a rear bifurcate tail. In this design, the head is split and the usually erect dorsal fin is split and folded down over each side of the body halves. This is a common feature in north coast art style killer whales, split or not. This killer whale design could be used as a tattoo or on a button blanket.

North coast art style split killer whale

Split Body Designs with Symbolic Parts

Creatures can be identified by symbolic bodies and/or parts. Examples of symbols are the crosshatched tail of a beaver, the large dorsal fin of a killer whale, the scales on marine creatures or fish, the feathers of a bird, the front and rear flippers of a seal or sea lion and the frog's webbed toes and lack of a tail.

Mid coast art style split beaver bracelet design

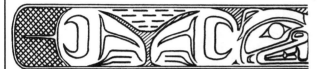
Right profile view

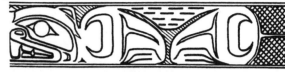
Left profile view

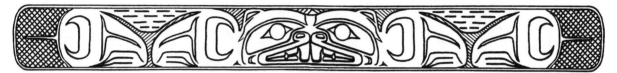
Full frontal view of head

This design combines two horizontal profiled beaver figures at head centre to produce a front view of the beaver head. The head is joined to each profiled body half, showing front and rear legs and crosshatched tail.

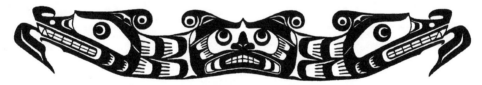
Mid coast art style Sisiutl

This design shows a supernatural two-bodied serpent joined to a central stylized human head. Spiral horns denote the supernatural in many creatures.

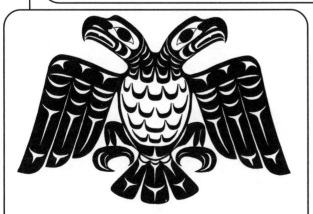
South coast art style two-headed eagle

The mid coast style Sisiutl design is of a complete three-headed, two-bodied creature that is not necessarily a split design. The south coast art style eagle has overtones of a split design but actually represents a mythological two-headed bird.

Neither of these designs display internal features characteristic of many split designs. The bodies of the two serpents and the eagle show external coverings of scales and feathers, respectively.

Learning by Designing: Pacific Northwest Coast Native Indian Art, Volume 1

Balance, Apparent Symmetry, and X-ray Design

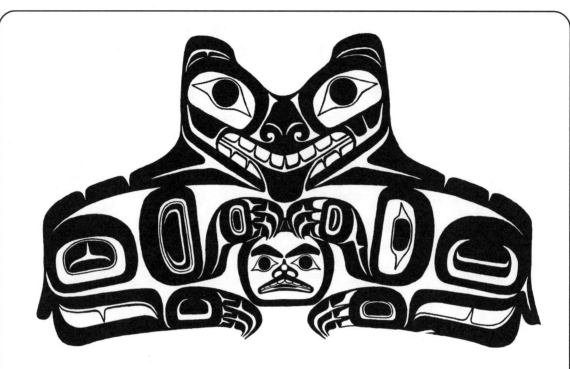

North coast art style split bear design showing a bear holding a human head

Some designs, like the split bear above, have balance and apparent symmetry. The artist has used bilaterally symmetrical and identical primary formlines on the two halves of the head and body; however, if you look closely, there are subtle variations. The interior secondary filler design units on each of the two halves differ. Inner ovoids in the front and rear paws, shoulders, and hips all differ. The claws in the front and rear paws, as well as the ears, cheeks, tails, rear and front legs all have different positive or negative design units. Therefore, this design has balance but no bilateral symmetry like most split body designs.

The X-ray principle of showing internal anatomy uses ovoids or circles to show movable joints such as ball and socket. X-ray design can also show parts of the skeleton, as well as internal organs and their contents. By splitting designs and using x-ray design techniques, the artist can fill an entire given space with design - a distinctive feature of this art form. A split bilaterally symmetrical design, using the X-ray technique, is a unique attempt by the artist to portray the three-dimensional features of a creature on a flat two-dimensional surface.

Body Parts and Appendages

Comparing Bodies Across Art Styles

Although most design elements are decorative, others are symbolic such as the spiny body of the sea urchin or the circular discs on the legs of an octopus. Artists use great freedom in altering the proportion and size of bodies and appendages in their designs.

Mid coast art style octopus
– head and body are combined
– legs with suckers are reduced to four in number

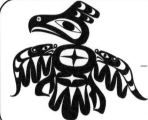

West coast art style thunderbird
– front view body is a simple ovoid with legs, wings, head and tail attached

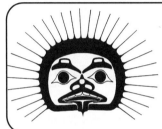

North coast art style sea urchin
– head and body are combined
– legs radiate from body

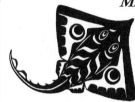

Mid coast art style skate
– body has triangular side fins
– elongate tail is spined
– negative internal S shapes represent ribs
- head/body combined

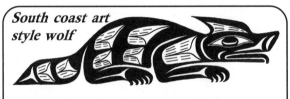

South coast art style wolf
– body, tail and legs have negative U shapes
– dashing represents fur

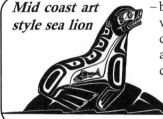

Mid coast art style sea lion
– body shows x-ray view of spinal column, ovoid joints and a stomach containing a salmon

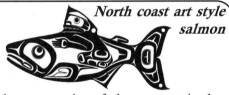

North coast art style salmon
– body shows x-ray view of a human contained in the dorsal fin and salmon body

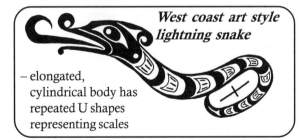

West coast art style lightning snake
– elongated, cylindrical body has repeated U shapes representing scales

West coast art style hummingbird
– body, wing and tail show simplified U shape feather designs

North coast art style dragonfly
– large head
– elongated, segmented insect body is joined by two sets of crosshatched "veined" wings

Learning by Designing: Pacific Northwest Coast Native Indian Art, Volume 1

Body Parts and Appendages

Arms and Hands - Human

The human arm can vary in design complexity from a stylized curved fineline to an elaborate, multi-jointed, semi-realistic design. South and west coast art style arms and hands are often semi-realistic and naturally proportioned. They can be a solid colour with negative design elements. Semi-realistic mid coast art style arms and hands often contain ovoids or circles to indicate the moving joints in the shoulder, elbow, wrist and fingers. They can be drawn palm up or down, profiled, holding, gripping, or in perspective. North coast art style arms and hands are usually stylized with front view palms, fingers and thumb.

South coast art style arm and hands

North coast art style arms and hands

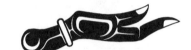
- palm up hand and wrist with bracelet

- stylized hand with only three fingers and simple formline arm

Mid coast art style arm and hands with fingernails
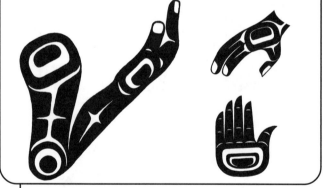

Holding

North coast art style

Gripping

Mid coast art style

West coast art style arm and hands
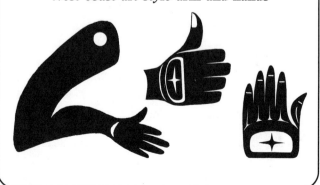

Haida style chief holding a copper

Salish style grieving human

132 *Learning by Designing*: Pacific Northwest Coast Native Indian Art, Volume 1

Body Parts and Appendages

Legs and Feet - Human

Legs and feet generally have less design detail than arms and hands. In most art styles, movable joints are shown in a similar way to arms and hands. Mid coast art style designs have the greatest content and detail. In some coastal sculptural styles, feet are so unimportant that they are not even included.

South coast art style profiled legs and feet

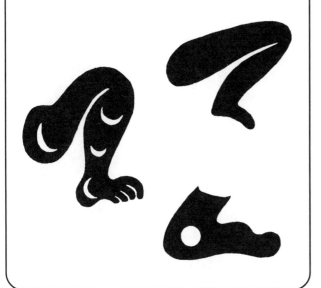

Mid coast art style profiled hip, leg and foot, also front and side views of toed feet

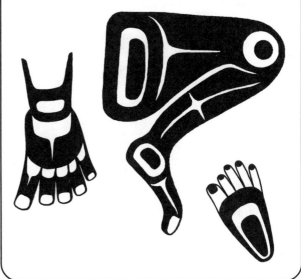

West coast art style profiled legs and feet

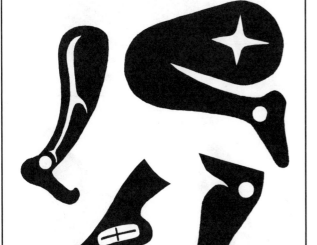

North coast art style profiled hip, legs and feet

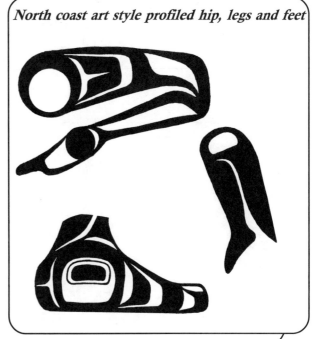

Learning by Designing: Pacific Northwest Coast Native Indian Art, Volume 1

Body Parts and Appendages

Legs and Feet - Animal

Simple or complex animal legs and feet usually show the specific characteristics of the creature such as hooves, paws, or claws. Profiled feet can be designed with one, two, three or four toes or claws. Ovoids or circles show skeletal joints such as hips, knees, ankles or toes. Legs and feet can be red, attached to black formline bodies. Designs within legs, paws or feet are usually repeated in fore and rear limbs to make the design uniform.

South coast art style

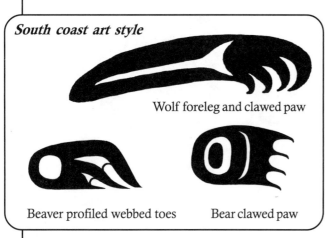

Wolf foreleg and clawed paw

Beaver profiled webbed toes

Bear clawed paw

North coast art style

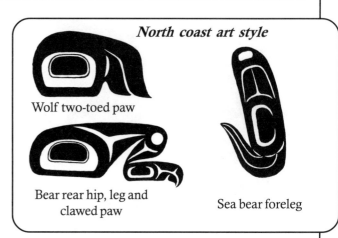

Wolf two-toed paw

Bear rear hip, leg and clawed paw

Sea bear foreleg

West coast art style

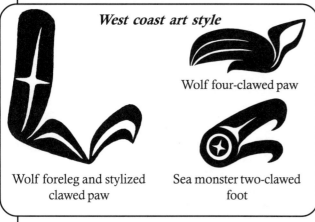

Wolf four-clawed paw

Wolf foreleg and stylized clawed paw

Sea monster two-clawed foot

Mid coast art style crab

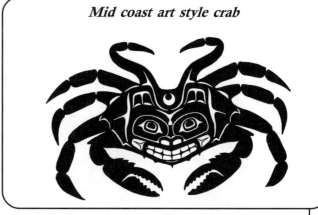

Mid coast art style

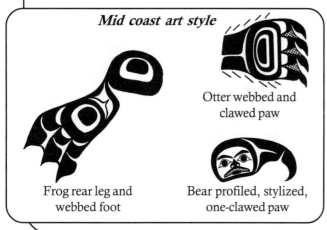

Otter webbed and clawed paw

Frog rear leg and webbed foot

Bear profiled, stylized, one-clawed paw

Mid coast art style

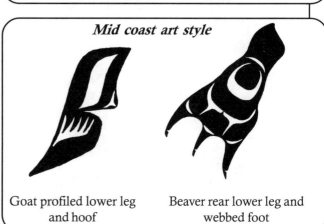

Goat profiled lower leg and hoof

Beaver rear lower leg and webbed foot

Body Parts and Appendages

Flippers - Seal, Whale and Sea Creature

Flippers are paddle-like limbs that are used to move a creature along, either in the water or on land. Seals, whales, porpoises, dolphins and sea lions as well as mythological creatures use their forelimb flippers to direct their movements and swim underwater. Sea lions can move their rear flippers forward to walk while on land, seals cannot. Most flipper designs contain an ovoid or circle to symbolize a movable joint where flipper and body meet.

Mid coast art style sea lion

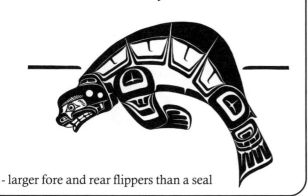

- larger fore and rear flippers than a seal

West coast art style sea wolf

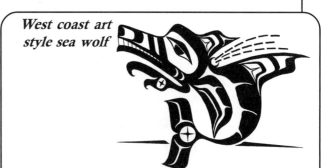

- mythological creature transforming from a killer whale to a wolf
- large fore flippers

South coast art style harbour seal

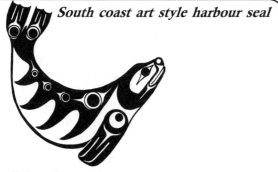

- small front flippers
- may have claws on all flippers

Mid coast art style broaching Right whale

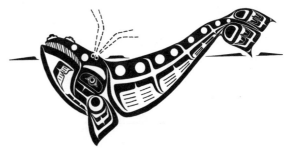

- wide fore flippers serve mainly to help guide the body

Mid coast art style sea wolf

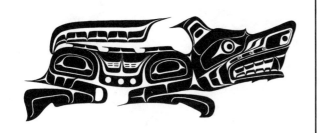

- front and rear paws are paddle-like flippers

Mid coast art style harbour porpoise

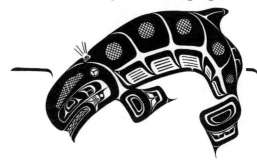

- small rounded front flippers are used to help steer

Learning by Designing: Pacific Northwest Coast Native Indian Art, Volume 1

Body Parts and Appendages

Legs and Feet - Bird Toes, Claws, Webs

North coast art style bird legs, feet and toes are often stylized and joined to an ovoid or circle foot joint. Specific toe and claw characteristics reflect the natural features of the bird, e.g. curved clawed feet of eagles and thunderbirds. West and south coast art style profiled legs and feet can be abstract and have two, three or four toes/claws. Mid coast art style leg, foot, and toe designs are often semi-realistic. Swimming birds can have webbed toes.

Mid coast art style
- semi-realistic eagle leg and clawed foot

North coast art style Eagle/Raven family crest
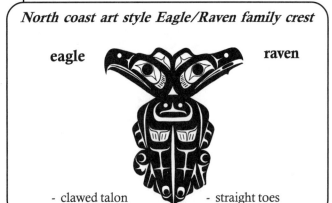
eagle raven
- clawed talon - straight toes

Mid coast art style chickadee
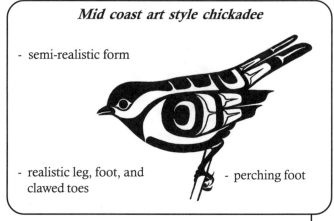
- semi-realistic form
- realistic leg, foot, and clawed toes
- perching foot

North coast art style
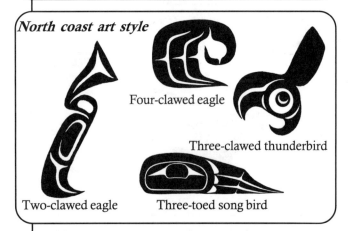
Four-clawed eagle
Three-clawed thunderbird
Two-clawed eagle
Three-toed song bird

Mid coast art style
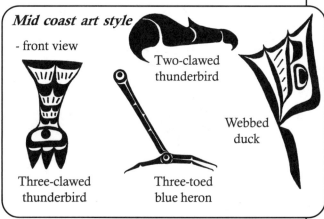
- front view
Two-clawed thunderbird
Webbed duck
Three-clawed thunderbird
Three-toed blue heron

West coast art style
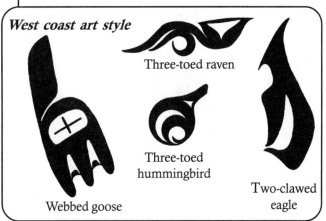
Three-toed raven
Three-toed hummingbird
Webbed goose
Two-clawed eagle

South coast art style
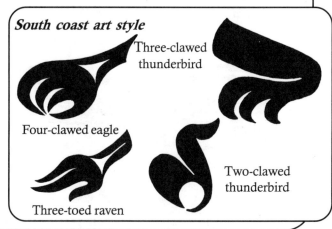
Three-clawed thunderbird
Four-clawed eagle
Two-clawed thunderbird
Three-toed raven

Body Parts and Appendages

Fins and Tails - Fish and Sea Creature

Fish, whales, and mythological sea creatures have primary formline fins and tails which help to identify them. Often fins are omitted or exaggerated in size and have complex internal designs. Rayed fins of salmon, cod and sculpin often contain parallel dashing representing the rays. Dorsal and tail fin size and position, together with teeth or baleen, help to identify a species of whale.

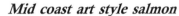
Mid coast art style salmon

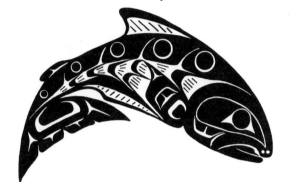

This salmon has dashed dorsal and anal fins. The small adipose fin at the rear of the dorsal is a fleshy fin and is also found on oolichan. The pectoral (side) fin and the caudal (tail) fin have an ovoid base indicating motion. Salmon tails are bilaterally symmetrical. The salmon's body has internal circles representing vertebrae and U shapes with dashed lines representing scales.

Mid coast art style dogfish

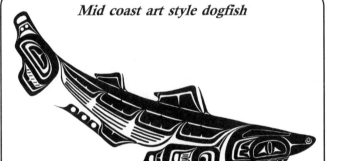

This profile shows most of the characteristics of a shark or dogfish. The two dorsal fins have spines in front. The asymmetrical tail has an ovoid base with formline U shapes forming the lobes. The pelvic fin is joined by a long three section formline representing the male dogfish's claspers. The pectoral fin has a formline ovoid base and stacked U shapes.

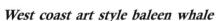
West coast art style baleen whale

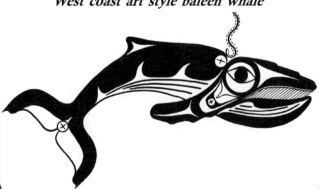

This profiled whale has parallel lines in the mouth representing the baleen of the Gray and Humpback whales of the Pacific Coast. The small dorsal fin, bumps on the nose and the elongated front flipper fin, as well as the large bifurcate tail help to identify this whale as do the parallel lines in the throat and belly (expansion grooves). It is a Humpback.

Learning by Designing: Pacific Northwest Coast Native Indian Art, Volume 1

Body Parts and Appendages

Fins and Tails - Fish and Sea Creature continued

Fins and tails are usually drawn fully extended. Fin ends often are pointed, sometimes indicating spines. Pectoral, pelvic and tail fins in most art styles originate from ovoids or circles indicating movement. Dorsal, adipose, and anal fins do not move and therefore seldom have joints indicated. Faces often appear at the base of dorsal and tail fins. South coast art styles contain few fin faces and whale tails are seldom profiled.

Mid coast art style halibut

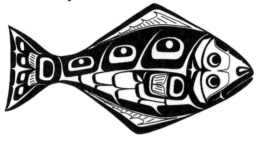

- elongated fins found on both sides of flatfish bodies
- both eyes are on the top side as is the right pectoral fin

West coast art style salmon

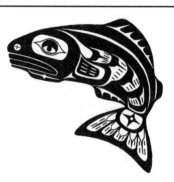

- long dorsal and body fins with parallel dashing represent fin rays

Mid coast art style red snapper

- most rockfish have spiny fins
- sharp spines occur on the front dorsal and on most body fins but not on the tail fin

South coast art style killer whale

- large tail and dorsal fins characteristics of an orca
- many coastal artists take the liberty of turning the naturally profiled whale tail fin 90° to show both flukes

West coast art style sea monster

- in most coastal art styles, mythological sea monsters and undersea animals and birds have gills and/or blow holes as well as body appendages with fins, often spined
- rump fins and tails can act as rudders

Mid coast art style whale tail

- profiled whale tail fin shows right fluke with a human head at its base

Fins and Tails - Fish and Sea Creature continued

Fish fins in the south coast art style are usually drawn as stylized U shapes outside of the main body design. North coast art styles often place heads in dorsal fins. Mid coast art style tail fins often contain a face with features.

Mid coast art style skate

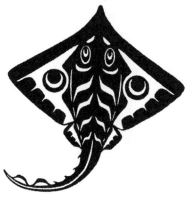

- large triangular pectoral fins (wings) on both sides of the body
- long cylindrical spined tail with two small dorsal fins
- mouth underneath eyes
- eyes on top

North coast art style mythological killer whale dorsal fins

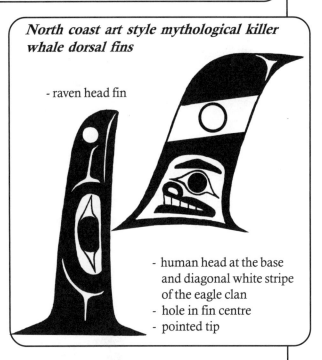

- raven head fin
- human head at the base and diagonal white stripe of the eagle clan
- hole in fin centre
- pointed tip

South coast art style sturgeon

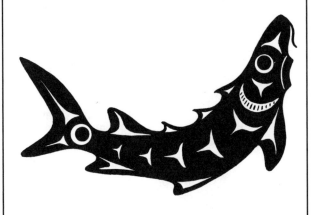

- asymmetrical tail fin like the dogfish or shark
- heavy body scales on back and body sides

Mid coast art style

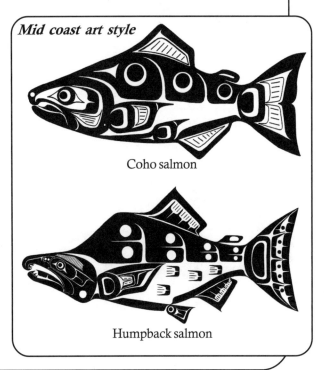

Coho salmon

Humpback salmon

Learning by Designing: Pacific Northwest Coast Native Indian Art, Volume 1

Body Parts and Appendages

Tails - Whale

Bull killer whale (Orca) - profile view

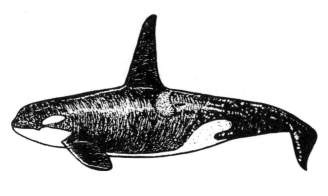
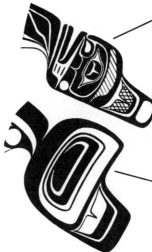

Mid coast art style
- one lobe of bifurcate tail
- frequently drawn as human face in profile
- U shape protrudes from stylized head top/rear

North coast art style
- tail lobe is ovoid shape
- U shape extends from bottom lower edge

Bull killer whale (Orca) - showing perspective

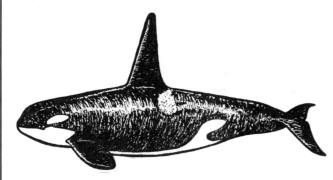

Mid coast art style
- bifurcate flukes are angled and rear fluke is foreshortened to give illusion of perspective and depth

Bull killer whale (Orca) - symmetrical top view

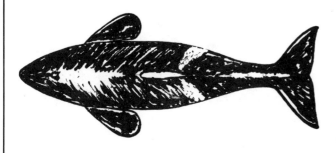

Mid or west coast art style
- two ovoids form the base of tail lobes
- U shapes extend from bottom outer edge of ovoids

Mid or west coast art style
- two joined ovoids form a human face design
- U shapes extend from top outside edge of ovoids

Learning by Designing: Pacific Northwest Coast Native Indian Art

Body Parts and Appendages

Tails - Whale continued

Whale tails have traditionally been drawn face-on with symmetrical flukes or profiled from the side. Contemporary northwest coast artists are now using formlined perspective designs as in the lower right box. Bilaterally symmetrical designs are typical in whale tails. Faces and two ovoid design complexes are common. Profiled tails in mid and north coast styles usually contain a face or ovoid with formline U shape extensions. In many designs, a profiled whale body will have the tail fin turned unnaturally 90° to show it in a face-on position.

Mid coast art style killer whale tail

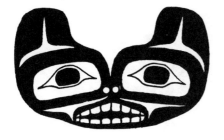

West coast art style gray whale tail

Mid coast art style sperm whale tail

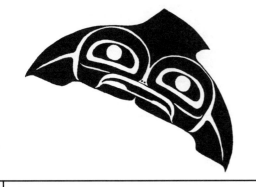

Mid coast art style humpback whale tail

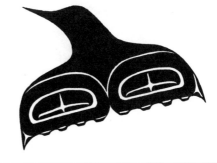

North coast art style profiled side view of the left fluke of a whale's tail

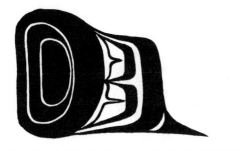

Mid coast art style perspective view of a whale's tail as it dives

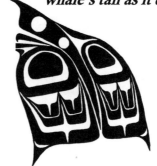

Learning by Designing: Pacific Northwest Coast Native Indian Art

Body Parts and Appendages

Tails - Otter

Tails of animals are generally hair or fur-covered. Hair can be represented by short fine lines and can be external or internal to the formlined tail. The small tails of the bear, sea lion, seal are often omitted in a design. Whale and beaver tails often contain human faces. Long tails can be coiled or folded over the back of profiled bodies.

Mid coast art style sleeping sea otter and pup

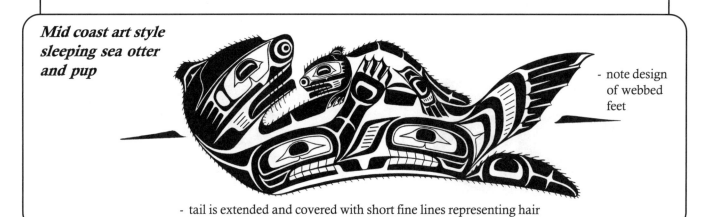

- note design of webbed feet

- tail is extended and covered with short fine lines representing hair

Mid coast art style diving land otter

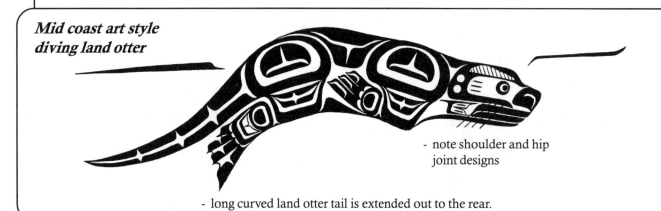

- note shoulder and hip joint designs

- long curved land otter tail is extended out to the rear.

Mid coast art style floating sea otter and pup

- In all three otter designs, the water surface is represented by short lines at the front and rear of the bodies.

- hair-covered tail is folded back under the body

- body is profiled but the head is turned face-on

Body Parts and Appendages

Tails - Animal

Tail characteristics can often help to identify a creature. The beaver is a good example with its broad, crosshatched tail which often contains a face. Frontal views of beavers often have the tail folded up over the stomach area.

North coast art style beaver

- large flat tail is filled with internal crosshatching

West coast art style deer in perspective view

- erect semi-realistic tail has a serrated rear edge representing hair

Mid/north coast art style mythological mouse woman

- scaly tail of the mouse is coiled up over the stomach area

North coast art style sitting bear

- the small tail of the bear is a narrow formline U shape

Learning by Designing: Pacific Northwest Coast Native Indian Art

Body Parts and Appendages

Tails - Animal continued

Possibly the greatest design variation is found in wolf tail designs. The bushy tail is found in any position, with internal negative or positive dashing, and/or exterior dashing representing hair. The mythological sea bear and sea wolf often have broad pointed tails and rudder-like appendages.

North coast art style sea monster

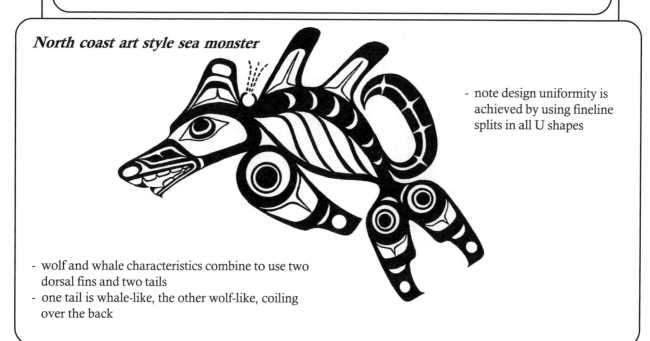

- note design uniformity is achieved by using fineline splits in all U shapes

- wolf and whale characteristics combine to use two dorsal fins and two tails
- one tail is whale-like, the other wolf-like, coiling over the back

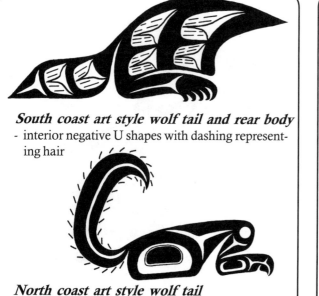

South coast art style wolf tail and rear body
- interior negative U shapes with dashing representing hair

North coast art style wolf tail
- dashing external to formline represents hair

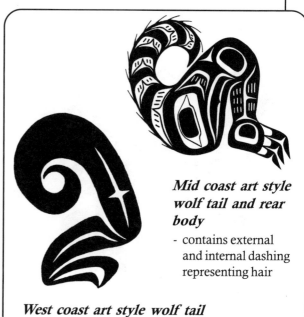

Mid coast art style wolf tail and rear body
- contains external and internal dashing representing hair

West coast art style wolf tail
- tapered and tightly coiled

Learning by Designing: Pacific Northwest Coast Native Indian Art

Body Parts and Appendages

Wings and Tails - Bird

Northwest Coast art style feathers are based on the U shape. Wing feathers are usually longer and narrower than tail feathers. One or several feathers can represent all feathers in a wing or tail. North coast style designs seldom have more than four feathers. West coast designs may have eight or more rounded or pointed wing feathers. Wing feathers are usually pointed while tail feathers are rounded. Body feathers are usually squarish, rounded end U shapes which are joined in parallel rows across the body.

North coast art style bald eagle

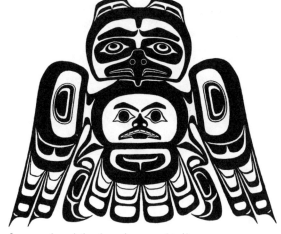

- face-on head, body, wings and tail
- two pointed end wing feathers
- four rounded end tail feathers

South coast art style bald eagle

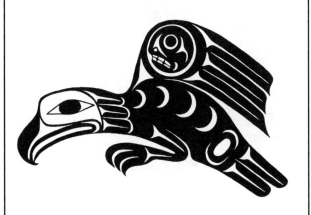

- profiled head, body, wing and tail
- three pointed end wing feathers
- two rounded end tail feathers

Bird feathers

- realistic pointed end raven wing feather
- mid/north coast art style pointed end wing feather

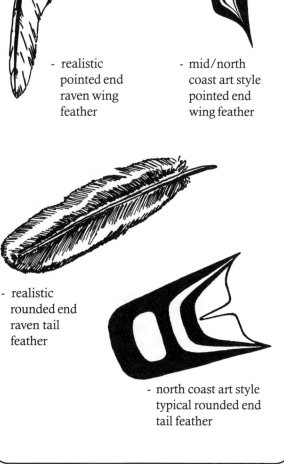

- realistic rounded end raven tail feather

- north coast art style typical rounded end tail feather

Learning by Designing: Pacific Northwest Coast Native Indian Art

Body Parts and Appendages

Wings and Tails - Bird continued

Frontal views of birds in all coastal art styles have wings which can be drawn up, out, or down and range from full outstretched wings to wings held in tight to the body. North and mid coast wings usually have an ovoid joint base while south and west coast wings often do not.

West coast art style thunderbird

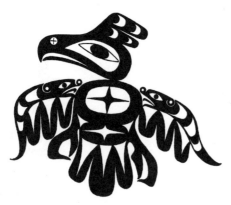

- wings outstretched
- both wing and tail feathers are round ended with soft curved internal splits
- two lightning snakes form the uppr formline edge of both wings

North coast art style raven with sun

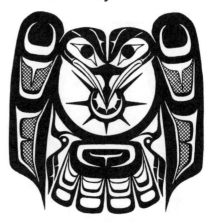

- edge view of wings folded in tight against body
- only one feather per wing
- wing feather with pointed end
- tail feather with rounded end

Mid coast art style thunderbird

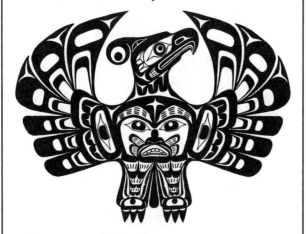

- wings outstretched and up
- each wing has three pointed primary feathers and three rounded secondaries
- ovoid joint with eye at base of wing
- round ended tail feathers are covered by legs and clawed feet

South coast art style eagle

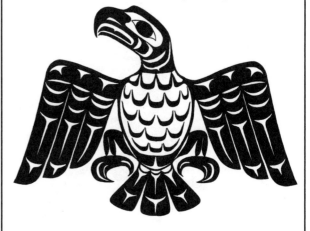

- wings outstretched up and down
- each wing has three soft pointed feathers
- round ended tail feathers, like the wing feathers, contain multiple negative crescent slits and trigons
- U shape feathers extend across the body cavity
- no formline ovoid or oval joints in wings or tail

Body Parts and Appendages

Wings and Tails Side Views - Bird

Profiled bird designs have the wing positioned behind, above, below or alongside the body. All coastal art styles often have profiled tail designs with only one or two feathers. Wing and tail joint ovoids or circles frequently contain human or animal faces or heads.

North coast art style raven

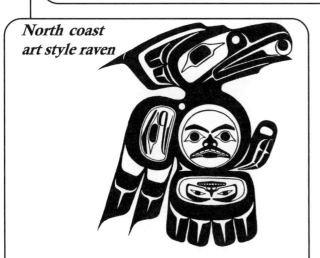

- body, wing and tail all contain a face/head design
- tail turned 90° to show all four tail feathers and frontal view of face
- wing located behind body

West coast art style hovering hummingbird

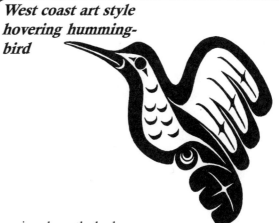

- wing above the body
- all wing and tail feathers typically rounded
- tail turned 90° to show three stylized feathers
- no ovoid joint design elements
- wing and tail feathers all contain typical four point interior design

Mid coast art style contemporary diving jay

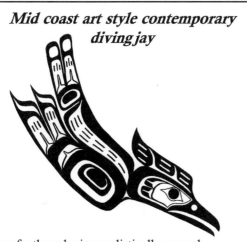

- two-feathered wing realistically curved
- wing placed below and alongside the arched body and tail
- both wing and tail feathers contain similar internal design elements
- dashing on feathers

Mid coast art style contemporary sleeping sandpiper

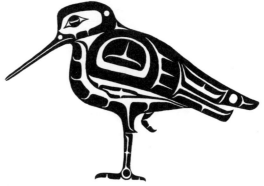

- sleeping bird standing on one leg
- wings pulled in against the body
- single tail and wing feathers
- negative internal design units
- X-ray showing internal parts

How to Draw Ovoids

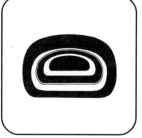

North coast art style ovoid

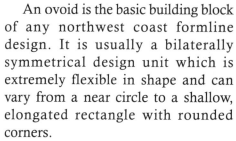

An ovoid is the basic building block of any northwest coast formline design. It is usually a bilaterally symmetrical design unit which is extremely flexible in shape and can vary from a near circle to a shallow, elongated rectangle with rounded corners.

The bottom line of the ovoid can be straight, slightly convex or concave. Often, the longer and more slender the ovoid, the more concave the bottom. Usually, the more circular in shape or where width and depth are similar, the more convex the bottom line. Top and sides are always convex with the greatest width being at the bilateral centre of the ovoid unit regardless of the shape.

Ovoids often represent heads, eyes, joints, and bodies.

West coast art style ovoid

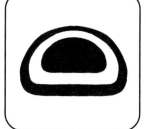

Mid coast art style ovoid

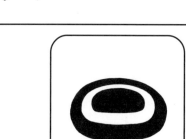

South coast art style ovoid

Learning by Designing: Pacific Northwest Coast Native Indian Art, Volume 1

Approaches to Drawing Ovoids

There can be several approaches to drawing ovoids. Each person develops a favourite after attempting each approach. An ovoid can be sketched freehand, drawn within a rectangular guideline, half-drawn and folded or made into a template.

Using sketch lines to draw an ovoid

This ovoid is sketched using a quick curved line for the top, a straight line for the bottom and two curved lines which join the top and bottom.

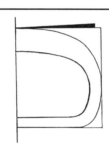

Making and using an ovoid template

This ovoid shows the use of a template. Until an artist becomes familiar with the symmetry of an ovoid, a template makes drawing easier. How to make a template will be described on the following pages.

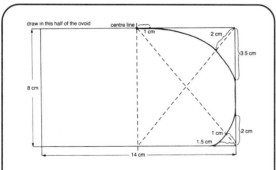

Using a reference rectangle to draw an ovoid

This ovoid was drawn using a reference rectangle. Measurements are made at diagonal points from the corners and lines are drawn to join the points. This method is explained in detail in the book, *Learning by Doing Northwest Coast Native Indian Art,* by Karin Clark and Jim Gilbert.

How to Draw Ovoids

Making Ovoid Patterns or Templates

Patterns or templates were used by First Nations artists. These templates were often made out of thin tree bark. Not all designs were created using patterns. Until an artist becomes familiar with design shapes and can draw them freehand to his/her satisfaction, it is helpful to use patterns.

Great variation in size, internal design structure and shape can be seen in ovoids. Ovoids may be circle-like, tall and narrow, long and thin, or have straight, concave or convex bottom lines.

Ovoid formline thickness varies a great deal among different artists or coast cultural groups. For example, Tlingit (north coast art style) ovoids may have thick wall width with the thickest line width at the top of the ovoid. Kwakwaka'wakw (mid coast art style) ovoids may have a thin wall width, straight bottom line, with the thickest line width at the bottom of the ovoid.

Step 1. Guideline rectangle

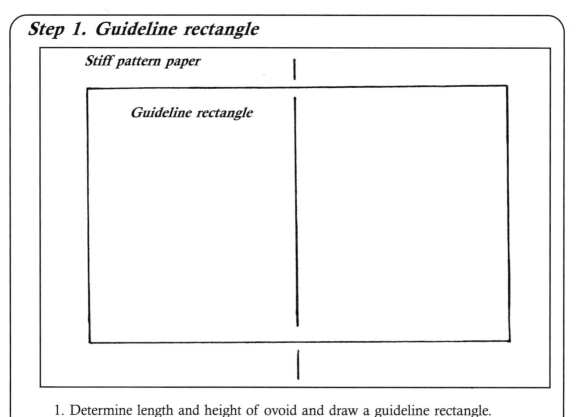

1. Determine length and height of ovoid and draw a guideline rectangle. Draw a centre line through the rectangle.

Making Ovoid Patterns or Templates continued

Step 2. Outside ovoid

- outside fineline starts at centre line and parallels guideline for a short distance
- top/side line curves down and out
- side/bottom line curves in and around to parallel guideline bottom line
- ovoid bottom may be straight, or curve slightly in or out

Note: regardless of size or shape, north coast art style ovoids are drawn using a similar formula and curved line rules and structure.

Guideline rectangle

2. In **one side only** of the rectangle draw the outside fineline of the ovoid.

Step 3. Inside ovoid

- outside fineline ovoid
- the width between the drawn outside and inside finelines is wider at the top of the ovoid than at the bottom
- *North coast art style ovoid*
- both finelines at the bottom of the ovoid should be parallel
- inside fineline ovoid

3. Draw another ovoid inside the first ovoid using the same straight and curved line formula as was used to draw the outside fineline.

How to Draw Ovoids

Making Ovoid Patterns or Templates continued

Step 4. Fold and cut

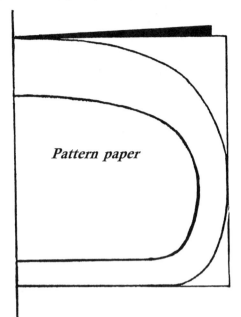

Pattern paper

4. Carefully fold pattern paper on the ovoid centre line. *First*, cut out on the **inside** ovoid fineline. *Second*, cut out on the **outside** ovoid fineline.

Step 5. Fineline ovoid

Drawn fineline ovoid

5. Open and lay out cut ovoids where they are needed to complete the main design. Trace around the outside of both templates. This creates a fineline ovoid that is bilaterally symmetrical.

Step 6. Painted ovoid

Painted formline ovoid

6. Paint in the area between the inside and outside finelines. This creates a formline ovoid. The shape of this ovoid is typically north coast art style because the top formline width is wider than the side or bottom width.

How to Draw Ovoids Across Art Styles

Reference rectangles reflect how ovoids vary in structure from the rigid, almost square/rectangular shapes of the north coast art style areas to the free-flowing circular style of the south.

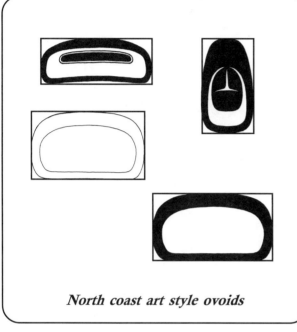

North coast art style ovoids

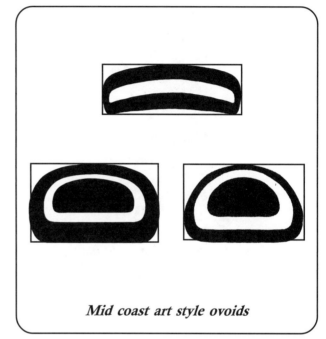

Mid coast art style ovoids

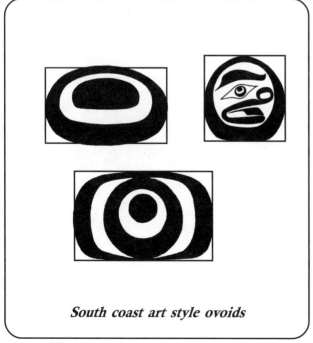

South coast art style ovoids

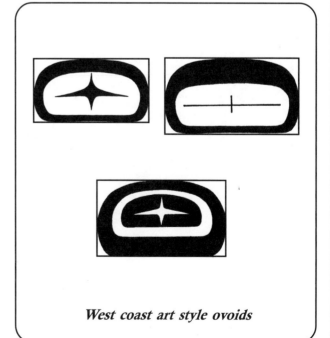

West coast art style ovoids

How to Draw Ovoids

Ovoids Used in Designs Across Art Styles

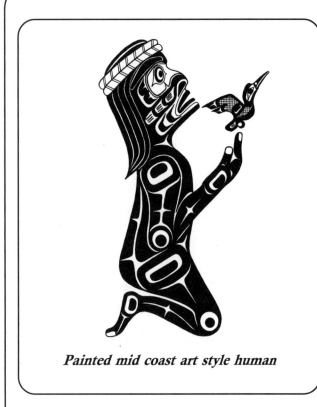

Painted mid coast art style human

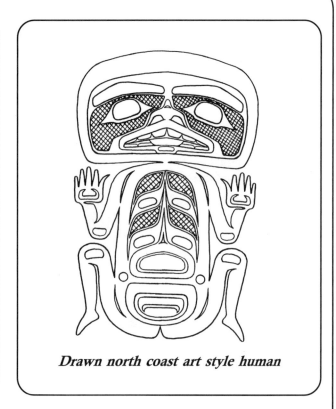

Drawn north coast art style human

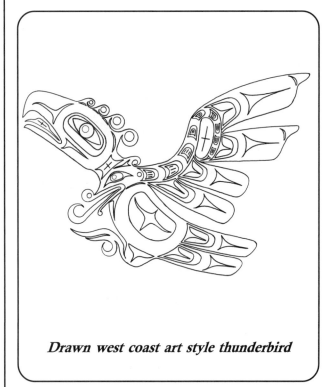

Drawn west coast art style thunderbird

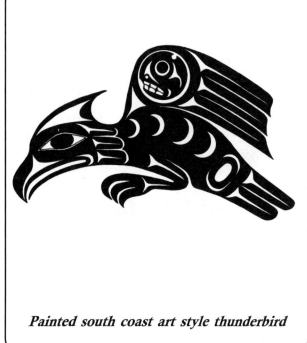

Painted south coast art style thunderbird

How to Draw a North Coast Art Style Eye and Eyelid

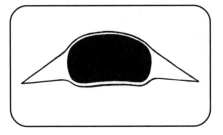

North coast art style ovoid eye with eyelid

There is enormous variation in how eyes and eyelid lines are drawn in Pacific Northwest Coast art. Eyeballs can be oval, ovoid (solid or relieved), or circular (solid or relieved). Eyelid lines vary in length, slant and edges. There are variations in the eye orbit, colour, position of the eye within the orbit, position of the pupil within the eyeball, and positive or negative eye orbits. Most eyeballs have non-concentric design features.

Eyelid lengths are usually equal but in some designs the eyelid line is shorter towards the nose and longer towards the ear. Many artists use negative relieving shapes to reduce the weight of a solid colour. These relieving shapes can be crescents, trigons, quadrons, ovoids, or circles. The iris can be attached or not attached to the eyelid line, but the eyelid line closest to the iris is always the thinnest. The iris and its pupil can be placed to show where the creature is looking. For additional examples, please see *Examples of Head Components - Eyes*

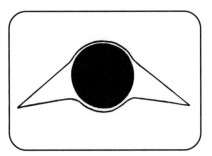

North coast art style circular eye with eyelid

Drawing a North Coast Art Style Eye and Eyelid

Design Principles

1. An eyeball and eyelid design, shape or size often depends on the type of creature and the size of the eye orbit.
2. Eyeball designs are always placed in the top half of an eye orbit.
3. The eyeball design unit is usually symmetrical.
4. The painted eyelid ends are usually level in relation to the enclosed eyeball.
5. The eyelid line parallels the top and bottom of the eyeball, regardless of shape. The bottom eyelid line is usually slightly farther away from the eyeball than the top eyelid line.
6. At the top sides of the eyeball, the top eyelids curve out and down toward the pointed ends.
7. At the bottom sides of the eyeball, the lower eyelids curve out and up toward the pointed ends.
8. The eyelid lines may, in some instances, be slightly concave.
9. Regardless of eyeball design complexity, the eyeball and eyelid are usually painted black.

Step 1. Drawn eyeball

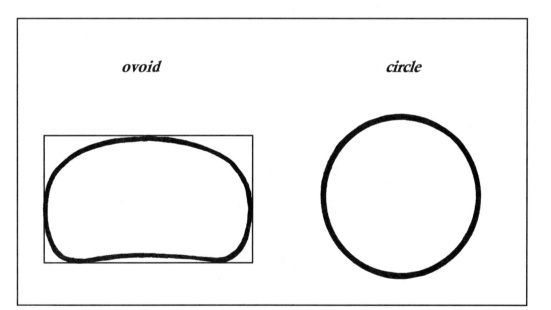

1. Choose an eyeball shape. Draw an ovoid using the information in the *How to Draw an Ovoid* chapter. Draw a circle using a circle template or compass.

Drawing a North Coast Art Style Eye and Eyelid continued

Step 2. Guidelines

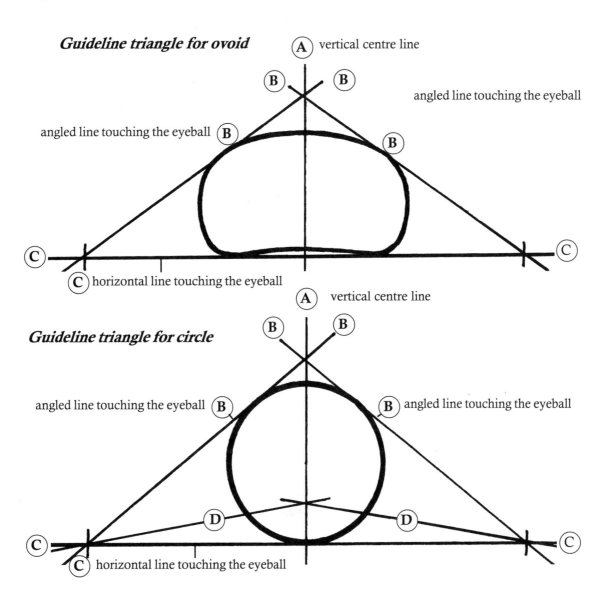

2. Draw light pencil guidelines that look like a triangle surrounding the eyeball.
 A. Draw a vertical line down the centre of the circle or ovoid.
 B. Draw two angled lines that come down from above the eyeball and touch on the top right and left of the eyeball.
 C. Draw a horizontal line that touches the bottom of the eyeball.
 D. CIRCLE: Draw an additional two slightly angled lines from the two bottom corners of the triangle that meet at the vertical centre line, slightly above the base of the triangle.

 ✸ In both cases, the pointed eyelid ends are usually equidistant from centre line (A).

Drawing a North Coast Art Style Eye and Eyelid continued

Step 3. Ovoid eyelid lines

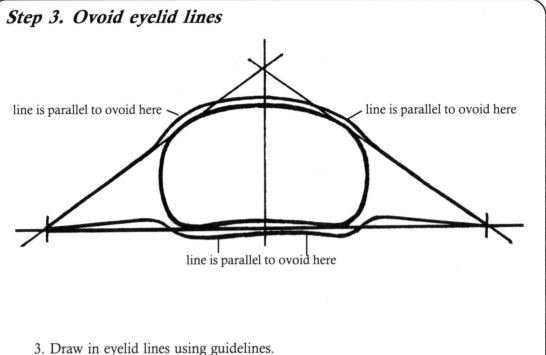

3. Draw in eyelid lines using guidelines.

Step 3. Circle eyelid lines

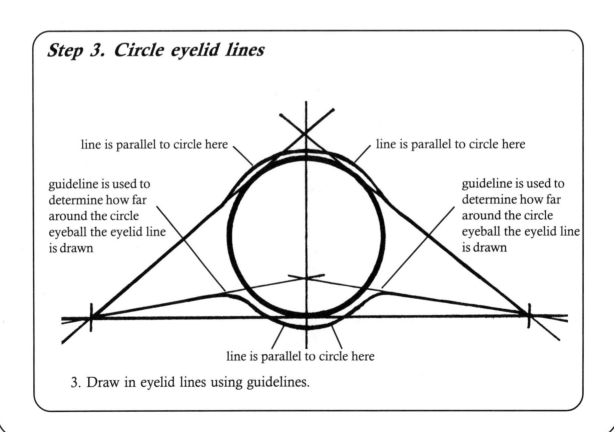

3. Draw in eyelid lines using guidelines.

Painted North Coast Art Style Eye and Eyelid

Step 4. Erase and paint

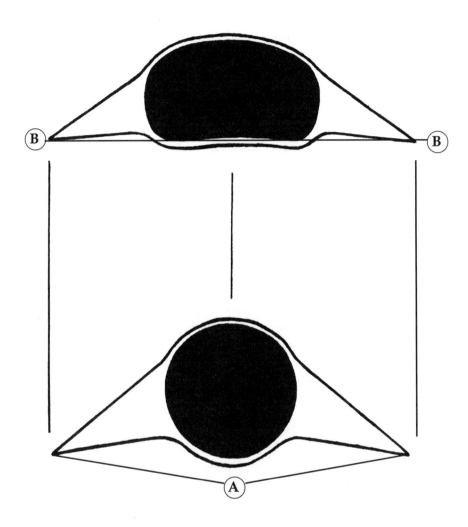

4. Erase guidelines and paint eyeball with eyelid line.

 A. Eyelid lengths vary, often in geometric relationship to the eyeball shape - width and height. The pointed eyelid ends are usually at equal distances from the eyeball centre.
 B. On the horizontal plane, the eyelid corners are rarely above the centre of the eyeball or below the bottom of the eyeball.
 C. Eye orbit size determines eye and eyelid size.

How to Draw U shapes

North coast art style U shape as ear

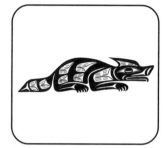

South coast art style U shapes showing fur

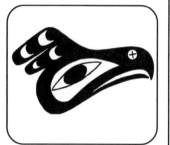

West coast art style U shapes as feathers/ plumes

U shapes are a commonly used design unit. Their shape, structure, and internal design complexity varies a great deal. The characteristic shape is like the letter 'U' in which two somewhat thin and parallel sides are joined to a thicker, rounded end.

U shapes in Northwest Coast art can range in shape from free form to a bilaterally symmetrical unit. They can be a solid colour, simple outline, textured, elongated, squat, split from front to rear or vice versa, or be internally relieved in mass by relieving shapes. The sides of the U shape taper at formline juncture points.

U shapes can represent feathers, scales, cheeks, ears, tongues, teeth, snouts, nostrils, mouths, fingers, fins, flippers, claws, feet, tails, limbs, plumes, horns, flukes, beaks, and rays or simply be design filler units.

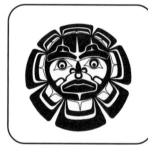

Mid coast art style U shapes as sun's rays

Free form solid U shapes as killer whale dorsal fins

Approaches to Drawing U shapes

There can be several approaches to drawing U shapes. Each artist develops a favourite after attempting different approaches. A U shape can be sketched freehand, drawn within a rectangular guideline, half-drawn and folded or made into a template.

Using sketch lines to draw a U shape

This U shape is sketched using a slightly curved line for the bottom, semi-straight lines for the sides. A small curved line joins each rounded corner.

Making and using a U shape template

This U shape shows the use of a model or template. Until an artist becomes familiar with the symmetry of some U shapes, a template makes drawing easier. How to make a template will be explained on the following pages.

Using a reference rectangle to draw a U shape

This U shape was drawn using a reference rectangle. Measurements are made at diagonal points from the corners and lines are drawn to join the points. This method is used in the book *Learning by Doing Northwest Coast Native Indian Art* by Karin Clark and Jim Gilbert.

How to Draw U shapes

Making U shape Patterns or Templates

Until an artist becomes familiar with design shapes and can draw them free-hand to his/her satisfaction, it may be helpful to use patterns.

U shapes vary in composition, size, structure, shape and colour. Some U shapes are primary black formlines which help shape outer areas of a given form, while others are internal design elements which fill spaces. Regardless of their colour, filler U shapes are usually joined to the black primary formline at their tapered leg ends; however, in some coastal art styles they can float unattached. As internal design units, U shapes are usually red, green, black or a combination of any of these colours.

U shapes may be paired, joined or stacked within a design's internal spaces. Throughout the four coastal art styles, U shapes range from round ended narrow units with thin side legs and elaborate internal decoration such as dashing, fine lines and crosshatching, to U design elements which are greater in width than in height, are square ended, or arranged in solid colour pairs.

1. Determine length and height of U shape and draw a guideline rectangle. Draw a centre line through the rectangle.

162 *Learning by Designing*: Pacific Northwest Coast Native Indian Art, Volume 1

Making U shape Patterns or Templates continued

Guideline rectangle fold line

Note: regardless of size or shape, U shapes are often drawn using similar formula and curved line rules and structure. U shapes often rotate in space.

side/bottom line curves in and around to parallel rectangle guidelines

2. In *one side only* of the rectangle draw the outside fineline of the U shape.

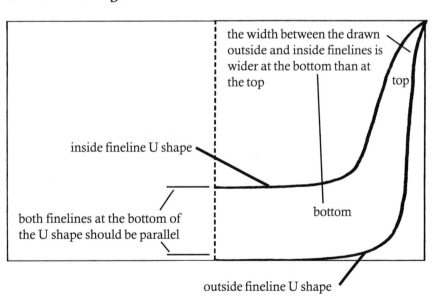

Guideline rectangle

the width between the drawn outside and inside finelines is wider at the bottom than at the top

top

inside fineline U shape

bottom

both finelines at the bottom of the U shape should be parallel

outside fineline U shape

3. Draw another U shape inside the first U shape using the same straight and curved line formula as used in the outside fineline.

Learning by Designing: Pacific Northwest Coast Native Indian Art, Volume 1

How to Draw U shapes

Making U shape Patterns or Templates continued

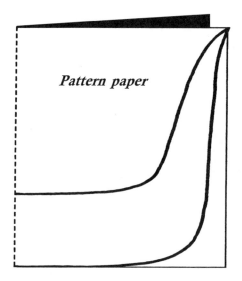

4. Carefully fold pattern paper on the U shape centre line. *First*, cut out on the **inside** U shape fineline. *Second*, cut out on the **outside** U shape fineline.

Drawn fineline north coast art style U shape

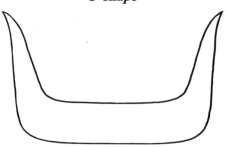

5. Open and lay out cut U shape where needed to complete the design. Trace around the outside of the template. This creates a fineline U shape that is bilaterally symmetrical. U shapes are often free form and modified to represent different things.

Painted formline north coast art style U shape

6. Paint in the area between the inside and outside finelines. This creates a formline U shape. The shape of this U remains the same as it rotates in the design space depending on what it is representing.

How to Draw U shapes for Design Purposes

Below are designs in all four coastal art styles with examples of the different uses of primary formline and secondary filler U shapes. Internal U shapes may be positive or negative. Many feathers, tails, fins, ears, beaks, claws and tongues have pointed extensions.

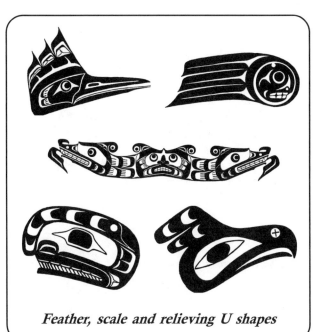

Feather, scale and relieving U shapes

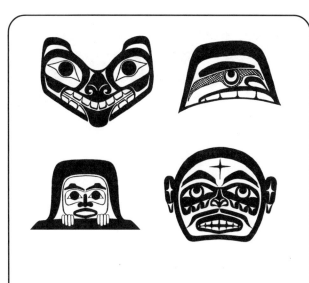

Cheek, ear, tongue, tooth, snout, and mouth U shapes

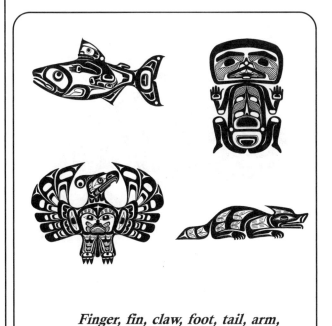

Finger, fin, claw, foot, tail, arm, and leg U shapes

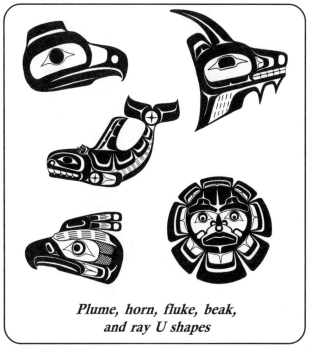

Plume, horn, fluke, beak, and ray U shapes

Learning by Designing: Pacific Northwest Coast Native Indian Art, Volume 1

How to Draw U shapes

U shapes Used in Designs Across Art Styles

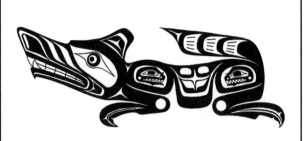

Painted mid coast art style wolf

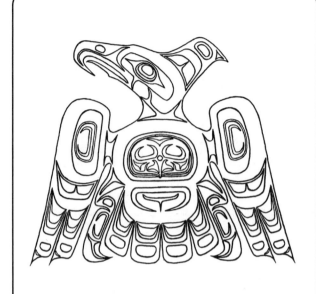

Drawn north coast art style thunderbird

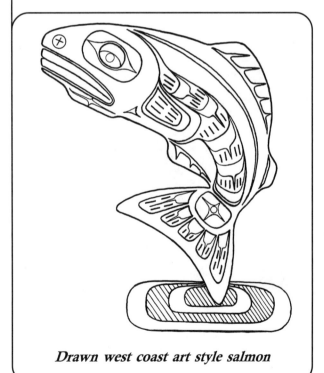

Drawn west coast art style salmon

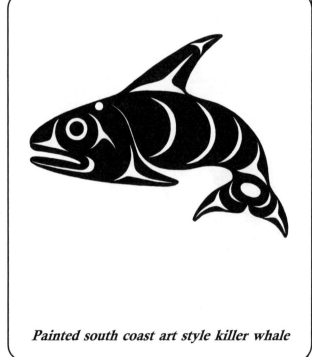

Painted south coast art style killer whale

How to Draw an Eagle Head

The following simple formline design uses ovoids and U shapes to create an eagle head. Initial shapes are drawn, joined, then painted to create the final design. This design is representative of north or mid coast art style.

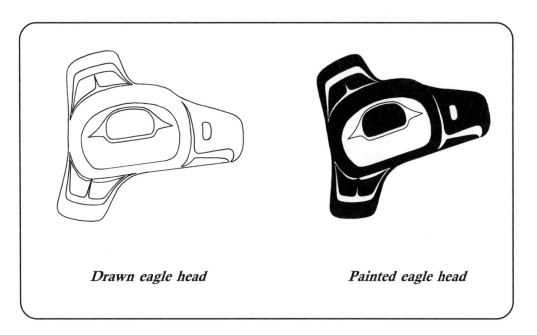

Drawn eagle head *Painted eagle head*

Step 1. Primary ovoid

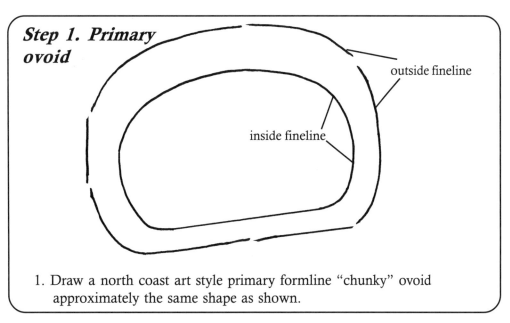

1. Draw a north coast art style primary formline "chunky" ovoid approximately the same shape as shown.

Learning by Designing: Pacific Northwest Coast Native Indian Art, Volume 1

How to Draw Simple Formline Designs - Eagle Head

How to Draw an Eagle Head continued

Step 2. Primary U shapes

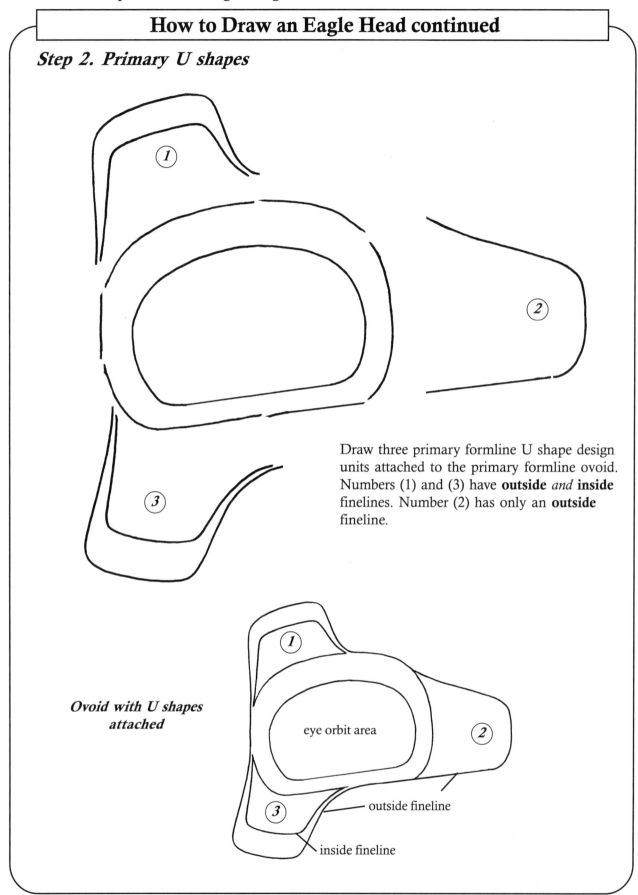

Draw three primary formline U shape design units attached to the primary formline ovoid. Numbers (1) and (3) have **outside** *and* **inside** finelines. Number (2) has only an **outside** fineline.

Ovoid with U shapes attached

168 *Learning by Designing*: Pacific Northwest Coast Native Indian Art, Volume 1

How to Draw Simple Formline Designs - Eagle Head

How to Draw an Eagle Head continued

Step 3. Secondary filler units

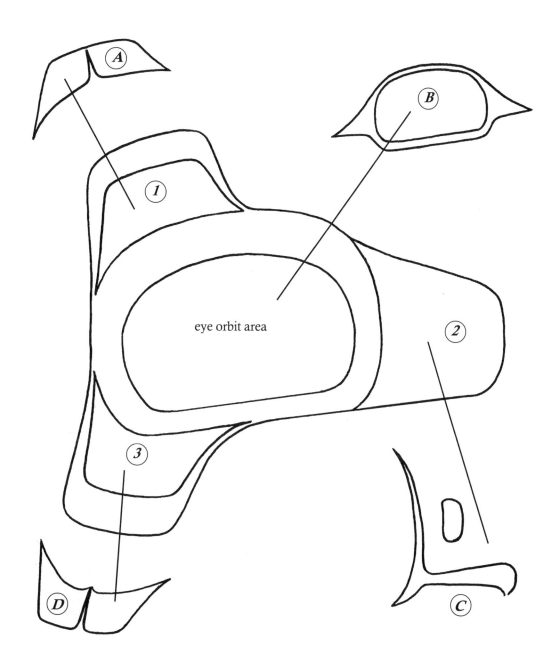

A. Inner secondary filler design units in ear area (1)
B. Eyeball with eyelid line in eye orbit area
C. Beak and nostril detail in area (2)
D. Reverse split U filler in feather area (3)

Learning by Designing: Pacific Northwest Coast Native Indian Art, Volume 1

How to Draw Simple Formline Designs - Eagle Head

How to Draw an Eagle Head continued

The following completed formline designs use ovoids and U shapes to create an eagle head. Initial shapes are drawn, joined, then painted to create the final design. The primary formline, eyeball and eyelid lines are black. Secondary filler units like U shapes and splits can be either black or red.

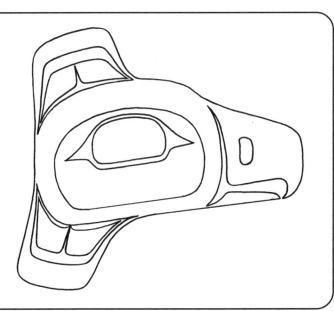

Drawn eagle head with fineline formline edges and secondary filler design units

Step 4. Painted formline

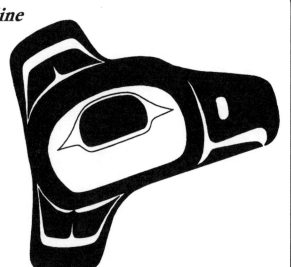

- split U shape filler units can be painted red or black
- split U shape filler units can be joined at the leg ends to the black formline or be unattached and floating
- eyeball and eyelid line are always black

How to Draw Simple Formline Designs - Salmon Head

How to Draw a Salmon Head

The following formline design uses ovoids and U shapes to create a salmon head. Initial shapes are drawn, then painted to create the final design. Use of a reference rectangle or ovoid template is helpful to complete your drawing. Use pencil for the initial drawing, then transfer this drawing to thicker paper or wood for painting.

North coast art style salmon head

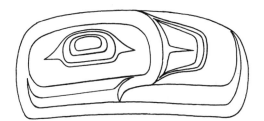

Drawn salmon head

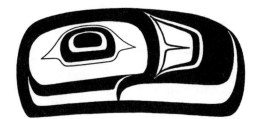

Painted salmon head

Step 1. Reference rectangle

A. Draw a guideline reference rectangle on your paper the desired head size. Draw the head ovoid in this rectangle.

Learning by Designing: Pacific Northwest Coast Native Indian Art, Volume 1

How to Draw a Salmon Head continued

Step 2. Primary formline ovoid

A. Draw an ovoid (1) with an outside fineline.
B. Draw a partial ovoid (2) with an inside fineline parallel to the outside fineline except on the right top (3) where it touches the outside.

Step 3. Eye orbit

A. Draw an inner ovoid (1) in the left side of the primary ovoid extending over the centre line.
B. Draw a partial ovoid around the inner ovoid by drawing a parallel line at front or right side (2) and along the bottom (3) of the inner ovoid. At inner ovoid left turn the bottom line up and taper to join the primary ovoid at (4).

How to Draw a Salmon Head continued

Step 4. Cheek/jaw hinge detail

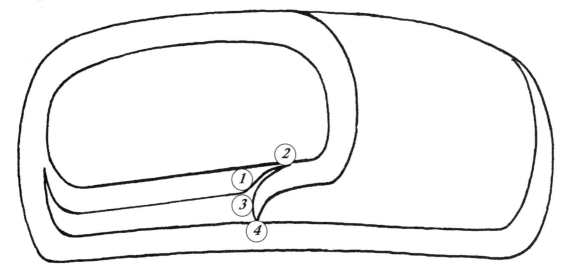

A. Draw a curved fineline (1) from the outside eye orbit fineline to meet the inside eye orbit fineline at (2), tapering the formlines at juncture points.

B. Draw a curved fineline (3) from the outside eye orbit fineline to meet the inside primary formline at (4), tapering the formlines at juncture points.

Step 5. Mouth area

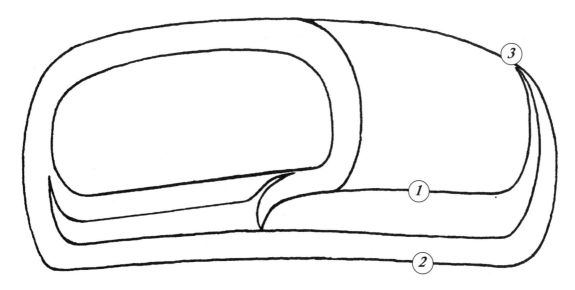

A. Draw an inner fineline (1) from the outside eye orbit, parallel to the bottom of the primary ovoid (2), and curving to the top of the outside primary ovoid.

B. Join at (3) on the outside primary ovoid.

How to Draw Simple Formline Designs - Salmon Head

How to Draw a Salmon Head continued

Step 6. Nose area

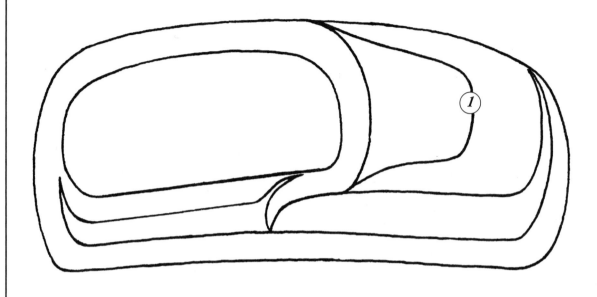

Draw an inner fineline (1) in the nose U shape.

Step 7. Basic fineline drawing of a salmon head

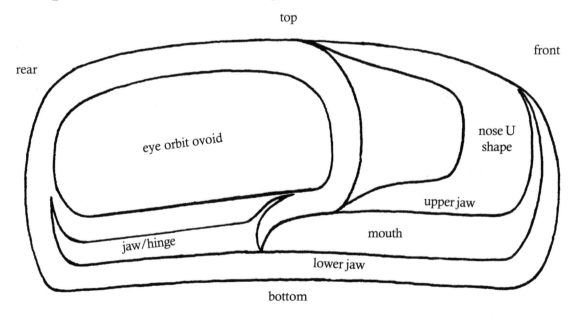

All finelines are actually the edge lines of the primary formlines making up the design. When the areas between the lines are painted in, the formlines will become clearer.

How to Draw a Salmon Head continued

Step 8. Secondary filler design units

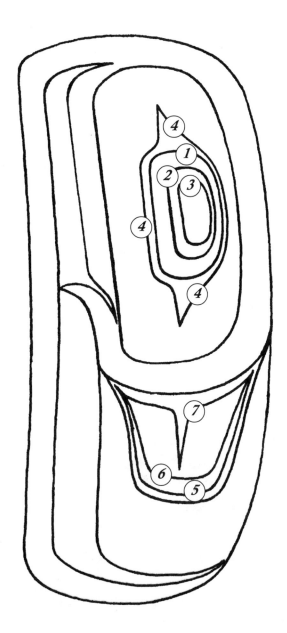

A. Draw the outside fineline (1) of the eyeball ovoid in the central upper eye orbit area.
B. Draw two internal fineline ovoids (2) and (3). All ovoid bottom lines are parallel.
C. Draw a typical north coast eyelid line (4) (bilaterally symmetrical with pointed ends) around the eyeball.
D. Draw outside (5) and inside (6) finelines inside the U shape.
E. Draw a fineline split U (7) inside the U shape.

How to Draw a Salmon Head continued

Colours: Primary formline (eyeball ovoids, eyelid) is black
Secondary formline (nose, mouth, cheek/jaw designs) is black
Split U in nose could be painted red

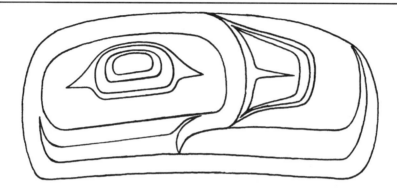

Standard features
1. Ovoid primary formline shape of head
2. Ovoid eye orbit has enclosed secondary design unit of ovoids (eyeball with pupil) with elongated pointed end eyelid lines. Eyeball and eyelid line are in the upper central area of the eye orbit.
3. U shape nose/snout with internal floating split U shape

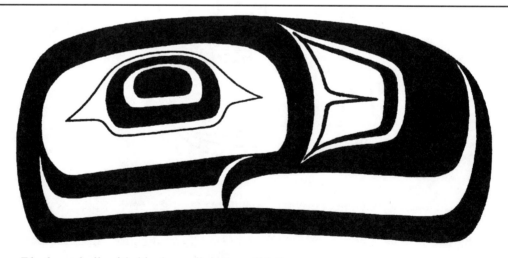

4. Black eyeball with black pupil and eyelid line
5. Inner split U shape in the nose could be painted red
6. Negative space jaw with toothless mouth
7. Eye orbit area inside head ovoid and outside of eyelid line could be painted blue/green

How to Draw Simple Formline Designs - Human Head

How to Draw a Human Head

The following north coast art style formline design uses ovoids and U shapes to create a human head. Initial shapes are drawn, then painted to create the final design. Based on repeated use of ovoid paper pattern templates drawn on folded stiff paper, eye orbits, eyes and heads can be drawn many times.

North coast art style human head

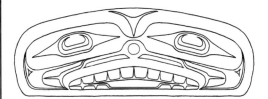
Drawn human head

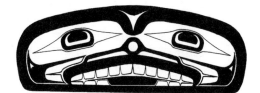
Painted human head

Step 1. Reference rectangle for eye orbit template

A. Draw a guideline reference rectangle on stiff paper approximately half the size of the desired head size.

Learning by Designing: Pacific Northwest Coast Native Indian Art, Volume 1

How to Draw Simple Formline Designs - Human Head

How to Draw a Human Head continued

Step 2. Ovoid eye orbit templates

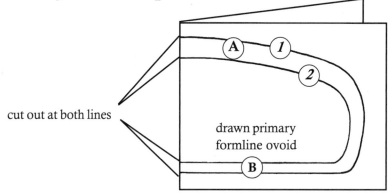

A. Draw a formline ovoid (1) with an outside fineline.
B. Draw a formline ovoid (2) with an inside fineline.
C. Cut out along both lines, cutting inside line first.
D. Formline width at top of ovoid at (A) is greater than width of bottom ovoid formline at (B); ovoid formline side width gradually tapers off from top to bottom in north coast art style. This principle does not hold for other Northwest Coast aboriginal art styles.

Step 3. Eye orbit pattern

A. Open primary formline ovoid paper patterns. One ovoid will be hollow, and the other will be solid. The hollow, or hole, represents the eye orbit.

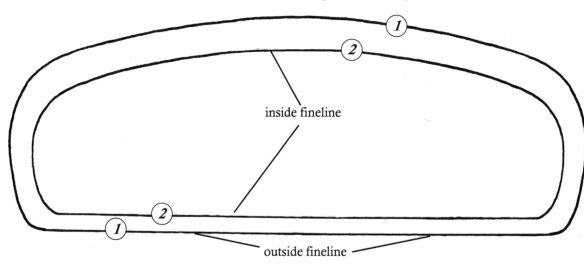

B. When coloured, the space between the drawn finelines of the formline ovoid shapes of (1) and (2) result in a primary formline ovoid.

How to Draw a Human Head continued

Step 4. Ovoid eye orbit templates within a reference rectangle form head ovoid

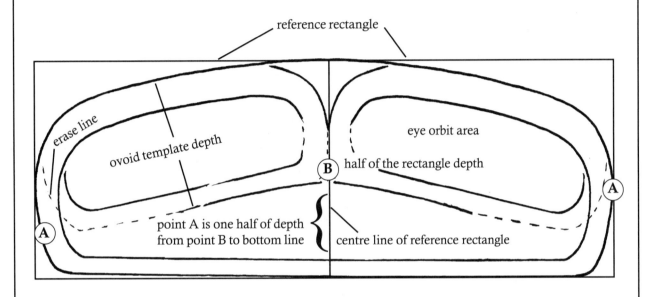

A. Draw a reference rectangle twice as deep as the ovoid template depth.
B. Make the length of reference rectangle twice the length of the ovoid template.
C. Lightly draw the perpendicular centre line of the rectangle.
D. Mark on the centre line the halfway point of the rectangle depth - (B).
E. Mark on the rectangle perpendicular end lines point (A) which is one half the depth from point B on the rectangle centre line to the bottom.

Learning by Designing: Pacific Northwest Coast Native Indian Art, Volume 1

How to Draw Simple Formline Designs - Human Head

How to Draw a Human Head continued

Step 5. Nose, nostrils, and brow line

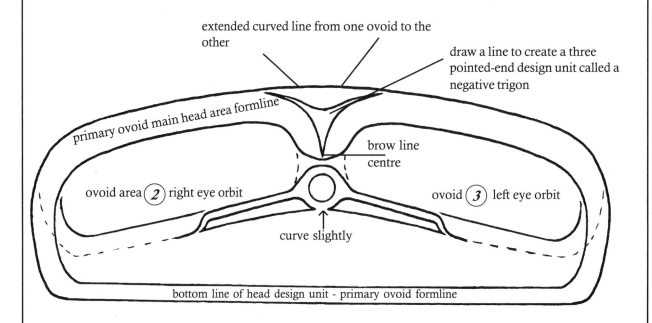

Nose detail

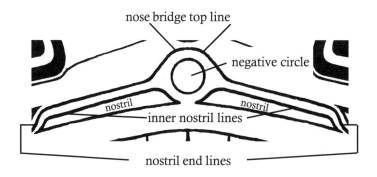

 A. Draw and join brow line.
 B. Draw and join nose bridge top line.
 C. Erase ovoid lines that are no longer needed.
 D. Draw nose weight relieving negative design circle.
 E. Draw two nostril end tapering lines.

How to Draw a Human Head continued

Step 6. Mouth, lips, teeth and tongue

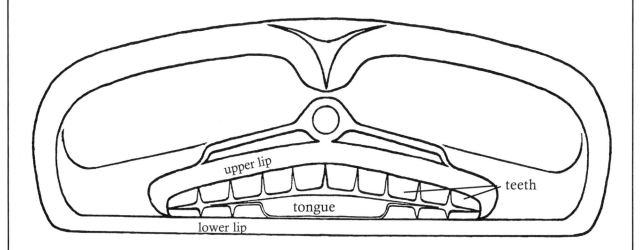

Mouth detail

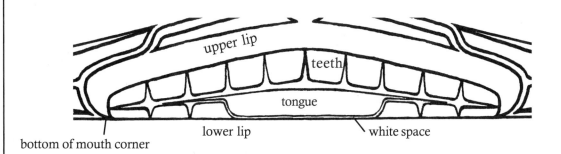

A. Slightly curve the middle top line of the upper lip to join with the nose.
B. Draw the upper lip line and curve down at the mouth ends.
C. Draw the inner line of the top lip.
D. Taper this line to join the upper lip line at the bottom of the mouth corner, joining to the lower lip.
E. Draw the teeth as a series of evenly spaced U shapes.
F. Draw the tongue where the middle bottom set of teeth would have been.

How to Draw a Human Head continued

Step 7. Cheek secondary filler design units

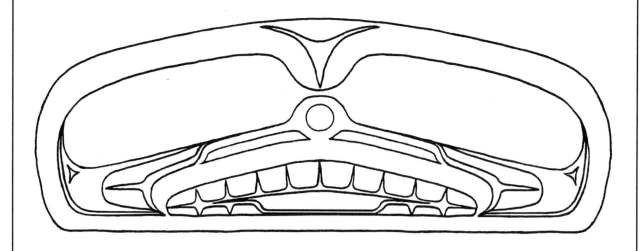

Cheek detail

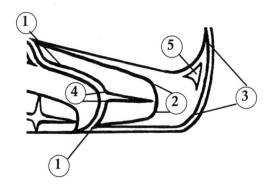

A. Draw a curved line (1) down following mouth curve from joint of nostril and inside lower line of ovoid at the eye orbit to inside line at the bottom of the primary formline head ovoid.
B. Draw a curved line (2) (modified U shape) down from the joint of the nostril into the cheek area almost touching the bottom corner of the mouth.
C. Draw a line (3) starting at (A) (lower mouth corner) and follow the primary formline ovoid until it joins the eye orbit.
D. Draw fineline split design unit (4) in the cheek U shape. The split is sloped parallel to lower line of the eye orbit ovoid
E. Draw a relieving shape (5) in the corner of the cheek close to the eye orbit. Match the lines of the relieving shape to the space.

How to Draw a Human Head continued

Step 8. Eyes

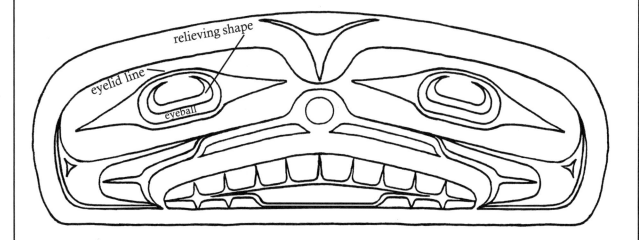

The eye design unit is situated centrally and in the upper area of each eye orbit. The eyeball ovoid is solid black relieved by a negative crescent in the upper area of the eyeball ovoid.

Eye detail

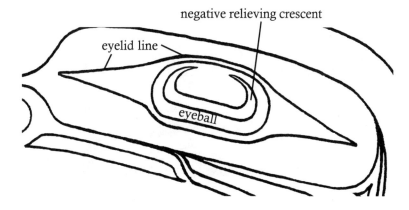

A. Draw or make an ovoid template (method used in making ovoid, steps 1 and 2). The eyeball ovoid length is usually less than one half of inside eye orbit width.
B. Make sure that the bottom line of the eyeball ovoid parallels the bottom line of the eye orbit ovoid.
C. See eyeball and eyelid line construction techniques in the chapter, *How to Draw a North Coast Art Style Eye and Eyelid.*

How to Draw Simple Formline Designs - Human Head

How to Draw a Human Head continued

Colours: Primary formline (eyeball ovoids, eyelid, teeth finelines) black
Secondary formline (nose, lips, cheek designs, tongue) red
Tertiary ground area (eye orbits) green

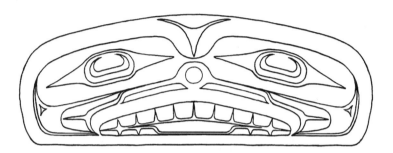

Standard features
1. Ovoid shaped head
2. Bilateral, symmetrical ovoids resulting in two eye orbits with enclosed secondary design units of ovoids (eyes) with enclosed, elongate pointed end eyelid lines (Ovoid eyeball heaviness is relieved by positioning a negative ovoid crescent unit "laying on its back" in upper area of inner ovoid eyeball)
3. Central nose bridge with line weight relieving circle and lateral flaring nostrils both tapering and joining top lip line

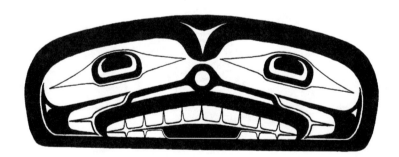

4. Mouth with upper and lower lips (red) - top lip line turns and tapers at ends to touch lower lip (bottom line of primary formline head ovoid)
5. Mouth has fineline, outlined teeth with tongue protruding out and covering lower central teeth
6. Cheek secondary filler design units are red, delineating low or high orbit area and filling space of cheek on either side of the mouth

How to Draw a Killer Whale

The following mid coast art style killer whale (Orca) design uses ovoids, U shapes and filler design units to create a full body complex design. The following exercise shows how to draw an Orca in the leaping position, body arched. Use 11 inch by 17 inch paper of good quality or wood that is smooth and flat. Draw with a pencil and make all guidelines and superficial design lines light to make erasing easier.

Drawn mid coast art style Orca *Painted mid coast art style Orca*

Step 1. Whale body position

Possible Formats

straight
curved
circular

All two-dimensional design line is of two basic forms - straight and circular. Any curved line has characteristics of both.

The following design uses a *curved* guideline to match the arch of the whale's back and head across the paper. The line determines the placement and size of the whale design.

Learning by Designing: Pacific Northwest Coast Native Indian Art, Volume 1

How to Draw Complex Designs - Killer Whale

How to Draw a Killer Whale continued

Step 2. Main design areas

A. Draw a curved line (Orca back line - O.B.L.) slightly above the center of your paper in horizontal format.
B. Mark on the curved O.B.L. the front, rear, and center of the line.
C. Block out the main whale design areas by drawing three guideline ovoids.
 ① Head ovoid - ovoid top line touches O.B.L. and lies to the rear of front mark
 ② Pectoral fin ovoid - ovoid front line adjoins rear of head ovoid - ovoid's bottom line is angled down slightly
 ③ Tail fin ovoid - ovoid centre line is below O.B.L. and its top line lies to the rear of mark on O.B.L.

186 *Learning by Designing*: Pacific Northwest Coast Native Indian Art, Volume 1

How to Draw a Killer Whale continued

Step 3. Whale outline

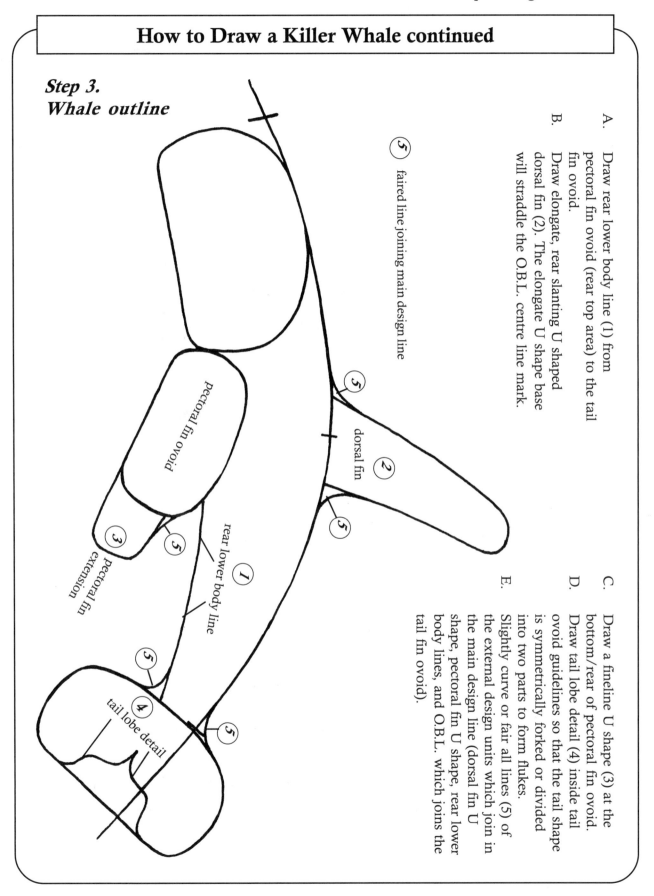

A. Draw rear lower body line (1) from pectoral fin ovoid (rear top area) to the tail fin ovoid.

B. Draw elongate, rear slanting U shaped dorsal fin (2). The elongate U shape base will straddle the O.B.L. centre line mark.

C. Draw a fineline U shape (3) at the bottom/rear of pectoral fin ovoid.

D. Draw tail lobe detail (4) inside tail ovoid guidelines so that the tail shape is symmetrically forked or divided into two parts to form flukes.

E. Slightly curve or fair all lines (5) of the external design units which join in the main design line (dorsal fin U shape, pectoral fin U shape, rear lower body lines, and O.B.L. which joins the tail fin ovoid).

How to Draw Complex Designs - Killer Whale

How to Draw a Killer Whale continued

Step 4. Outside shape

The outside fineline shape of the Orca is now complete. Erase all guidelines and marks. The next step is to draw internal lines to establish primary and secondary form lines, design filler units and details.

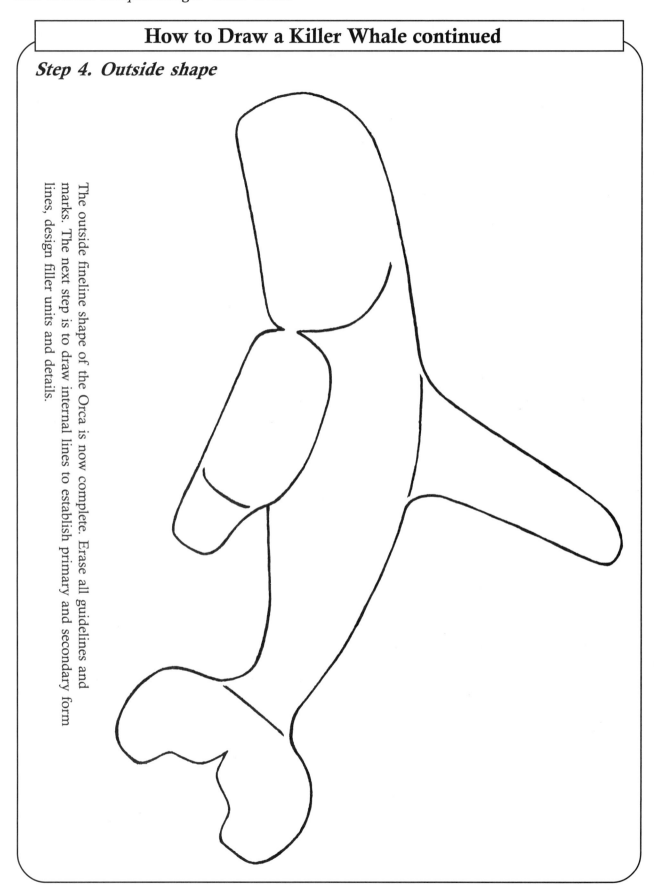

How to Draw a Killer Whale continued

Step 5. Internal units

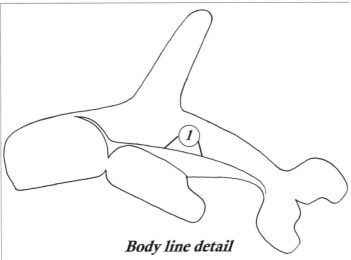

Body line detail

A. Draw a curved fineline (1) from the rear/top of the head ovoid to the lower area of the tail ovoid.

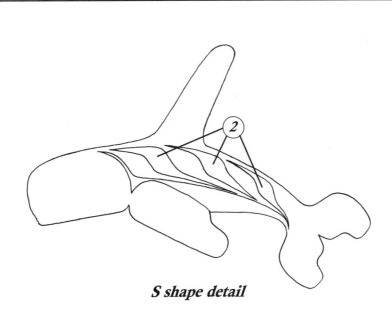

S shape detail

B. Draw three reverse S shaped negative design units (2) in the Orca back area.

How to Draw a Killer Whale continued

Step 6. Head ovoid detail

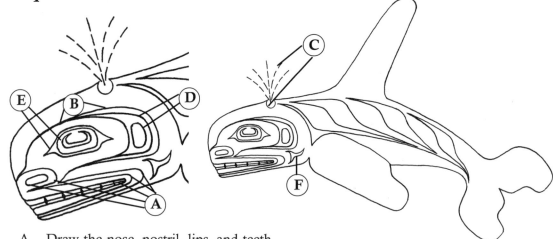

A. Draw the nose, nostril, lips, and teeth.
B. Draw the inside line of the primary formline of the head ovoid.
C. Using a plastic circle template, draw the blow hole and blow spout dashing.
D. Draw the secondary formline filler units in the rear of the eye orbits.
E. Draw the eyeball with relieving crescent and eyelid.
F. Draw the negative design trigon in the rear jaw area.

Step 7. Pectoral fin detail

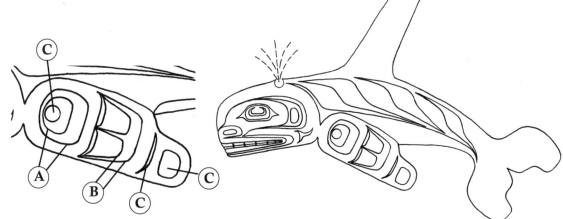

A. Draw the inside of the primary formline ovoid and the inner ovoid.
B. Draw a U shape line with double inner U shapes.
C. Draw the negative design units of the crescent, ovoid, and the circle in the inner ovoid.

How to Draw a Killer Whale continued

Step 8. Tail flukes detail

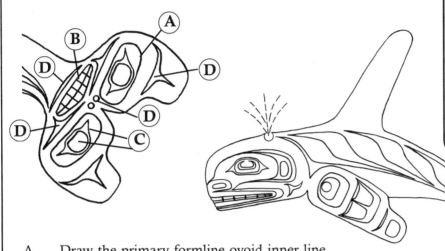

Tip: Draw one half of the tail/head detail design, overlay a piece of tracing paper, trace the ovoid, reverse the paper and transfer the design to the opposite side of the tail by re-tracing or applying pressure to the tracing paper.

A. Draw the primary formline ovoid inner line.
B. Draw the mouth with teeth.
C. Draw the eyeball and eyelid line.
D. Draw the negative design units of trigons in upper U shape and cheek area, the nostrils, and the crescent in the chin area.

Step 9. Dorsal fin detail

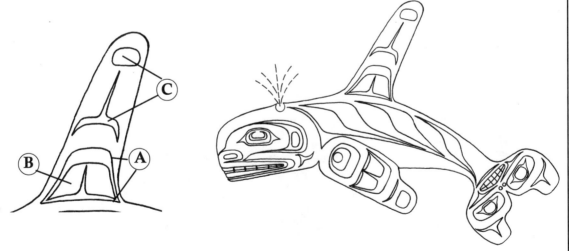

A. Draw the primary formline inside line as a U shape at the fin base.
B. Draw the secondary inner split U shape.
C. Draw the negative design units of the trigon and ovoid.

How to Draw a Killer Whale continued

Step 10. Completed body fineline

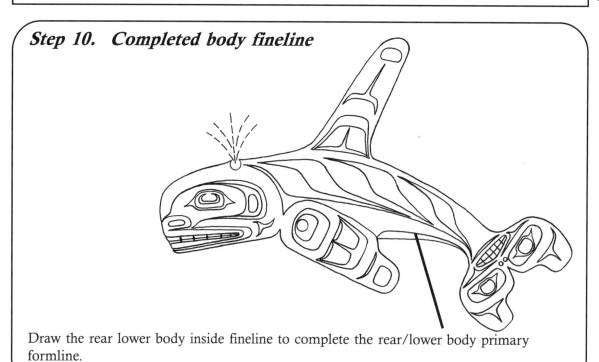

Draw the rear lower body inside fineline to complete the rear/lower body primary formline.

Step 11. Completed design

paint U shape red

paint teeth red

paint nose and lips red

paint double U shape red

Clean up your design lines, erase what you do not need, color, paint or carve.

How to Draw a Wolf Head

The following north coast art style design starts with a realistic drawing of a wolf head, then uses the outline of the same drawing as the basis for drawing and colouring a single colour wolf head using north coast art style design formline principles and rules. This technique will work for many other creatures and art styles, as well.

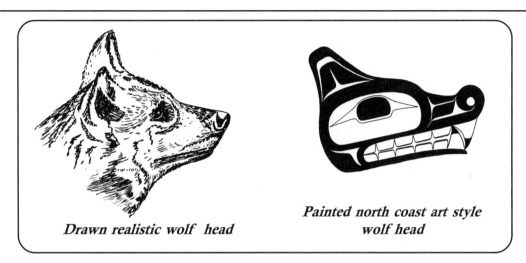

Drawn realistic wolf head

Painted north coast art style wolf head

Step 1. Realistic wolf head reference

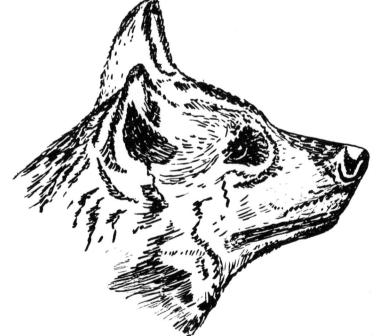

Draw a realistic wolf head or wolf head outline the size of your proposed finished design.

Learning by Designing: Pacific Northwest Coast Native Indian Art, Volume 1

How to Draw a Wolf Head continued

Step 2. Realistic wolf head outline

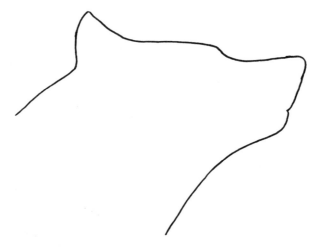

- A. Darken the outline of your original drawing with ink or dark pencil.
- B. Put a new piece of paper over your drawing and secure with tape or paper clip.
- C. Trace over your outline on your new paper.
- D. Remove and file the original drawing.

Step 3. Dotted outline

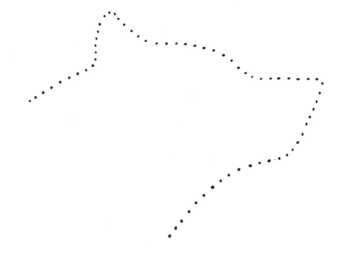

You may choose to do this step without doing Step 2. Either erase some parts of your outline or make a dotted outline instead of the solid outline in Step 2.

How to Draw a Wolf Head continued

Step 4. Fineline outline using dotted realistic guideline

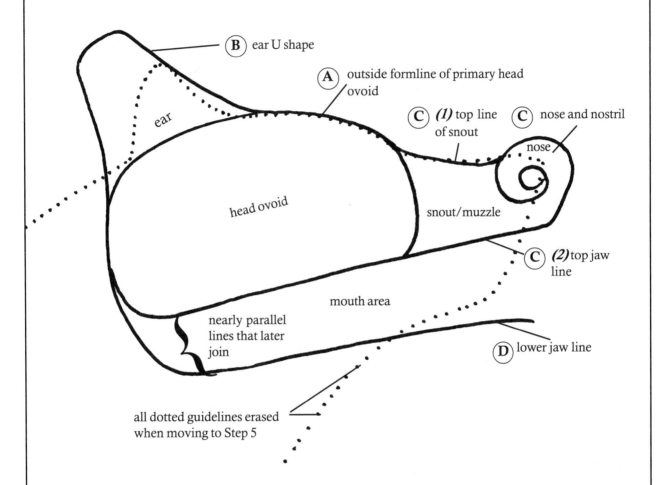

A. Draw the main formline ovoid of the head.

B. Extend the ear length to a somewhat narrow and tapered round-ended U shape which is sloped to the rear of the head.

C. Extend the muzzle/snout length forward from the realistic outline and add the nose with its spiral nostril design.
 (1) Draw a joining line from the forehead area of the formline head ovoid.
 (2) Draw a joining line from the top jaw area of the head ovoid to the lower muzzle/snout area and then curve and taper the line back and around to form a spiral nose with a circular nostril.

D. Draw the lower jaw line from the head formline ovoid rear bottom (jaw hinge area) forward to the jaw tip. Slope this line slightly to accommodate teeth.

Learning by Designing: Pacific Northwest Coast Native Indian Art, Volume 1

How to Draw a Wolf Head continued

Step 5. Ear, eye orbit, inside muzzle and inside mouth

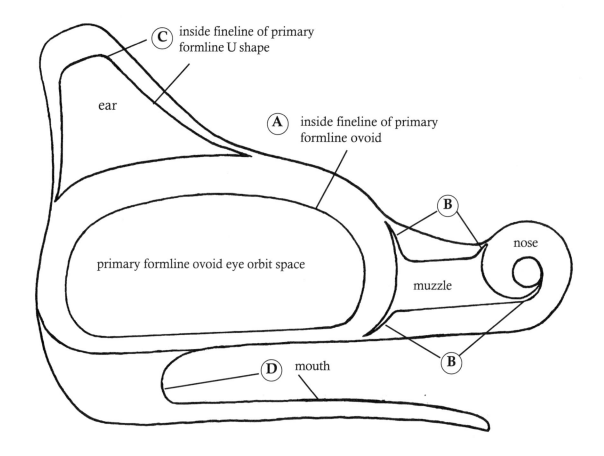

A. Draw the inside fineline of the primary head ovoid. This forms the eye orbit. In north coast art style art, the resulting formline width at the top of the ovoid is wider than at the bottom of the ovoid.

B. Draw the inside fineline of the muzzle formline by curving the line up at both ends to result in a tapered juncture. Make a similar taper at the rear of the top jaw/muzzle line and the coiled end of the spiralled nose line.

C. Draw the inside fineline of the ear U shape.

D. Draw the inside fineline of the mouth area parallel to the existing lower jaw line. Start to curve the inside fineline up to join the primary head ovoid about 1/3 of the way in from the left side of the primary ovoid.

How to Draw a Wolf Head continued

Step 6. Ear split U shape, snout S shape, and the eye

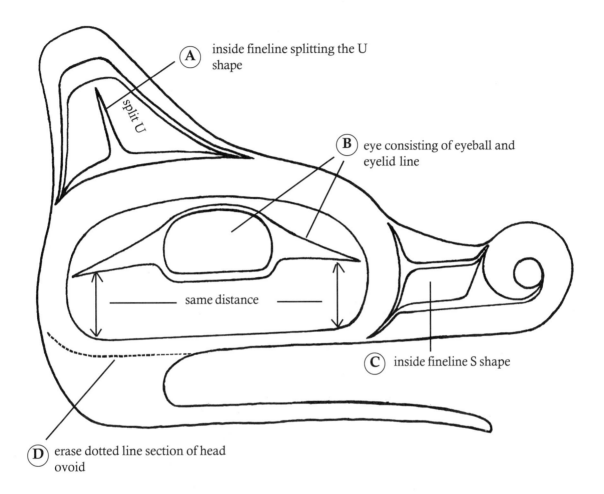

A. Draw the split in the U shape. Since this is a one-colour (black) design, join the tapered bottom lines to the ovoid formline.

B. Draw the eyeball ovoid first. Centre the ovoid from left to right and raise it above the horizontal centre line of the eye orbit. The bottom of the eye ovoid is parallel to the bottom line of the head ovoid. Draw the eyelid line around the eyeball ovoid. This eyelid line is typical of the north coast art style. See the chapter, *Examples of Head Components - Eyes*.

C. Draw the S shape filler in the snout. The top and bottom of the S shape are parallel to the primary formline. Join the tapered, pointed ends to the formline at the top/rear nose area and to the bottom right of the head ovoid.

D. Erase the dotted line section of the head ovoid.

How to Draw a Wolf Head continued

Step 7. Teeth

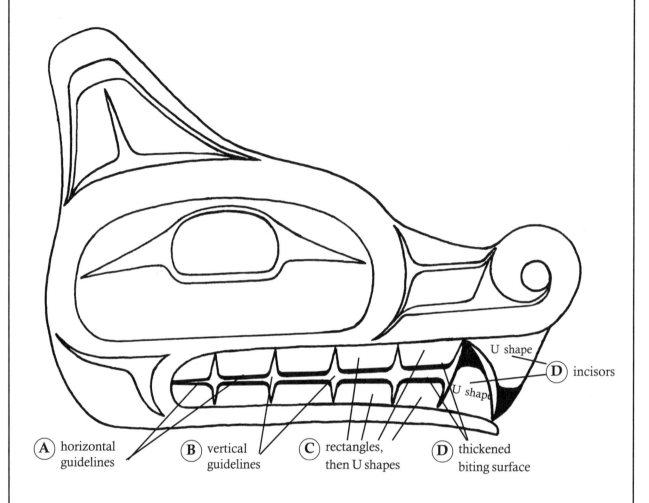

A. Draw two light guidelines that join at the back of the mouth and run parallel to the top and bottom lips. This will represent the biting surface of the teeth. Stop the line where you want the incisor teeth to start.
B. Draw light vertical lines through the horizontal guidelines at equal intervals from the back of the mouth to the incisor teeth. This will separate the individual teeth.
C. You should have a series of five rectangles on the top and five on the bottom. Round off the corners of these rectangles to shape the teeth into U shapes.
D. Draw the two incisor teeth about the same width at each base. They are U shapes with pointed, curved, solid colour extensions.
E. Slightly thicken the biting surface line of the teeth, remembering to fair these lines into the side lines of the teeth.

How to Draw a Wolf Head continued

Design overlay
showing similarities and differences between realistic and north coast art style drawings of a wolf head

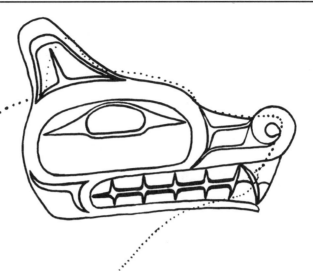

Step 8. Completed design

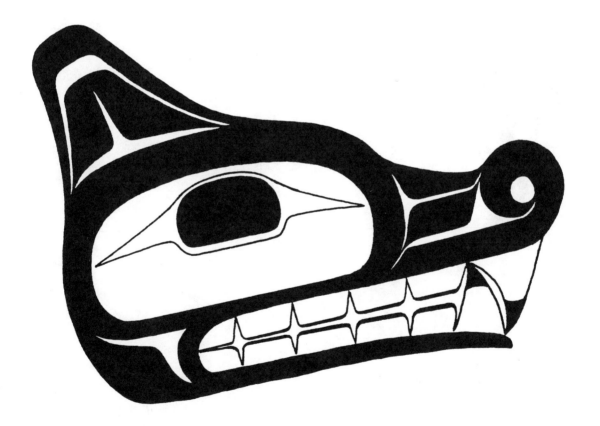

A. Paint or colour in the formline with black.
B. If this design were a multi-coloured design, the split in the ear U shape and the S shape in the snout could be red, the eye orbit outside of the eyelid lines could be blue/green.

How to Draw a Wolf Head Summary

The following diagram is a summary of major steps in using a realistic drawing as the basis for an aboriginal drawing. The heads in northwest coast art are often proportionately large compared to the overall size of the creature.

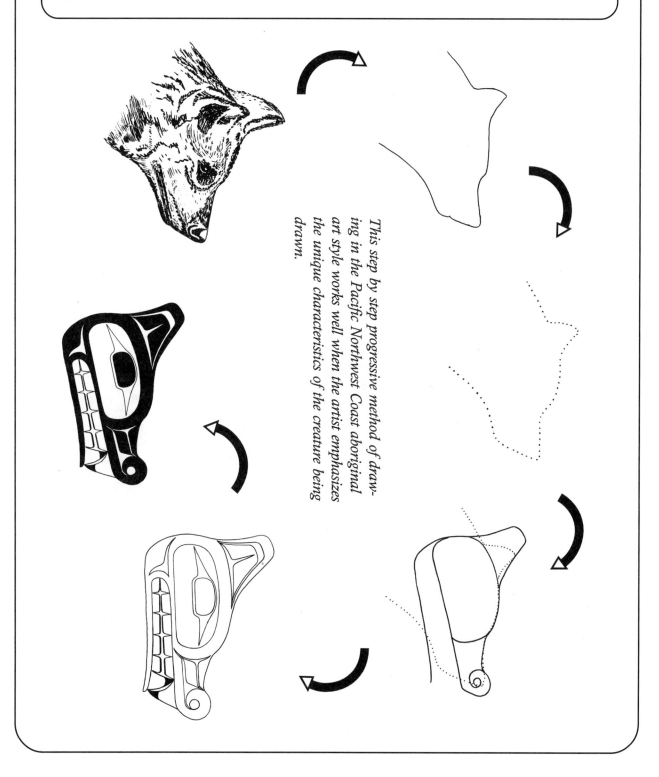

This step by step progressive method of drawing in the Pacific Northwest Coast aboriginal art style works well when the artist emphasizes the unique characteristics of the creature being drawn.

Glossary

General Terms

Aboriginal people
a term defined in the Canadian *Constitution Act* of 1982 that refers to all indigenous people in Canada, including Indians (status and non-status), Métis, and Inuit people.

Aboriginal rights
the freedom to use and occupy traditional lands and resources to maintain a traditional Aboriginal life style. Aboriginal rights are protected in the *Constitution Act* of 1982.

Adipose
soft single rear back fin on salmon, trout and oolichan

Alevin
a newly hatched salmon living in the stream bed gravel

Amphibian
animals such as a frog or salamander that live both on land and in water

Anal
single, rear bottom fin of fish

Anthropologist
scientist who studies societies, customs, and cultures of human beings

Appendage
an attachment or projection to a main part

Argillite
carbonaceous, black, medium soft, shale stone from Slate Chuck Creek area of Haida Gwaii.

Baleen
elongated bristles in the mouth of a whale, used to strain ocean water to filter out food

Band
the legal definition given to distinct groups of Aboriginal clans and families by the *Indian Act*.

Bentwood box/chest
a wooden container whose four sides are formed from a single piece of wood

Bifurcate
divided into two branches

Bighouse
large, ceremonial, community building used by Pacific Northwest Coast aboriginal groups

Bookwus (Bukwus, Bukwis)
Kwakwaka'wakw mythological creature- wild man of the woods

Ceremonial house screen
wooden, woven mat or fabric screens painted with crests, family or cultural designs

Chief
leader of aboriginal peoples who may be either hereditary or elected

Chilkat
a Tlingit First Nations group from northern Alaska

Chinook (spring, Tyee - salmon)
largest of the Pacific salmon

Chum (salmon)
most abundant and widespread spawning salmon in the Pacific (usually preserved by smoking)

Clan
a tribe bearing the same surname, united under a chief, a set of persons having common ancestors

Clasper
a rear appendage on a male dogfish (shark or other fish) used during breeding

Coho (salmon)
Pacific salmon with red flesh

Contemporary
living or happening at the same time; present-day

Copper
a valuable, large shield-like sheet of heavy copper plate, often painted, usually associated with wealth and potlatches

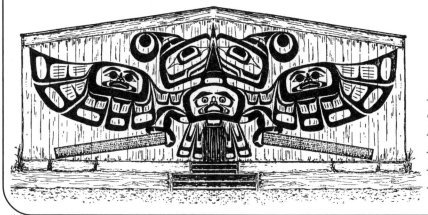

Kwakwaka'wakw house front design showing Thunderbird helping to build the first big-house at Nimpkish River by lifting and placing the large roof beams.

Learning by Designing: Pacific Northwest Coast Native Indian Art, Volume 1

Glossary - General Terms continued

Crest
an identifying family emblem or heraldic design or object

Culture
a way of life, customs, ways, habits, and values of a group of living things

Curio
a rare or unusual object eliciting curiosity

Dogfish
small Pacific shark

Dorsal fin
medial upright fin on the back of the creature

Dzunukwa (Tsonoqua, Tsonokwa, Dzonoqwa, Dsonoqwa, Sanuukwa)
a Kwakwaka'wakw mythical giantess - wild woman of the woods

Edenshaw, Charles
Haida master artist, 1839-1924

Elder
a person who lives a good life, is kind, caring, wise, and respected in the community, and who shares his or her experiences and cultural knowledge.

Elected chief
a person elected chief of the band in a Department of Indian Affairs election held according to the *Indian Act*

Ethnography
scientific study of human races and cultures

Eye socket
depression or hole in the skull which contains the eyeball complex

Face on
front view

First Nations
self-determined political and organizational unit of the Aboriginal community that has the power to negotiate, on a government-to-government basis, between the province and Canada; also used instead of "First People" to designate aboriginal people

First Peoples
aboriginal peoples of Canada; includes Indians, Inuit, and Métis

Flipper
limb of a sea mammal, used for swimming

Floating
unattached, free

Flukes
either of the two lobes of a whale's tail

Frontally
front view, as seen by an onlooker

Frontlet
a woven, carved, painted, and often inlaid forehead headdress depicting a crest, worn for display or dancing

Geekumhl (gikaml)
Tsonoqua mask worn by chief, associated with the power and wealth of the copper

Gill filaments
soft red filaments which project from gill arch and absorb oxygen from the water

Gill rakers
projections on gill arch which help strain food from the water

Gitksan
people of the central Skeena River, classified as the Tsimshian

Grease
semi-solidified oolichan fish oil used as a condiment and sometimes as a unit of exchange

Guardian spirit
ritualistically acquired mystical spirit, protector or defender

Haida
First Nations people of Haida Gwaii (Queen Charlotte Islands)

Haida Gwaii
First Nations name given to the Queen Charlotte Islands

Haisla
First Nations people of the Kitimat area of the B.C. coast

Headdress
covering or ornament for the head

Heiltsuk
First Nations people of the Bella Bella area of the B.C. coast

Hereditary chief
inherited leadership position of Nation(s) based on clan and/or family affiliation

House front
edge set upright cedar boards on a bighouse front, facing the water with a large, often painted crest design

Humpback (salmon or whale)
species of small Pacific salmon or large baleen-type whale

Indian
a term used historically to describe the first

Glossary - General Terms continued

inhabitants of North and South America and used to define indigenous people under the *Indian Act*. It is a term used to distinguish between the three general categories of Aboriginal people (Indians, Inuit and Metis). The term has generally been replaced by *Aboriginal people*, as defined in the *Constitution Act* of 1982. Most Canadian Aboriginal people today prefer to be known as First Nations people.

Indian Act
the principal federal statute dealing with Registered Status Indians or Treaty Indians, local government, and the management of reserve lands and communal monies.

Indigenous
living or occurring naturally in a specific region

Kaigani
people of Haida Gwaii origin who reside on islands in southern Alaska

Kuhlus (Kolus, Kohlus, Kulus)
mythological Kwakwaka'wakw bird, brother of Thunderbird

Kwagulth (Kwagiulth, Kwagyul)
name of the First Nations people of the Fort Rupert area of Vancouver Island

Kwakiutl
former name given to the Kwakwaka'wakw Nation

Kwakwaka'wakw
First Nations people of the mid coast who speak the Kwakwala language

Labret
ornament of wood, bone, stone inserted in lower lip of women

Language groups
term used by linguists and anthropologists to categorize Aboriginal cultures

Legend
a traditional story of a specific culture often blending the historical and the supernatural

Lightning snake
a mythological, supernatural serpent with large head and extended tongue, said to create lightning and usually associated with Thunderbird

Longhouse (bighouse)
Native ceremonial building for large gatherings, potlatches, dances or funerals, formerly used as extended family homes

Makah
First Nations people who live on the northwest tip of the Olympic Peninsula (Nuu Chah Nulth nation)

Master carver or artist
a recognized, skilled individual who is able to teach all aspects of the trade to others

Membrane
a thin pliable partition, boundary or lining

Mouse woman
small supernatural old woman of the north coast First Nations myths, taking the form of a mouse, grandmother of Raven

Muzzle
nose and mouth of an animal

Myth (mythological)
a traditional tale usually about supernatural events or creatures

Nakapenkem
Kwagiulth name given to master carver and chief Mungo Martin (meaning "a potlatch chief ten times over")

Nisga'a (Nishga, Nisaka, Niska)
First Nations people living along the Nass River in northern B.C.

Nuu Chah Nulth (formerly Nootka)
First Nations people living on the west coast of Vancouver Island and northwest coast of Washington (Olympic Peninsula - Makah)

Nuxalk (formerly Bella Coola)
First Nations people living in the Bella Coola Valley region of the interior, central B.C. coast

Oolichan (eulachan, ooligan)
a schooling small fish; extremely oily; rendered for the oil by First Nations people

Orca (blackfish, killer whale)
a small, toothed black and white dolphin (whale)

Partition and dance screens
wooden, mat or fabric screens which partition off parts of a house

Pectoral
relating to front or upper area of body

Pelvic
relating to the bony basin-shaped cavity at the base of the human trunk

Plume
feather or tuft of feathers, a crest on a helmet; a token of honour; indicates mythological creature in northwest coast art

Potlatch
a Chinook term meaning "give." A potlatch is a traditional ceremony, practised by many Aboriginal people of the Northwest coast, at which the hosts present gifts to their guests who witness and validate social claims

Glossary - General Terms continued

Potlatch rings
enclosed, disc-shaped, cylinders of woven fibre fastened and stacked upright on the crown of ceremonial hats said to show the number of potlatches given by the wearer

Proboscis
a long flexible snout or mouth such as found on an insect or elephant seal

Profile
side view or outline

Raptor
any bird of prey

Regalia
traditional and/or ceremonial clothing and headdress

Semi-realistic
partially realistic or not quite real

Shaman
an individual with access to the world of good and evil spirits

Sisiutl
mythical mid coast art style two-bodied serpent with central human head

Sockeye (salmon)
Pacific salmon with prized red flesh

Soul catcher
carved bone amulet, often inlaid with abalone used by a shaman to retrieve the lost spiritual part of a human being

Speaker's staff (talking stick)
long staff held by the speaker at a gathering indicating the person holding the staff has the authority to speak

Spirit helper
personal guardian spirit acquired through ritualistic questing

Sternum
central breast bone

Supernatural
having magical or mystical forces beyond the powers or laws of nature

Symbolic (symbolism)
use of symbols, image or figure to represent something else

Tlingit
First Nations people of the Alaska panhandle

Tobacco mortar
small stone vessel used to prepare plant leaves for chewing

Totem pole
carved cedar pole, often very large, traditionally placed upright facing the sea in front of a village or house, representing family history

Traditional
1. of, based on, or handed down by tradition (including European influences such as bead work on moccasins)
2. most Aboriginal practices and beliefs, especially those not influenced by European contact

Transformation
change of outward appearance or inner nature from one form to another

Treaty
in the provincial context, an agreement arrived at between British Columbia, Canada, and Aboriginal people in the province. It can clarify Aboriginal rights to land and resources and address issues such as self-government and the social, economic, and environmental concerns of all parties. Treaties are intended to meet the government's requirement to recognize and negotiate with First Nations. Treaties will define, for example, the applications of Aboriginal rights and the extent and exercise of First Nations governance.

Tsimshian
First Nations people of the lower Skeena River and the coastal areas south of it, sometimes includes the Nisga'a and Gitksan

Underworld
under the earth in a supernatural region

Vertebrae
segments of the backbone

Wasgo (Wasco)
large supernatural sea wolf of Haida mythology

Welcome poles (figures)
carved red cedar, single figure sculptures, usually humans with outstretched arms, palms up

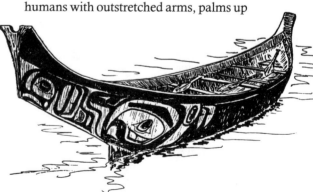

North coast style cedar canoe

Glossary

Art Terms

Abstract
effect achieved by grouping shapes and colours in patterns rather than by recognizable physical reality

Applique
a fabric artwork where one piece of material is cut out to a specific pattern and then applied to another

Artistic licence
an artist's own deviation or irregularity of standard practice or rule

Asymmetrical
lack of symmetry or balance; two parts are not the same

Bas relief
carving where the design projects slightly from the background

Bilateral symmetry
division into two identical, balanced, uniform halves

Bundle dashing
parallel lines arranged in groups or bundles with spaces between lines and bundles

Calligraphy
fine handwriting style

Concave
hollow and curved inward

Concentric
having a common centre

Conical
(cone-like) a solid body tapering to a point from a solid base

Contemporary artist
living artist practising latest ideas, theories, forms, or styles

Convex
curving outwards; bulging

Crescent
a curved shape with two pointed ends; like the young moon in shape

Crosshatching
surface decoration of intersecting parallel finelines

Dashing (dash lines)
parallel finelines, with breaks, drawn in uniform fashion

Delineate
to draw an outline; describe in words

Design unit
single plan, pattern or element

Elongated
long in proportion to width

Enclosed
to surround; to envelope; to contain

Encircle
to enclose in a circle; to surround

Engraving
surface design, carved or cut on a hard medium such as wood, metal or stone

Face-on
front view so that the whole face can be seen

Fair
a term describing an adjoining line which curves at the juncture point

Free form
design unit or complex which is recognizable in form rather than abstract

Flat design
design on a single dimension with little or no depth

Filler unit
design element placed within enclosing formline so as to fill or partially fill the given space

Fineline
a drawn, painted or carved line of minimum width

Formline
is a continuous, curving line which swells and shrinks in width throughout its length, seldom becoming parallel with other lines and delineating a form or a shape (See diagram next page)

Hatching
design of close parallel lines, and angled finelines

Incised
cut into, engraved, carved

Inverted
turned about, around, or upside down

Joiner lines
short lines which join major formline units together to create a total continuous formline

Glossary - Art Terms continued

Formline - Mid coast art style human holding a copper

Negative areas define the limits of the edge or boundary of the formline and its contained design units. These same negative areas also help the form flow by relieving otherwise heavy coloured areas. At some formline junctions, the resultant negative areas formed can be enriched by hatching or crosshatching. Negative areas in mid and west coast art styles may also contain rows of dashes, dots or straight lines.

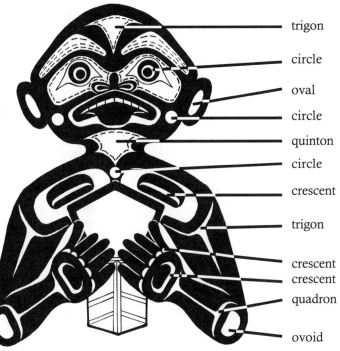

- trigon
- circle
- oval
- circle
- quinton
- circle
- crescent
- trigon
- crescent
- crescent
- quadron
- ovoid

Lateral
relating to the side

Legs
two long side extensions of a U shape

Limited edition print
a graphic which has a finite number of printings - usually titled, numbered and signed by the artist

Medially joined
connected in the middle

Native art
artworks in Northwest Coast tradition from the hands of First Nations artists

Native art style
artworks in Northwest Coast tradition from the hands of non-First Nations artists

Negative space
a design area, background space or element between positive design shapes

Non-concentric
design characteristic where elements do not have a common centre

Oval
egg-shaped, or elliptical, design unit

Ovoid
is a bilaterally symmetrical design unit which is extremely flexible in shape and can vary from a near circle to a shallow, elongated, rectangle with rounded corners

Perspective
drawing so as to give the impression of relative distance, size or position

Primary formline
continuous, typically black line which forms the main design shape

Quadron
closed figure with four curved sides and four points, usually negative, that delineates or helps outline the shapes in a design

Quinton
closed figure with five curved sides and five points, usually negative, that delineates or helps outline shapes in a design

Learning by Designing: Pacific Northwest Coast Native Indian Art, Volume 1

Glossary - Art Terms continued

Relieving shapes/units/spaces
elements or shapes, usually negative, within or bordering positive formlines or solid-colour design elements which help relieve solid colour mass in a design (See **Formline** - previous page)

S shape
is a formline and secondary design unit that is shaped like the letter "S". S shapes can be found reversed or rotated.

Salmon head
design of Tlingit origin, which is a common design unit that contains essential features representing a salmon head

Secondary formlines
formlines enclosed, floating or joined to primary formline, usually design filler units

Serigraph
an artistic print made by the silk-screen printing process

Spherical
having the shape of a round solid body like a ball

Split design
a design in which a creature is split into two halves, usually identical, but remains joined in some area

Stacked
orderly arrangement of joined units, one on top of the other

Stylized
fixed artificial manner or tradition

Symbolism
use of symbols, images, figures to represent an idea

Symmetry
exact duplication of opposite sides of a design

Tertiary
term given to isolated formline design elements or areas which are enclosed by primary or secondary elements, usually classed as background or base

Transformation mask
a multiple identity mask which opens to reveal one or more humans or creatures

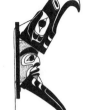

Trigon
closed negative design element with three curved sides and three points, often seen as T or Y shaped, that delineates or helps outline shapes in a design

U shape
is a formline and secondary design unit that is shaped like the letter "U". U shapes can be found reversed or rotated in a design

U shape (fineline split)

U shape

Fineline split U shape

U shape (solid split)

Solid split U shape

U shape (reverse split)

Reverse split U shape

X-ray vision
design technique to show a creature's internal structure

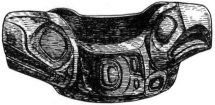

North coast style wooden grease dish with whale and eagle design

Learning by Designing: Pacific Northwest Coast Native Indian Art, Volume 1

Bibliography

Abbott, Donald M. ed. *The World is as Sharp as a Knife, An Anthology in Honour of Wilson Duff.* Victoria, B.C.: British Columbia Provincial Museum, 1981.

Arima, Eugene Y. *The Westcoast (Nooka) People.* Special Publications 6, Victoria, B.C.: British Columbia Provincial Museum, 1983.

Averil, L. and D. Morris. *Northwest Coast Native and Native-style Art.* Seattle Washington: University of Washington Press, 1995

Barbeau, C. Marius. *Haida Carvers in Argillite.* Ottawa: Department of Northern Affairs and Natural Resources, National Museum of Canada, 1957.

Blackman, Margaret B. and Edwin S. Hall. *Contemporary Northwest Indian Art: Tradition and innovation in Serigraphy.* American Indian Art Magazine, Vol. 6, no. 3, Summer 1981.

Blackman, Margaret B. and Edwin S. Hall. *The Afterimage and Image After: Visual Documents and the Renaissance in Northwest Coast Art.* American Indian Art Magazine, Spring no. 2, 1982.

Boas, Franz. *The Social Organization and Secret Societies of the Kwakiutl Indians.* Report to the United States National Museum, 1895. Washington, D. C., 1897.

Boas, Franz. *The Mythology of the Bella Coola Indians.* Memoirs of the American Museum of Natural History, Vol. 2, pt. 2. New York: American Museum of Natural History, 1898: 25 - 127.

Boas, Franz, and Hunt, George. *Kwakiutl Texts.* Second Series. Publlications of the Jesup North Pacific Expedition, vol. 10. Leiden: E. E. Brill, 1906.

Boas, Franz. *Ethnology of the Kwakiutl.* Thirty-fifth Annual Report of the Bureau of American Ethnology. Washington, D.C., 1921.

Boas, Franz. *Primitive Art.* New York: Dover Publications, Inc., 1955.

Brown, Stephen C. *The Spirit Within.* Seattle, Washington: Seattle Art Museum, 1995.

Brown, Stephen C. *Native Visions.* Seattle, Washington: University of Washington Press, 1998.

Carlson, Rog, ed. *Indian Art Traditions of the Northwest Coast.* Burnaby, B.C.: Archaeology Press, Simon Fraser University, 1983.

Clark, Karin and Jim Gilbert. *Learning by Doing Northwest Coast Native Indian Art.* Victoria, B.C.: Raven Publishing, 1990.

Childerhose, R.J. & Marj Trim. *Pacific Salmon & Steelhead Trout.* Vancourver, B.C.: Douglas & McIntyre, 1979.

Cocking, Clive. "Indian Renaissance/New Life for Traditional Art", UBC Chronicle. University of British Columbia, Winter, 1971.

Coe, Ralph T. *Sacred Circles: Two Thousand Years of North American Indian Art.* London: Arts Council of Great Britain, 1976.

Conn, Richard. *Native Indian Art in Denver Art Museum.* Denver: Denver Art Museum, 1979.

Davidson, Robert. *A Voice from the Inside.* Vancouver: Gallery of Tribal Art, 1992.

Davidson, S.J. "Kerf-bent Boxes: Woodworking Techniques and Carving Tools of the Northwest Coast." Fine Wood. May/June, no. 22, 1980.

Dawn, Leslie. *The Northwest Coast Native Print: A Contemporary Tradition Comes of Age.* Art Gallery of Greater Victoria. 1984.

DeMott, Barbara. *Beyond the Revival, Contemporary Northwest Native Art.* Vancouver: Emily Carr College of Art and Design, 1989.

Drew, Leslie and Douglas Wilson. *Argillite: Art of the Haida.* Surrey, B.C.: Hancock House Publishers, 1980.

Drew, Leslie. *Haida, Their Art and Culture.* Surrey, B.C.: Hancock House Publishers, 1982.

Drucker, Philip. *Indians of the Northwest Coast.* Garden City, New York: The National History Press, 1963.

Duff, Wilson, Bill Holm, and Bill Reid. *Arts of the Raven.* Vancouver, B.C.: Vancouver Art Gallery, 1964.

Duff, Wilson. *Master Pieces of Indian and Eskimo Art From Canada, The Northwest Coast.* National Gallery of Canada, 1969 - 70.

Fair, S.W. *Alaska Native Arts and Crafts.* Alaska Geographic, Vol. 12, No. 3, 1985.

Feder, Norman. *Incised Relief Carving of the Halkomelem and Straits Salish,* American Indian Art 8, no. 2, 1983.

First Annual Collection 'Ksan 1978 Original Graphics. Vancouver, B.C.: Children of the Raven Publishing Inc., 1978.

Gunther, Erna. *Viewer s Guide to Indian Cultures of the Pacific Northwest.* University of Washington, 1955.

Haberland, Wolfgang. *Donnervogel und Raubwal: Die Indianische Kunst der Nordwestkueste Nordamericas.* Museum fur Volkerkunde and Christians Verlag, Hamburg, 1979.

Hall, Edwin S. Jr. & Blackman, Margaret B. *Northwest Coast Indian Graphics.* Seattle and London: Washington Press, 1981.

Bibliography continued

Hawthorn, Audrey. *Art of the Kwakiutl Indians and Other Northwest Coast Tribes.* Seattle: Univerity of Washington Press, 1967.

Hawthorn, Audrey. *Kwakiutl Art.* Seattle: University of Washington Press, 1967.

Hoffman, Gerhard ed. *Zeitgenossische Kunst der Indianer und Eskimos in Kanada.* Edition Cantz, Stuttgart, 1988.

Holm, Bill. *American Indian Art Form and Tradition. Heraldic Carving Styles of the Northwest Coast.* Minneapolis: Minneapolis Institute of Arts, U.S.A., 1972.

Holm, Bill. *Crooked Beak of Heaven.* Seattle: University of Washington Press, 1972.

Holm, Bill. *Northwest Coast Indian Art: An Analysis of Form.* Seattle and London: University of Washington Press, 1970.

Holm, Bill. *Smokey-Top: The Art and Times of Willie Seaweed.* Seattle: University of Washington Press, 1983.

Holm, Bill. *Spirit and Ancestor, A Century of Northwest Coast Indian Art at the Burke Museum.* Monograph 4. Seattle: University of Washington Press, 1967.

Holm, Bill. "Structure and Design." In William C. Sturtevant, comp., *Boxes and Bowls: Decorated Containers by Nineteenth Century Haida, Tlingit, Bella Bella, and Tsimshian Indian Artists.* Washington, D. C.: Smithsonian Institution Press, 1974.

Holm, Bill. "The Art of Willie Seaweed: A Kwakiutl Master." *The Human Mirror: Material and Spatial Images of Man.* Edited by Miles Richardson. Baton Rouge: Louisiana University Press, 1974.

Holm, Bill. *The Box of Daylight: Northwest Coast Indian Art.* Seattle: Seattle Art Museum and University of Washington Press, 1983.

Holm, Bill. "Will the Real Charles Edensaw Please Stand Up?": The Problem of Attribution in Northwest Coast Indian Art." *The World is as Sharp as a Knife: An Anthology in Honour of Wllson Duff.* British Columbia Provincial Museum, Victoria, 1981.

Holm, Bill, and Bill Reid. *Indian Art of the Northwest Coast: A Dialogue on Craftsmanship and Aesthetics.* Houston: Institue for the Arts, Rice University, 1975.

Inverarity, Robert Bruce. *Art of the Northwest Coast Indians.* Berkeley: University of California Press, 1950.

Jenness, Diamond. *The Faith of a Coast Salish Indian.* Anthropology in British Columbia Memoirs 3. Victoria, B.C.: British Columbia Provincial Museum, 1955.

Jonaitis, Aldona. *Art of the Northern Tlingit.* Seattle: University of Washington Press, 1986.

Jonaitis, Aldona. *Tlingit Halibut Hooks: An Analysis of the Visual Symbols of a Rite of Passage.* Anthropological Papers of the American Museum of Natural History, Vol.57, pt. 1, 1981.

Jonaitis, Aldona. *From the Land of the Totem Poles: the Northwest Coast Indian Art Collection at the American Museum of Natural History.* American Museum of Natural History, New York. Vancouver: Douglas and McIntyre, 1988.

Kaplan, Susan A., and Kristin J. Barsness. *Ravens Journey.* Philadelphia: University of Pennsylvania, 1986.

Keithahn, Edward L. *The Authentic History of Shakes Island and Clan.* Wrangell, Alaska: The Wrangell Sentinel, 1940. Reprint, Wrangell Historical Society, 1981.

Keithahn, Edward L. *Monuments in Cedar.* Seattle: Superior Press, 1963.

McDonald, George. *'Ksan, Breath of Our Grandfathers.* Ottawa: National Museum of Man, Communications Division, 1972.

McDonald, G.F. *Haida Art.* Vancouver: Douglas & McIntyre, 1996.

Macnair, Peter, Alan L Hoover, and Kevin Neary. *The Legacy: Continuing Traditions of Canadian Northwest Coast Indian Art,* Victoria, B.C.: British Columbia Provincial Museum, 1980.

Macnair, Peter L. et al. *The Legacy, Traditions and Innovation in Northwest Coast Art.* Vancouver: Douglas & McIntyre, 1984.

Mayhew, Anne. "Return of the Salmon Eaters." Beautiful British Columbia Magazine, Fall 1990.

Northwest Coast Indian Artists Guild 1977 Graphics Collection. Ottawa: Canadian Indian Marketing Services, 1978.

Northwest Coast Indian Artists Guild 1978 Graphics Collection. Ottawa: Canadian Indian Marketing Services, 1978.

Nuytten, Phil. *The Totem Carvers: Charlie James, Ellen Neal, Mungo Martin.* Vancouver, B.C.: Panorama Publications, Ltd. 1982.

Patterns Based on Northwest Indian Designs. B.C. Indian Arts and Welfare Society, 1955.

Pasnak, W. "'Artist Extraordinaire' Bill Reid", Air Canada Magazine, 1990.

Ritzenthaler, R., and Lee Parsons, ed. *Masks of the Northwest Coast.* Milwaukee Museum Publications in Art, no9. 2. Milwaukee, 1966.

Bibliography continued

Samuel, Cheryl. *The Chilkat Dancing Blanket.* Seattle: Pacific Search Press, 1982.

Samuel, Cheryl. *The Raven's Tail.* Seattle: University of Washington Press, 1988.

Sheenan, Carol. *Pipes That Won't Smoke, Coal That Won't Burn, Haida Sculpture in Argillite.* Calgary: The Glenbow Museum, 1981.

Steltzer, Ulli. *Indian Artists at Work.* Vancouver: Douglas & McIntyre, 1976.

Steltzer, Ulli. *A Haida Potlach.* Seattle: University of Washington Press, 1984.

Stewart, Hilary. *Artifacts of the Northwest Coast Indians.* Seattle: University of Washington Press, 1973.

Stewart, Hilary. *Indian Fishing.* Seattle: University of Washington Press, 1974.

Stewart, Hilary. *Indian Fishing: Early Methods on the Northwest Coast.* Seattle: University of Washington Press, 1977.

Stewart, Hilary. *Looking at Indian Art of the Northwest Coast Indians.* Vancouver: Douglas & McIntyre, 1979.

Stewart, Hilary. *Robert Davidson: Haida Printmaker.* Vancouver: Douglas & McIntyre, 1979.

Suttles, Wayne. *Handbook of the North American Indians Vol. 7.* Smithsonian Institution, 1990.

Swanton, J.R. "Tlingit Myths and Texts." U.S. Bureau of American Ethnology, Bulletin 29. Washington, D.C.: U.S. Bureau of American Ethnology, 1905.

Swanton, J. R. "Haida Texts and Myths." Bureau of American Ethnology, Bulletin 29. Washington, D.C.: U.S. Bureau of American Ethnology, 1905.

Thom, Ian. *Robert Davidson: Eagle of the Dawn.* Vancouver, B.C.: Vancouver Art Gallery and Douglas and McIntyre, 1993.

Wardwell, Allen. *Objects of Bright Pride: Northwest Coast Indian Art from the American Museum of Natural History.* New York: The Center for Inter-American Relations and the American Federation of Arts, 1978.

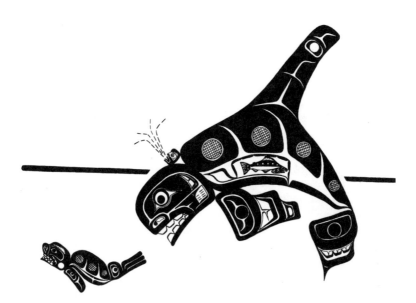

Killer Whale Hunting a Seal

Index

A
animal ears 83
animal legs and feet 134
animal snouts and noses 120
animal tails 143, 144
apparent symmetry in design 130
approaches to drawing
 ovoids 148
 U shapes 160

B
balance in design 130
baleen 117, 121, 137
beaks and bills 78
bear
 mid coast art style
 80, 83, 116, 120
 north coast art style
 114, 116, 120
 west coast art style 114
bear mouths 114, 116
bear, mythological sea
 mid coast art style 106
bear rattle 13
bear, sitting
 north coast art style 143
bear, split design
 north coast art style 130
beaver
 north coast art style
 83, 115, 120, 143
beaver head
 north coast art style 101
beaver mouths 115
Bentile, C. 73
bird ears - feathers/plumes 85, 86
bird feathers 145
bird legs and feet - toes, claws, webs 136
bird wings and tails 145, 146, 147
blow holes 116, 121
body and appendage designs 126
body parts and appendages *125*
Bookwus (Bukwis)
 mid coast art style 87
butterfly
 north coast art style 124

C
canoe
 north coast art style (iv)
chickadee
 mid coast art style 136
Chilkat blanket 3
chinook salmon head, realistic 105
close-up
 formline formation and joining 63
 ovoid 40
 U shape 48
comparing bodies across art styles 131
comparing eyes across art styles 101, 102
comparing formlines across art styles 32, 33
comparing gills across art styles 106
comparing human ears across art styles 82
comparing joining design units 62
comparing joining design units across art styles 64
comparing mouths of creatures across art styles 117
comparing noses across art styles 118
comparing ovoids across art styles 41, 42
comparing salmon heads across art styles 71
comparing U shapes across art styles 50, 51
Copper 73, 132, (vi)
crow
 west coast art style 86

D
deer
 mid coast art style 120
 west coast art style 143
deer, doe
 mid coast art style 84
deer, fork-horned
 mid coast art style 123
dog fish (shark)
 mid coast art style 124
dog salmon, X-ray design
 south coast art style 105
dogfish
 mid coast art style 103, 137
 north coast art style
 89, 106, 115
dogfish mouths 115
dogfish, split
 north coast art style 127
dragonfly
 north coast art style 131
drawn and painted formline 34
drawn and painted ovoids 43
drawn and painted S shapes 57
drawn and painted salmon heads 72
drawn and painted U shapes 52
drum and stick
 south coast art style 14
Dzunukwa
 mid coast art style 104
Dzunukwa, dancing
 mid coast art style 56
Dzunukwa, Sea
 mid coast art style 87

E
eagle
 mid coast art style 78, 85
 north coast art style 78
 south coast art style 146
 west coast art style 77
eagle, bald 77
 north coast art style 145
 south coast art style 145
eagle, contemporary
 mid coast art style 4, 86
eagle head
 formline components 30
 how to draw
 167, 168, 169, 170
eagle, profiled flying
 mid coast art style 58
eagle, two-headed
 south coast art style 129
Eagle/Raven family crest
 north coast art style 136
ears, animal 84
ears, mythological - plumes/horns 87

Index continued

examples of
 animal ears 83, 84
 animal snouts and noses 120
 beaks and bills 78
 bear mouths 114, 116
 beaver mouths 115
 bird ears - feathers/plumes 85, 86
 dogfish mouths 115
 eyebrows, north coast art style 88
 eyes 90, 92, 93, 94, 95, 96
 formline 29, 30
 free form heads 76
 heads in design units 74, 75
 human mouth area 112, 113
 joining design units 59, 61
 joining in a salmon head design 61
 killer whale mouths 116
 mythological ears - plumes/horns 87
 ovoids 36, 37, 38, 39
 S shapes 54, 55
 salmon head designs 67, 68, 69
 U shapes 45, 46, 47, 48
eye
 realistic human 91
 variations
 circular within same design 97
eye and eyelid
 how to draw north coast art style *155*, 156, 157, 158
eyelid design
 variations in 100
eyes **90**, 92, 93, 94, 95, 96
 variations in 98

F

female
 north coast art style 118
fish and sea creatures' fins and tails 136, 138, 139
fish nose/snout 124
fish, supernatural
 mid coast art style 87
flippers - seals, whales and sea creatures 134
formline 27, **28**
 close-up of 30
 examples of 29, 30
formline components
 eagle head 30
 killer whale 30

Four Major Art Style Regions of the Pacific Northwest Coast 17
frog
 north coast art style 6, 111

G

Geekumhl
 mid coast art style 108
gill cover 105
gill filaments 105
gill rakers 105
goat
 north coast art style 120
grease dish (vi)

H

Haida style chief 132
Hamatsa dancer 73
halibut
 mid coast art style 138
hats, conical style 11, 26, 107
head
 north coast art style 82
 west coast art style 82
head components
 beaks and bills *77*
 cheeks 79, 80
 ears *81*
 eyebrows *88*
 eyes *90*
 foreheads *103*, 104
 gills *105*
 hair 108
 hats, headbands, hair 26, *107*
 moustaches, fur 109
 mouths *111*
 noses *118*
 whiskers, beards 110
head, contemporary
 south coast art style 82
heads *73*
heads in design units 74
heron, blue
 mid coast art style 78
heron, contemporary
 south coast art style 80
horns and spines 123
housefront design (i)
how to draw
 eagle head *167*, 168, 169, 170

human head
 177, 178, 179, 180, 181, 182, 183, 184
killer whale
 185, 187, 188, 189, 190, 191, 192
north coast art style eye and eyelid *155*, 156
ovoids *148*
ovoids across art styles 152
salmon head
 171, 172, 173, 174, 175, 176
U shapes *160*
wolf head
 193, 194, 195, 196, 197, 198, 199
how to draw a wolf head summary 200
how to draw U shapes for design purposes 165
human
 mid coast art style 32, 104, 125, vi
 north coast art style 31, 32, 34
 south coast art style 33, 89
 west coast art style 33, 80, 89, 108, 118
human arms and hands 132
human female
 north coast art style 125
human legs and feet 133
human mouth area 112, 113
humans
 west coast art style 104
hummingbird
 mid coast art style 78
 west coast art style 131
hummingbird, hovering
 west coast art style 147
Henry Hunt pole 5

I

inner ovoid variations 37, 39
insect proboscis/beak 124

J

jay, contemporary diving
 mid coast art style 86, 147
joining design units *58*, 59, 61
joining in a salmon head design 61
joining profiled heads 65

K

killer whale
 formline components 30

Index continued

how to draw
 185, 187, 188, 189, 190, 191, 192
 mid coast art style 53, 57, 62, 126
 south coast art style 54, 138
 west coast art style 104
killer whale, bull (Orca) 140
killer whale mouths
 examples of 116
killer whale, split
 north coast art style 128
kingfisher
 mid coast art style 78, 86
kulus (kuhlus, kolus) 85

L

land otter diving
 west coast art style 142
lightning snake
 west coast art style 131

M

making ovoid patterns or templates
 150, 151, 153
making U shape patterns or templates
 162, 165
man
 mid coast art style 76, 107
 west coast art style 108
man with a moustache
 mid coast art style 109
 west coast art style 109
man with head ring or band
 mid coast art style 107
mid coast art style ----------------------
 bear 80, 83, 116, 120
 bear, mythological sea 106
 blue heron 78
 Bookwus 87
 chickadee 136
 deer 120
 deer, doe 84
 deer, fork-horned 123
 dog fish (shark) 124
 dogfish 103, 137
 Dzunukwa
 82, 101, 104, 108, 125
 Dzunukwa, dancing 56
 Dzunukwa, sea 87, 106
 eagle 78, 85
 eagle, contemporary 86
 eagle, profiled flying 58

fish, supernatural 87
formline ovoid 36
Geekumhl 108
halibut 138
Hamatsa dancer 73
human 32, 104, *125*
hummingbird 78
jay, contemporary diving 147
killer whale 53, 57, 62, 126
kingfisher 78, 86
man 76, 107
man with a moustache 109
man with head ring or band 107
mosquito 124
mountain goat 123
mythological mouse woman 143
octopus 78, 103, 131
osprey 78, 89
osprey - fish hawk 86
osprey transforming into a man
 80
otter, land 83, 120
otter, sea 83, 104, 110, 120,
 142
porpoise 135
raven, split design 127
raven "The Artist" 44
red snapper 138
Right whale 135
salmon 117, 137
salmon, coho 139
salmon head 71, 80, 106
salmon, humpback 139
salmon, ocean 124
salmon, spawning 124
salmon, split 128
sandpiper, contemporary sleeping
 147
sculpin 123
sea lion 106, 117, 131, 135
sea otter 89
sea otter floating with pup 142
sea otter sleeping with pup 142
sea urchin 123
sea wolf 135
Sisiutl 87, 122, 129
Sisiutl, centre head of 80
sisiutl serpent head, mythological
 117
skate 124, 131, 139
sperm whale 117

split beaver bracelet design 129
sun 89
thunderbird 85, 87, 146, (i)
whale head 121
whale tail 138
wolf 83, 109, 120 ----------------
monster, mythological sea
 north coast art style 106
mosquito
 mid coast art style 124
 north coast art style 84, 124
mountain goat
 mid coast art style 123
 north coast art style 84, 110, 123
mouse
 west coast art style 120
mouse, mythological
 west coast art style 84
mouse woman, mythological
 north coast art style 110
mythological beings - snout/nose 122
mythological killer whale dorsal fins
 north coast art style 139
mythological lightning snake
 west coast art style 122
mythological mouse woman
 mid coast art style 143
 north coast art style 143
mythological sea monster
 west coast art style 122

N

north coast art style -----------------
 bear 114, 116, 120
 bear, grizzly 120
 bear, sitting 143
 bear, split design 130
 beaver 83, 115, 120, 143
 butterfly 124
 dogfish 89, 106, 115
 dogfish, split 127
 dragonfly 131
 eagle 78
 eagle, bald 145
 Eagle/Raven family crest 136
 examples of eyebrows 88
 eye and eyelid 159
 face in a U shape 74
 face in an ovoid 74
 female 118
 formline ovoid 36

Index continued

frog 6, 10, 111
goat 120
head 82
human 28, 31, 32, 34
human female 125
human formline 28
jay 86
killer whale, split 128
monster, mythological sea 106
mosquito 84, 124
mountain goat 84, 110, 123
mouse woman, mythological 110
mythological killer whale dorsal fins 139
mythological mouse woman 143
Orca 116
osprey 78, 86
owl 86
raven 77, 78, 86, 147
raven, mythical 78
raven with sun 146
salmon 131
salmon head 71
sculpin 123
sea monster 144
sea urchin 123, 131
thunderbird 20, 78
Wasgo 87, 122
wolf 84, 109, 117 -----------------

O

octopus
 mid coast art style 78, 103, 131
Orca
 north coast art style 116
osprey
 mid coast art style 78, 89
 north coast art style 78, 86
osprey - fish hawk
 mid coast art style 86
osprey transforming into a man
 mid coast art style 80
otter, land
 mid coast art style 83, 120
otter, sea
 mid coast art style 83, 104, 110, 120, 142
otter tails 143

ovoid *35*
 making patterns or templates 150, 151, 153
ovoids
 approaches to drawing 148
 examples of 36, 37, 38, 39
 how to draw *148*
ovoids used in designs across art styles 154
owl
 north coast art style 86, (ii)

P

porpoise
 mid coast art style 135
potlatch rings 107

Q

quadron 36, (vi)
quinton (vi)

R

raptors 77
raven 77
 north coast art style 77, 78, 86, 147
raven, mythical
 north coast art style 78
raven, split design
 mid coast art style 127
raven tail feather 44
raven "The Artist"
 mid coast art style 44
 north coast art style 7
raven with sun
 north coast art style 146
red snapper
 mid coast art style 138

S

S shape *53*
S shapes, examples of 54, 55
S shapes in a design 56
Salish style grieving human 132
salmon
 mid coast art style 117, 137
 north coast art style 131
 west coast art style 138
salmon, coho
 mid coast art style 139

salmon egg theory 35
salmon head 39, *66*
 how to draw *171*, 172, 173, 174, 175, 176
 mid coast art style 71, 80, 106
 north coast art style 71
 south coast art style 71
 west coast art style 71
salmon head design complexes 70
salmon head designs 67, 68, 69
salmon, humpback
 mid coast art style 139
salmon, ocean
 mid coast art style 124
salmon, spawning
 mid coast art style 9, 124
salmon, split
 mid coast art style 128
sandpiper, contemporary sleeping
 mid coast art style 147
sculpin
 mid coast art style 123
 north coast art style 123
sea lion
 mid coast art style 106, 117, 131, 135
sea monster
 north coast art style 144
 west coast art style 126, 138
sea monster, mythological
 west coast art style 117
sea otter
 mid coast art style 89
sea otter floating with pup
 mid coast art style 142
sea otter sleeping with pup
 mid coast art style 142
sea urchin
 mid coast art style 123
 north coast art style 123, 131
 west coast art style 123
sea wolf
 mid coast art style 135
 west coast art style 135
seal
 south coast art style 135
serpent
 west coast art style 122
serpent - lightning snake
 west coast art style 87

Index continued

serpent, mythological
 west coast art style 117
Sisiutl
 mid coast art style 87, 122, 129
Sisiutl, centre head of
 mid coast art style 80
sisiutl serpent head, mythological
 mid coast art style 117
skate
 mid coast art style 124, 131, 139
south coast art style -----------------
 dog salmon, X-ray design 105
 eagle 146
 eagle, bald 145
 eagle, two-headed 129
 formline ovoid 36
 head, contemporary 82
 heron, contemporary blue 80, 86
 human 33, 89
 killer whale 54, 138
 salmon head 71
 seal 135
 sturgeon 139
 thunderbird 87
 wolf 109, 131 --------------------
sperm whale
 mid coast art style 117
split beaver bracelet design
 mid coast art style 129
split body designs 127, 128
split body designs with symbolic parts
 129
sturgeon
 south coast art style 139
sun
 mid coast art style 89

T

Tai tats-toe 73
thunderbird
 mid coast art style 85, 87, 146, (i)
 north coast art style 78
 south coast art style 14, 87
 west coast art style
 76, 78, 87, 131, 146
Tlingit chief 20
transformation mask 9
trigon 36, (vi)

U

U shape *44*
 close-up 48
U shaped feather variations 44
U shapes
 approaches to drawing 160
 examples of 45, 46, 47, 48
 how to draw ***160***
 making patterns or templates
 162, 165
U shapes used in designs across art
 styles 166

W

Wasgo
 north coast art style 87, 122
west coast art style --------------------
 bear 114
 crow 86
 deer 143
 dogfish 115
 eagle 77
 face in a circle 74
 formline ovoid 36
 head 82
 human 33, 80, 89, 108, 118
 humans 104
 hummingbird 131
 hummingbird, hovering 147
 killer whale 104
 lightning snake 131
 man 26, 108
 man with a moustache 109
 mouse 120
 mouse, mythological 84
 mythological lightning snake 122
 mythological sea monster 122
 salmon 138
 salmon head 71
 sea monster 126, 138
 sea monster, mythological 117
 sea urchin 123
 sea wolf 135
 serpent 122
 serpent - lightning snake 87
 serpent, mythological 117
 thunderbird
 76, 78, 87, 131, 146
 whale, baleen 137

whale, humpback (baleen) 117
wolf 76 --------------------------
whale
 mid coast art style 135
whale, baleen
 west coast art style 117, 137
whale head
 mid coast art style 121
whale heads
 nose, nostril, blow hole designs
 121
whale, humpback (baleen)
 west coast art style 117
whale tail
 mid coast art style 138
whaler's hat 11
whales' tails 140, 141
wolf
 mid coast art style 83, 109, 120
 north coast art style
 84, 109, 117
 south coast art style 109, 131
 west coast art style 76
wolf head
 how to draw
 193, 194, 195, 196, 197, 198, 199
wolf skull, snout 111

X

X-ray in design 130, 131
X-ray vision technique 53

Reflection

Also Available from Raven Publishing

Learning by Doing Northwest Coast Native Indian Art

Table of Contents - Learning by Doing

Chapter 1
- Scope and Sequence Chart
- Introduction and Theoretical Construct
- Instructional Techniques
- Justification and Need

Chapter 2 - Review of the Literature
- Map
- Northwest Coast Native Indian Cultural Background
- Native Art - Kwagiulth Artists; Skills
- Curriculum
- Curriculum Model
 - Patterns of Instructional Programming; Methodology; Time; Interaction Patterns
 - Learner Needs; Supportive Environment; Program and Student Evaluation
 - Reporting
 - Present Day Development of Curriculums of Native Indian Art

Chapter 3 - Goals, Objectives, Handouts
- Goals and Objectives
- Evaluation
- Handout Materials: Rating Scale - Teacher Program Evaluation
- Rating Scale - Parent/Guardian Evaluation
- Questionnaire - Teacher Self-Evaluation
- Questionnaire - Student Self-Evaluation
- Questionnaire - Student Course Evaluation
- Example of a Criterion-Referenced Test
- Concept Checklist
- Group Record Card

Chapter 4 - Teaching/Learning the Concepts
- Basic Ovoid; Ovoid with Eyelid Line; U shape; Split U; Reverse Split U; Variations in U Shapes; 'S' Shaped Box End Design; Salmon-Trout Head; Killer Whale Head; Eagle Head; Carving Knife Handles; Bas-Relief Whale; Bas-Relief Eagle (Interior areas carved); Carved Serving Tray; Carved Ceremonial Paddle

Chapter 5 - Implementation
- Costs; Possible Uses; In-Service or Other Preparatory Activities; Materials; Line Drawings of all the Concepts

Bibliography

Soft Cover 160 pages

Raven Publishing
P.O. Box 325
5581 Horne Street
Union Bay, B.C. V0R 3B0
Canada

Phone: 250-335-1708 or 250-478-3222
Fax: 250-335-1710 or 250-478-3222
Email: artandculture@ravenpublishing.com
Website: http://www.ravenpublishing.com

Coming in 2000 from Raven Publishing

Limited Edition Sets

250 copies of **Learning by Designing Pacific Northwest Coast Native Indian Art, Volumes 1 and 2,** plus a Limited Edition Colour Print of *"Raven the Artist"* will be available in a three-part, numbered, signed, embossed and boxed set.

- and -

Learning by Designing Pacific Northwest Coast Native Indian Art Volume 2

Table of Contents - Learning by Designing - Volume 2

Introduction

Building on a First Nations Foundation
- Traditional First Nations Code of Ethics
- Twelve Principles of Aboriginal Philosophy
- Aboriginal Art within a Cultural Context
- Four Major Art Style Regions of the Pacific Northwest Coast
- Map: Culture & Art Style Regions of the Pacific Northwest Coast
- Map: Four Major Art Style Regions of the Pacific Northwest Coast
- History and Description of the North Coast Art Style
- History and Description of the Mid Coast Art Style
- History and Description of the South Coast Art Style
- History and Description of the West Coast of Vancouver Island Art Style

Introduction to Design
- Evolution and Formation of Design Shapes
- Evolution of the Ovoid - The Salmon Egg/Salmon Head Theory
- Two-Dimensional Design Styles
- Semi-Realistic Design Styles
- Extended and Rearranged Design Styles
- Myth Interpretation / Reading a Rearranged Design
- Reading a Two-Dimensional Design
- Overlapping - Depth and Perspective
- Perspective - Birds Wings and Tails
- The Elements - Rain, Clouds, Snow, Water, Ocean
- Trees and Coastal Islands
- Painting and Colours
- Basketry Designs - Geometric, Decorative, Animal, Woven or Painted
- Decorated Garments
- Decorative Garments - Button and Applique
- Contemporary Garments

Full Designs in the Style of the Four Art Areas : North, Mid, South and West Coast
- Human; Salmon; Thunderbird; Killer Whale; Wolf - all six themes drawn and painted in each style

Summary Chart

Quick Reference Charts - All 123 illustrations found throughout the book as well as additional drawings
- Birds; Fish; Heavenly Bodies and Elements; Humans; Insects; Mammals; Sea Animals

Glossary Bibliography Index